Style and Grace

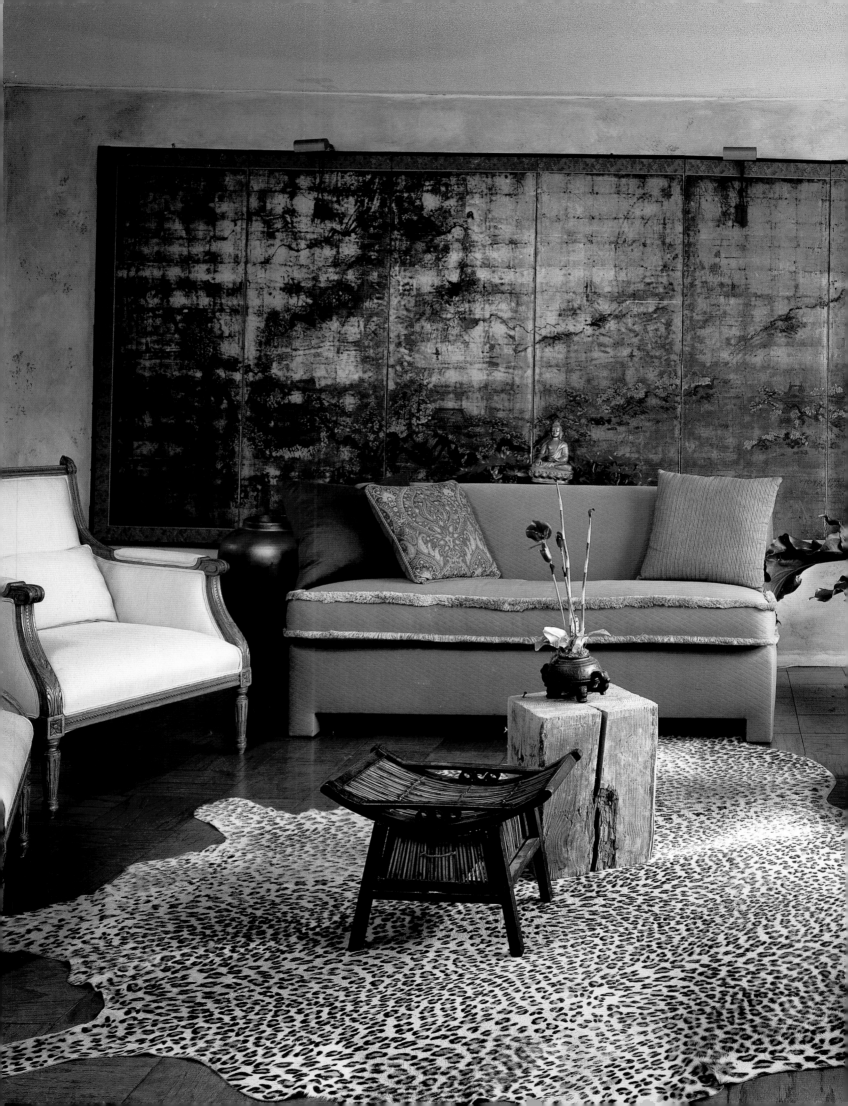

Style and Grace
African Americans at Home

Michael Henry Adams

Photographs by Mick Hales

Bulfinch Press
AOL Time Warner Book Group
Boston · New York · London

First Edition

ISBN 0-8212-2847-1
Library of Congress Control Number 2003103036

Design: lync.

Bulfinch Press is a division of AOL Time Warner Book Group.

PRINTED IN ENGLAND

For my magnificent six:

Evelyn Cunningham, Bobby Short, Eartha Kitt, Grafton S. Trew,
Alma Carter Rangel, and Mario Buatta—the most stylish people I've ever known

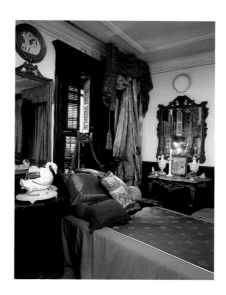

ACKNOWLEDGMENTS

Often with a book of this type many people never get beyond the illustrations. In this instance such an oversight is almost justified thanks to the brilliance of Mick Hales, one of the most talented photographers and nicest people in the world. In addition, it is imperative to thank my other remarkable collaborators: Ima Ebong, who first encouraged this undertaking, and Marta Hallett, whose company, Glitterati Incorporated, engaged the accomplished designer Lynne Yeamans and identified the worthy people at Bulfinch Press—publisher Jill Cohen and Kristen Schilo, my editor. Clarice Taylor's contributions were invaluable.

Quite apart from all those who helped bring this project to fruition, I am deeply indebted to all those who opened their wonderful homes to me with kindness and grace. Thank you, one and all!

Crucial to finding the fabulous places where these people live were several helpful individuals, including Susan Fales Hill, Sheri Bronfman, Jean-Claude Baker, Claudette Law, Chip Logan, Robin Bell-Stevens, David Levering Lewis, A'Lelia Bundles, Eva Tucholka, Chris McRea, April Tyler, Chippy Irvine, Geoffrey Holder, and Henry Mitchell.

Thanks is also due to Carolyn Cassady Kent, Peter Dixon, Anthony Q. Crusor, Eileen Morales, Kathleen Benson, Robert A. M. Stern, and Carson Anderson.

Finally, I offer abiding thanks to my family: my sisters, Deborah Louise Parham, Athena Marie Littlepage, Valerie Lynn Adams, Tracey Alexandria Smith; my stepmother, Sheila Adams; and my supportive parents, Willie Dean Hollinger Adams and Alexander Leroy Adams.

Foremost, through his tireless, patient efforts on behalf of this project, Michael McCollom has earned a place among my nearest and dearest friends.

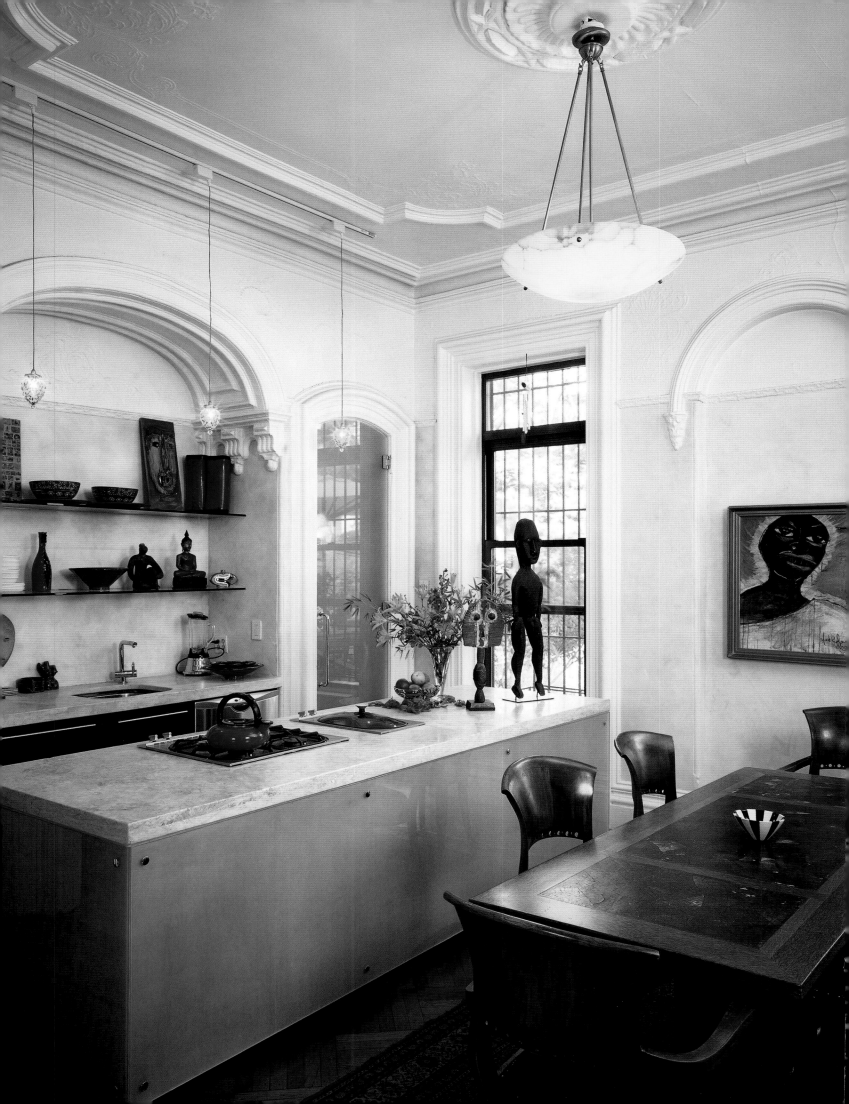

CONTENTS

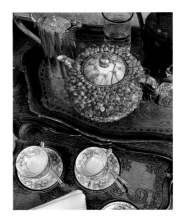

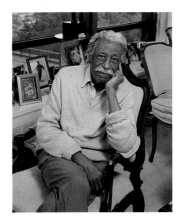

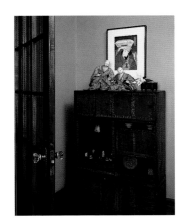

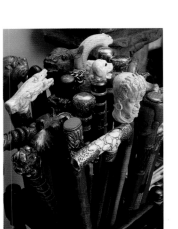

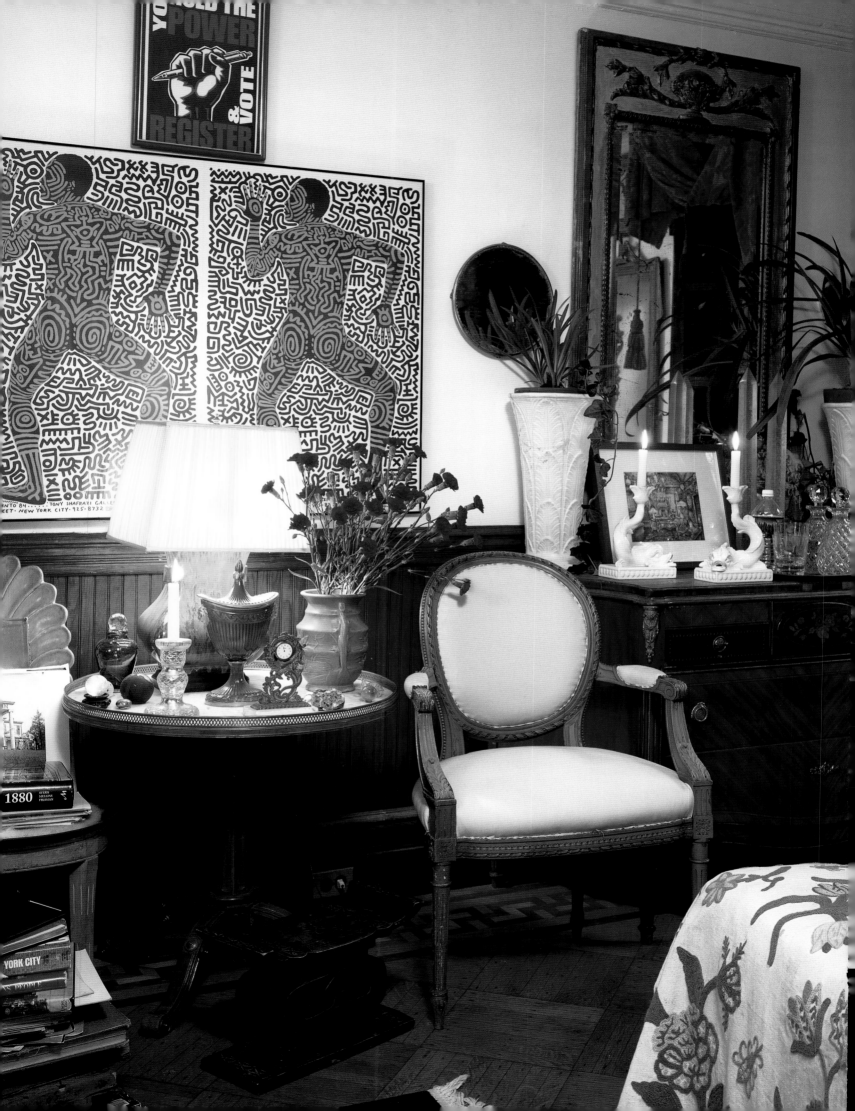

EXCEPTIONAL AFRICAN-AMERICAN DÉCOR

AT HOME WITH THE HUXTABLES

Today, it's hard to recall what an innovation *The Cosby Show* was. When the show first aired in 1984, even some blacks exclaimed, "Humph! There aren't any, or not many, African Americans who live like that."

Those familiar with the history of neighborhoods like Strivers Row and Sugar Hill in Harlem, Brooklyn's Fort Greene, St. Albans in Queens, or Mount Vernon, New Rochelle, and other "suburban Sugar Hills" reacted differently, but for most it was a revelation. That television program taught all America and beyond an important lesson: that affluent blacks resided in tastefully conceived interiors.

At the time, many African Americans, starved for affirming representations of black décor, rejoiced. The Huxtables' smart spaces had been a long time coming. Reassuringly normal, these rooms were "utterly unlike those ordinarily associated with

ABOVE: *In the author's Harlem apartment, diverse elements provide an atmosphere redolent of days gone by.*

OPPOSITE: *In the same room, the author combines Wedgwood candlesticks, vases, walls and upholstery, all white, along with a pair of Keith Haring posters.*

black life in much of the national consciousness," remembers April Tyler, a Harlem Realtor. "They betrayed neither the unlovely meagerness of *A Raisin in the Sun* nor the crass, overconspicuous trendiness of *Superfly*. Traditional and comfortably furnished, they featured the occasional African artifact alongside good Colonial reproductions. Inherent in them, we were certain, was an appropriate guide, worthy of application."

Now the program's low-key sets, depicting a fictional Brooklyn brownstone, might seem a trifle dull, which shows just how far things have advanced. Another indication of how far we've come in the post–*Cosby Show* era is the black influence on the dynamic and far-reaching new American multicultural eclecticism. Doors incised by West African master carvers or compact-disk shelves crafted in the Ivory Coast are par for the course. Black architects and black interior designers are working now as never before.

Hardly anyplace in this book is as conservatively decorated as the Huxtables' homestead was. If you're black and a neo-Florentine villa is your heart's desire, that's all right.

AFRICAN AMERICANS IN NEW YORK: THE WORLD CAPITAL OF STYLE

From the Colonial period to the Harlem Renaissance and beyond, New York holds a special place in the evolution of black style. Doubtless you are familiar with the songs about New York. Anything goes here—as long as it has style. It is the city that never sleeps, the hub around which the rest of the civilized world revolves. It's a wonderful town, where most residents are convinced that if they can make it here, in the Big Apple, they'll be all set. Millions have been drawn to this complicated, often frenetic place, and among the lures that cause the hopeful, far and wide, to be irresistibly attracted ever Gothamward is the pursuit of beauty. Many of this group have been blacks.

African Americans in the world's greatest city, now and in times past, have created compelling and enchanting home environments. Those decorating

ABOVE AND OPPOSITE: *On a Harlem rooftop, homeowners Stephanie and Michael Alston-Nero have created a luxurious refuge, replete with a papyrus-fringed goldfish pool.*

efforts, until recent years, have been all but ignored, although blacks have called New York home for as long as any European colonist has. Little survives to document the décor of the black presence in New York for the first three centuries of its history, but much of that heritage is embodied in this cross section of black New Yorkers' homes today. It provides a rare look at incomparable, sometimes unconventional, spaces, hopefully rendering questionable a host of enduring popular stereotypes about how black people live and providing answers to more interesting conundrums about black style.

BLACK STYLE?

One recurring issue is whether or not an identifiable "black style" exists in interior decorating.

"I can always identify a black singer. Whether Bobby Short, Sarah Vaughan, or Jessye Norman, there's always a definite quality held in common by even the most disciplined and rigorously trained among them. It's a kind of warmth and depth, a richness, sometimes a subtle thing but, for me, always unmistakable," says the elegant Grafton Trew, an actor by trade and an aficionado of matters of taste.

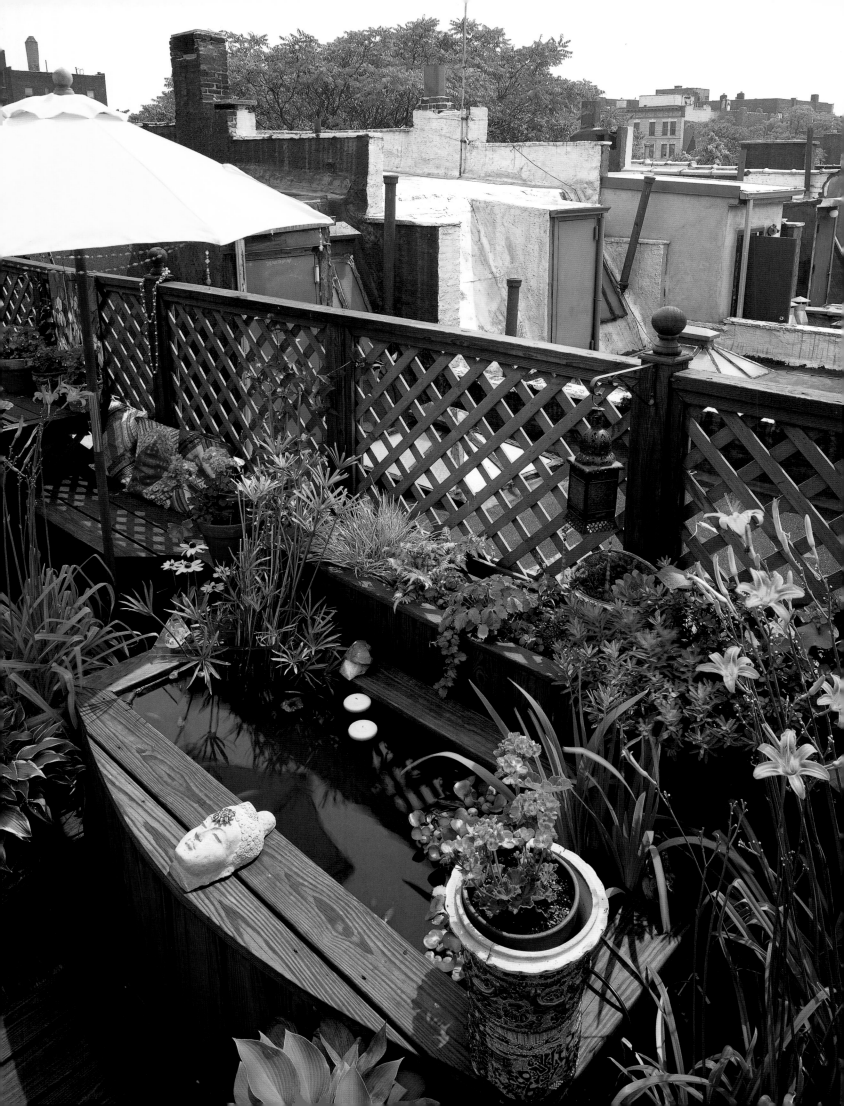

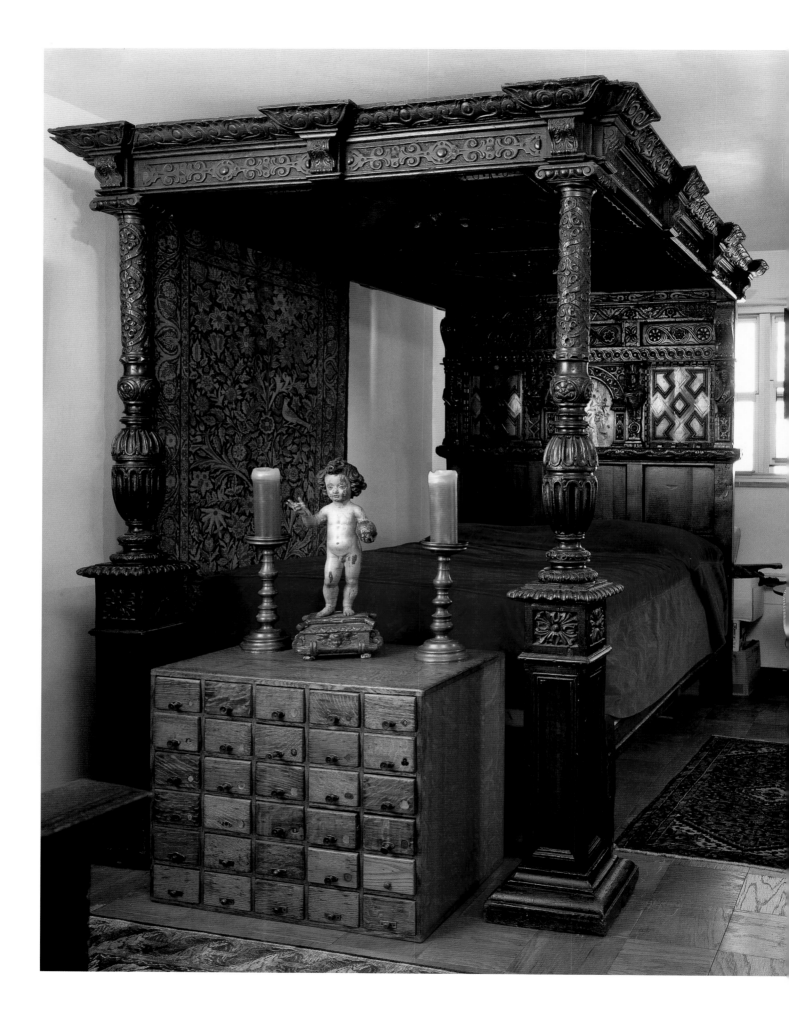

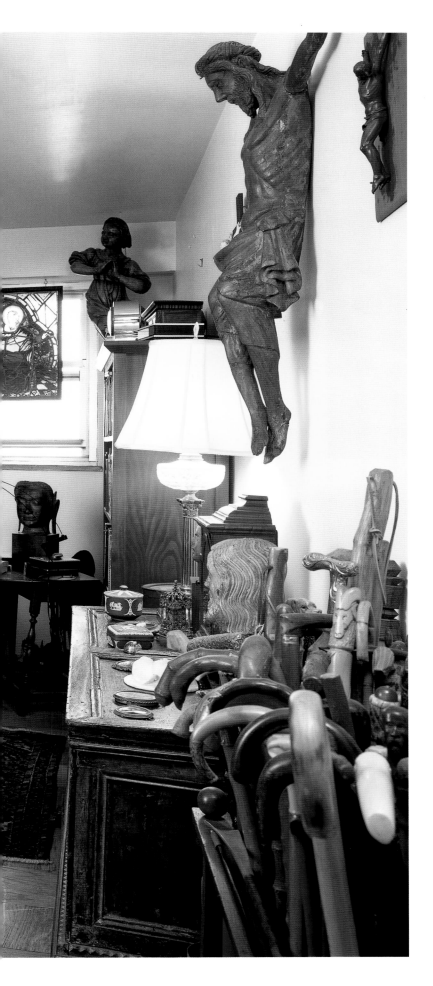

Through judicious acquisitions, human rights activist Bayard Rustin created an enviable art collection. His Elizabethan-style bed and other international antiques belie an otherwise ordinary interior.

Born in Harlem in 1915, Mr. Trew now lives in Turtle Bay. But he concedes, "It's a different story altogether with a room."

Stephen Birmingham, that prodigious chronicler of elite Americans, seems to have concluded that there is a "black style." In his 1977 book *Certain People*, which examines customs among African-American upper echelons, an entire chapter is devoted to "Taste."

"I remember well, reading that book and especially *that* chapter," says Carson Anderson, an architectural historian. "It was anonymous rich black vulgarians versus mostly anonymous rich white connoisseurs, and it was awful! Chief among the complaints of the 'connoisseurs' was what they deemed to be characteristic black ostentation. Especially memorable was a caustic quote, attributed to Louis Auchincloss, the novelist. Referring to the homes of 'gracious, cultivated' blacks he had visited in Harlem, Auchincloss reportedly said, 'It's very hard to describe. There were things in their houses and apartments that,

while obviously expensive, I just wouldn't want in mine.' Most unjust," recalls Mr. Anderson, "was the finger-pointing directed at a certain matron, who it's implied ought to have known better than to display 'gold-painted' walnuts in a costly classic Steuben glass bowl. But didn't Helena Rubenstein fill a wooden African bowl, on the floor of her Park Avenue drawing room, with colorful glass vegetables? What sanctioned Emily Post's use of silver-painted artificial fruit in a silver bowl? What made that more correct than gilded walnuts? Birmingham depicted bourgeois blacks as obsessively house-proud."

Whether house-proud and having a fondness for the ornate, blacks—only out of slavery for one hundred forty years and beyond Jim Crow for only fifty years—are still clearly in the wonderful throes of a rapidly evolving African-American decorating style.

Says an amused Grafton Trew, "My friend Diana Vreeland used always to say, 'Even bad taste is to be preferred to no taste at all.' It might be good or it might be god-awful, but I tell you, our folks have got some style!

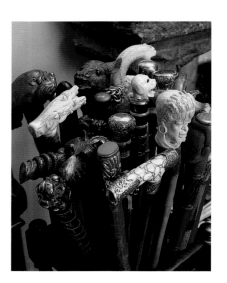

ABOVE: *Extraordinary walking sticks are among the most appealing objects in Rustin's collection.*

OPPOSITE: *Inspired by the collections of American millionaires, Rustin's early Renaissance Madonna and chairs were unfashionable in the 1950s and acquired inexpensively.*

The way we fix our hair, wear our clothes, or decorate our houses—it's, well, just as my grandmother used to say, 'You might be shocked, but you won't be bored!' I'm convinced we were born with style. We brought it over in the dank holds from Africa."

A hereditary style sense is an intriguing concept. A taste for fine objects and stylish surroundings comes to many as a matter of course. It's in our souls.

HOUSES *and* HOMES
As much as I appreciate and admire the beauty of objects and the solemnity of noble architecture, I've come to realize that they are all but meaningless in the absence of context provided by people. The most vital role that heritage and history play is to connect us one to another—past, present, and future—and to enable us to discover ourselves.

What is shown on these pages are not only interesting spaces, they are *homes*. They reflect the soulful living of those who have so generously opened their doors to share with us a bit of the beauty they have created.

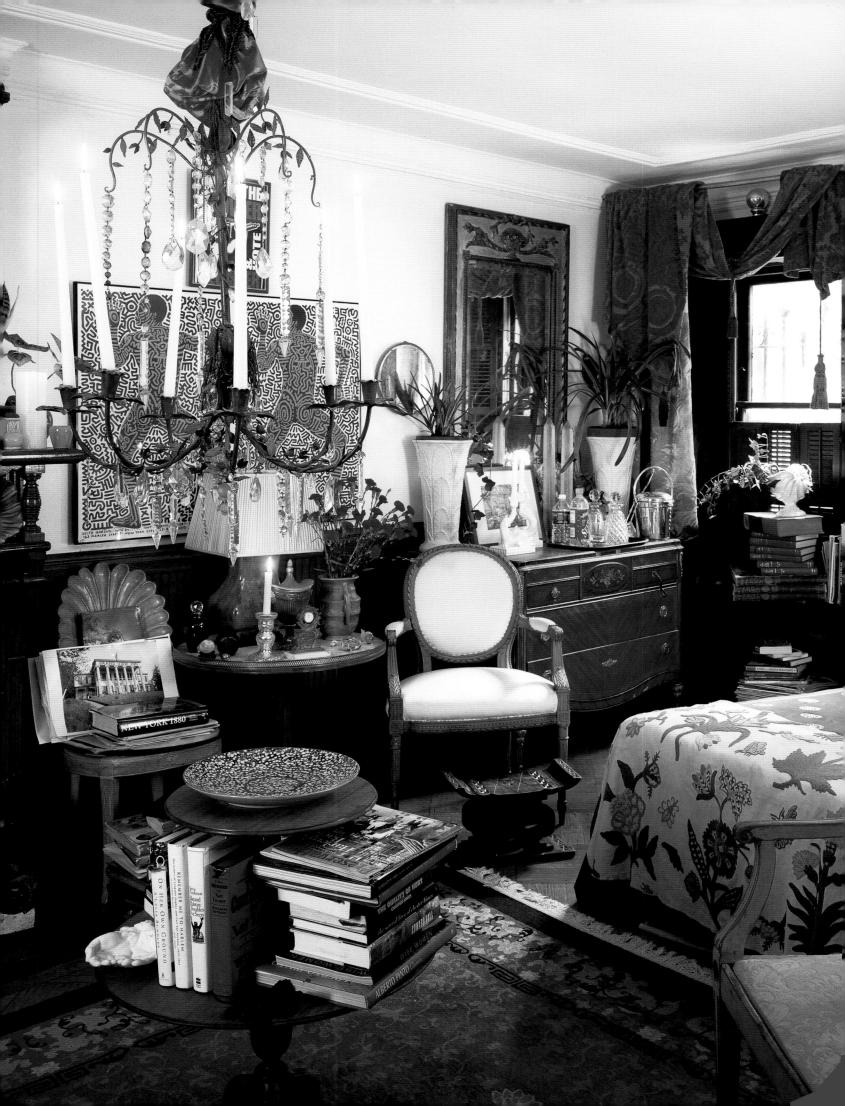

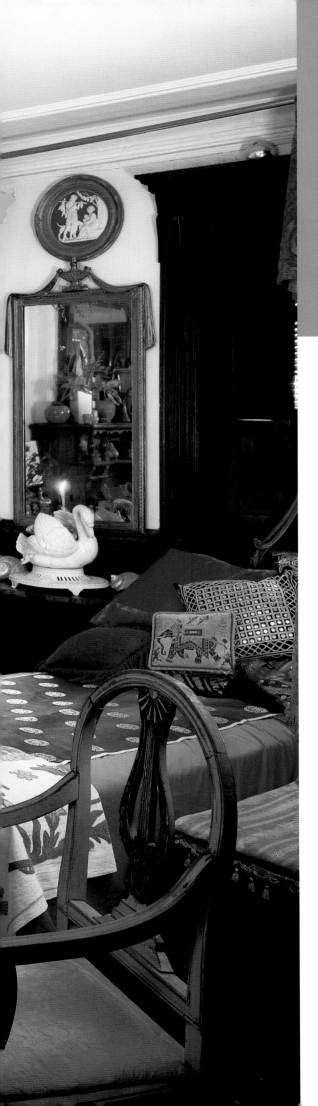

Michael Henry Adams

THE AUTHOR AT HOME

When I was a child living in Akron, Ohio, the appeal of courtly continental grandeur affected me. My great-grandmother's one-level Colonial ranch house was built about six years before my birth. I considered it the very acme of "deluxeness." Surrounded by two acres of garden and lawn, it had a long concrete front porch with a scrolling wrought-iron railing, painted white. Never used since Daddy Henry's death, the fireplace actually worked, as I discovered through surreptitious newspaper burning.

Mama Willie's collection of china figurines imported from England, Germany, and Japan was vast. In the dining room, where I only ever saw members of Mama Willie's women's club eat, was a suite of mahogany

ABOVE: *Light filters through a salvaged stained-glass window that looks out on the garden; a family photo provides a further sense of place to the highly personal space.*
LEFT: *Stark white walls and warm candlelight gently illuminate and unify the author's thrift shop finds, including a carved West African stool, a Chinese carpet, and a graceful lyre-back chair made by New York's Chamberlyn Company in the early 1900s.*

furniture with lyre-back chairs. I was told this furniture was called Duncan Phyfe, but why, I had no idea. Far preferable to me were the round marble-topped tables with curved legs in the living room and bedrooms. These held elaborate lamps with shades that glowed invitingly in the big picture window. Rose-strewn *Gone With the Wind* lamps lighted each bedside. Wallpaper borders, coordinated to match the pink and blue walls, were also rose-strewn. So were hooked rugs and chintz draperies over tied-back ruffled organdy curtains.

In contrast to all this, our nearby bungalow was too humble for words. But when I was thirteen, a miracle happened—I "met" Stan Hywet Hall.

Completed in 1915, Stan Hywet Hall was built by the founder of the Goodyear Tire and Rubber Company, Frank A. Seiberling, to replicate an Elizabethan manor house. With sixty-five rooms on seventy acres, including thirty acres of gardens, it remains the largest house ever built in Ohio. Designed by Charles S. Schneider and decorated by New York's H. F. Huber and Company, it was unquestionably one of the most elegant ever built in the county. Now, just as when I first saw it, Stan Hywet is open to the public as a house museum.

Along with antique photographs and American art pottery, the author collects furniture and architectural fragments salvaged from lost Harlem landmarks.

Over the objections of my mother, who thought it insane that I would work for free on my only day off as a busboy at the Fairlawn Country Club, I was a volunteer tour guide there for almost nine years. What an experience! In winter there were fewer visitors, and my young colleagues and I owned the place. Quite against the rules, the bolder among us would explore the unrestored guest rooms that weren't yet on the tour. Each room represented a different decorative period. There was the walnut-wainscoted William and Mary room, with striped, cut-velvet wallpaper and a damask-covered bed frame. A picture of delicacy, the adjacent Adam room had windows on two sides. There was a silhouette bedroom suite on the third

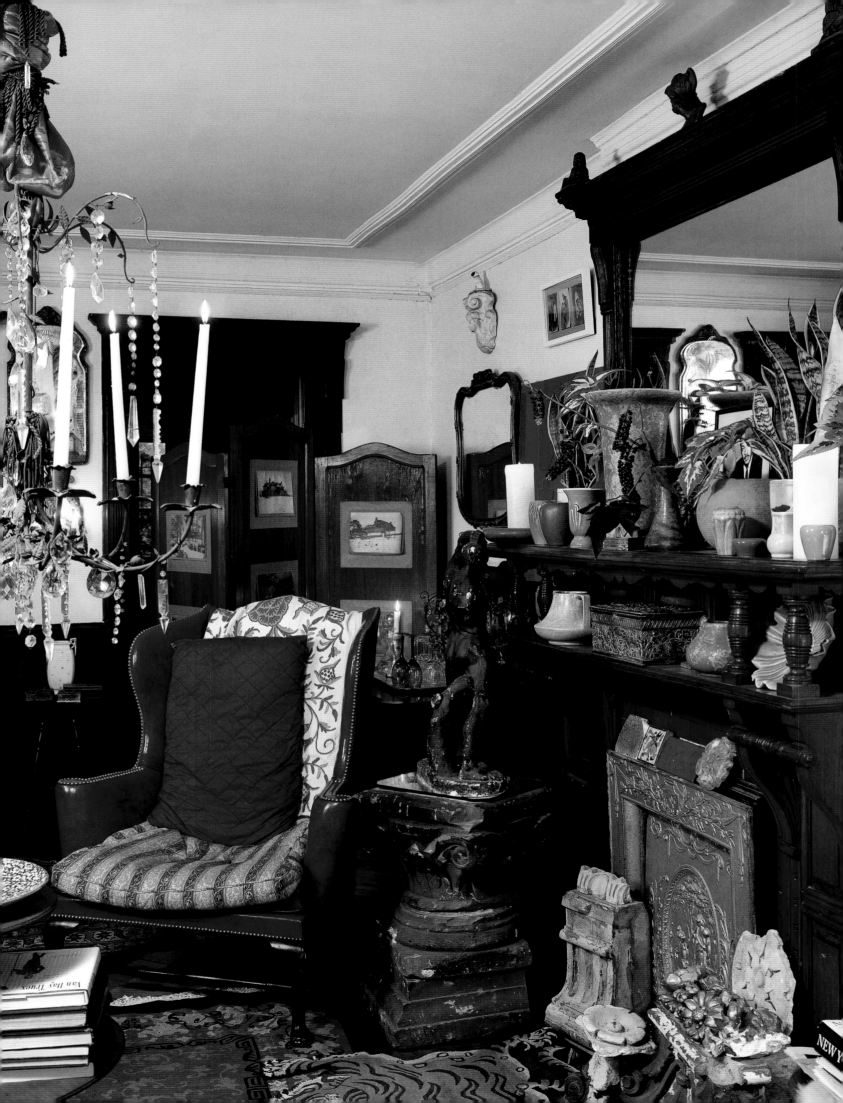

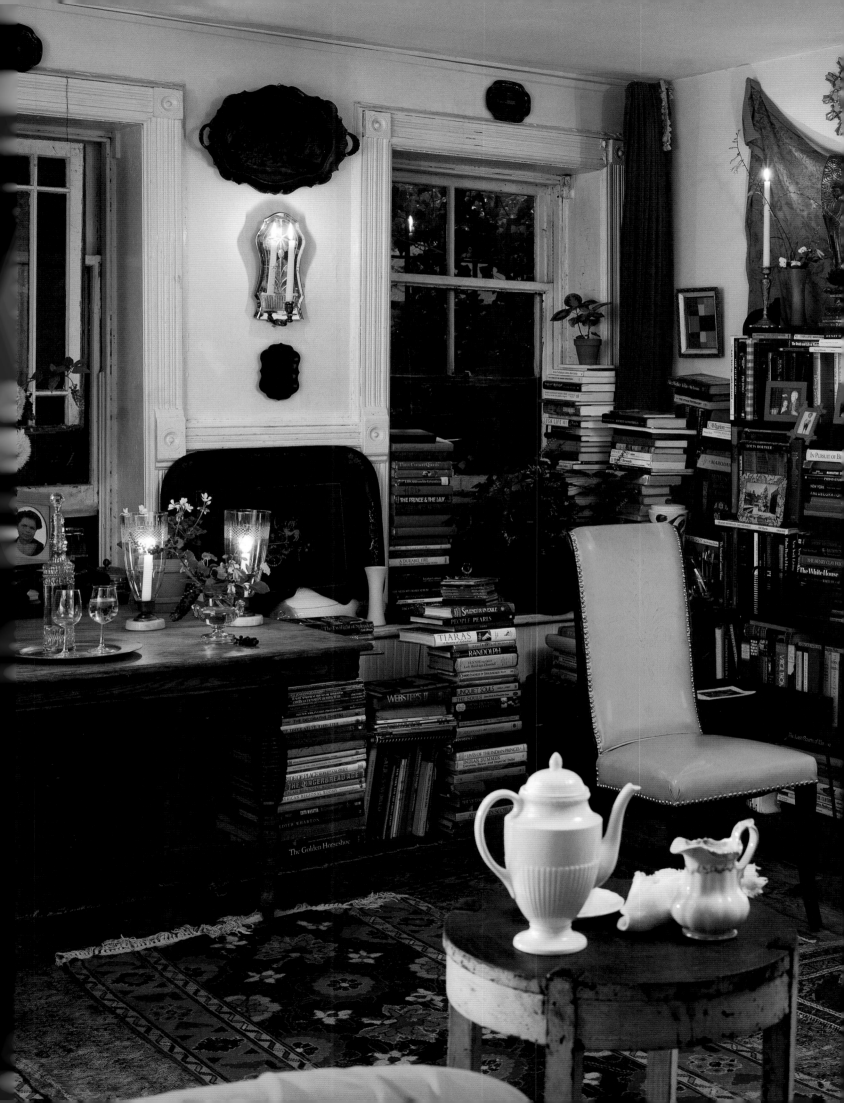

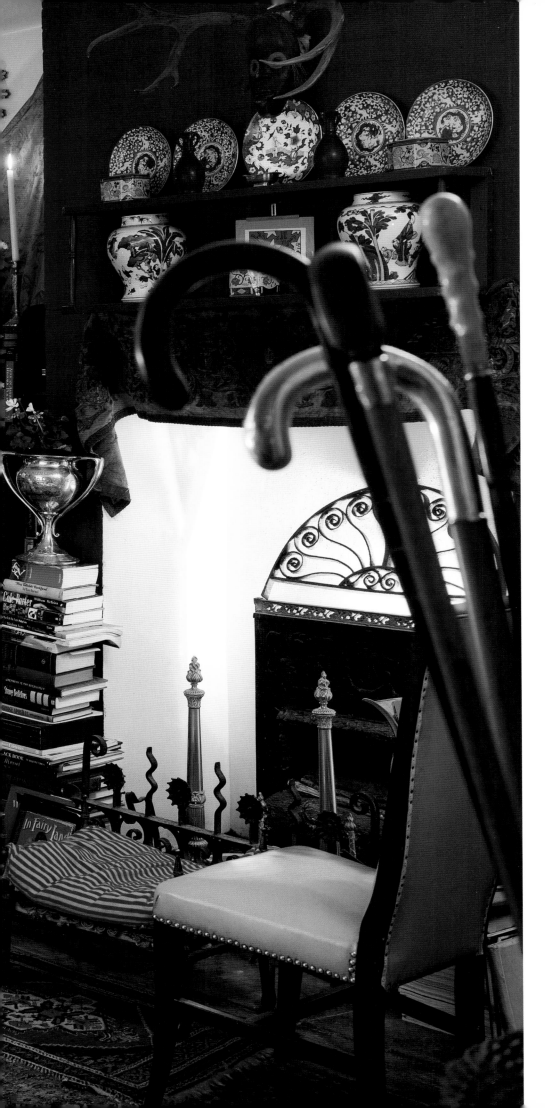

Stacked in seemingly random piles, books dominate the author's combination library, dining room, and sleeping space. Originally the kitchen of a Harlem brownstone, it also displays some of his most prized possessions—walking sticks once owned by Bayard Rustin.

story, next to the nursery, with wallpaper showing old-time games. Most inviting was the Georgian room, near the family bedrooms. Its imposing Hepplewhite bed, red lacquer pagoda-shaped clock, basaltware vestal virgin lamps, and soft gray walls remain the standard by which I assess distinction.

Because they occupied the third and fourth floors of the tower, the Gothic and Della Robbia rooms were our favorites. Slow and creaking, the paneled elevator by which they were reached was an unavoidable hazard that might easily give us away, but this only added adventure to our expeditions. Mr. Lee, the caretaker, was good enough only to discover us about every tenth time we rode up and then crept out onto the battlemented tower roof, with its staggering vista all the way to the horizon and to gardens below. The landscaped areas were was so skillfully devised that we felt atop the center of the world.

Irene Seiberling Harrison, the eldest child of Stan Hywet's builders, and I shared the same birthday—only she was eighty-one when I was fifteen. Mrs. Harrison lived on to reach one hundred five in the charming cottagelike gate lodge of her family's house, and we became friends.

"You are so knowledgeable, Mr. Adams, I believe that you must have lived before, and that's why you have so prodigious a knowledge." Mrs. Harrison imagined she had paid me the ultimate compliment. So did I. But I couldn't help being uneasy. The only way I could know so much about decoration from the past was to have lived then. Ultimately, Mrs. Harrison redeemed this idea by assuring me, "With all your talents and intelligence, you could acquire someplace, perhaps not quite so unmanageable as this, as your own home, if you really wanted to." It was then that I decided to dedicate myself to the study of what I later learned was historic preservation.

In addition to such auspicious purchases as the pair of embossed leather chairs, many of the author's furnishings—the pink metal table, from which tea is often served in white porcelain wear, and the convex mirror over the mantel—were rescued from the trash.

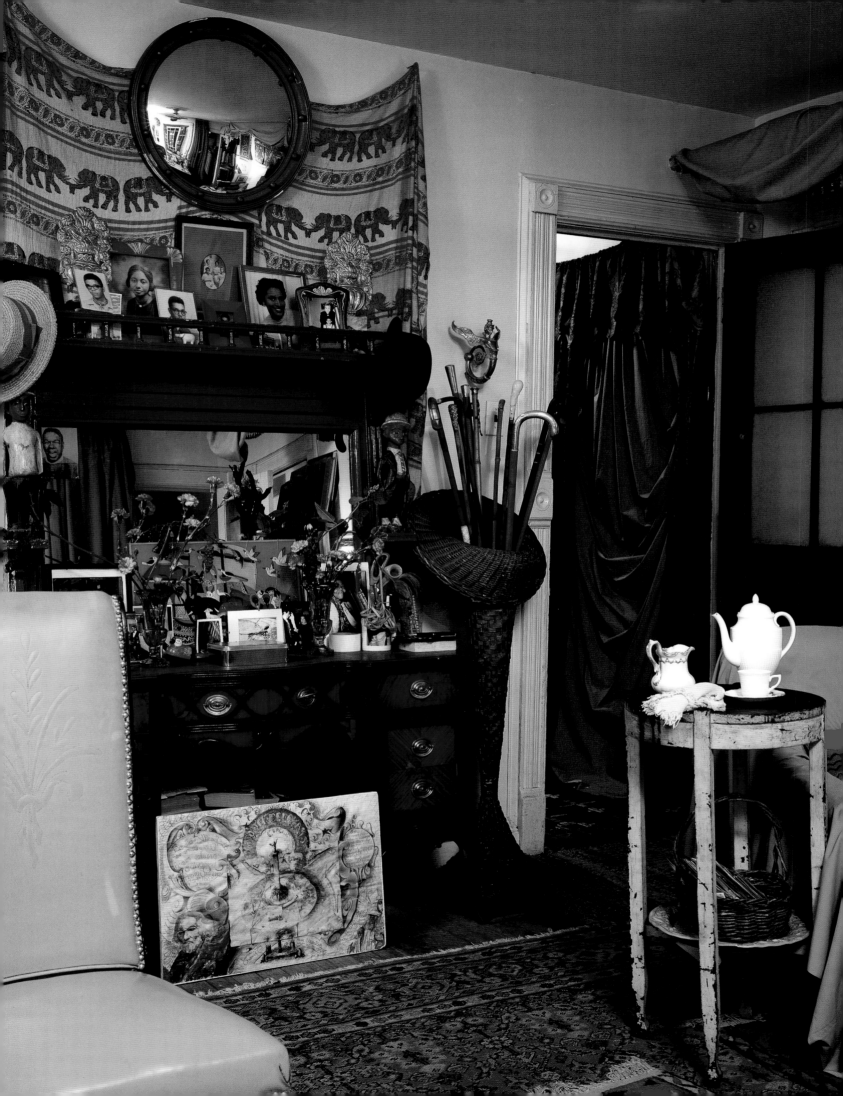

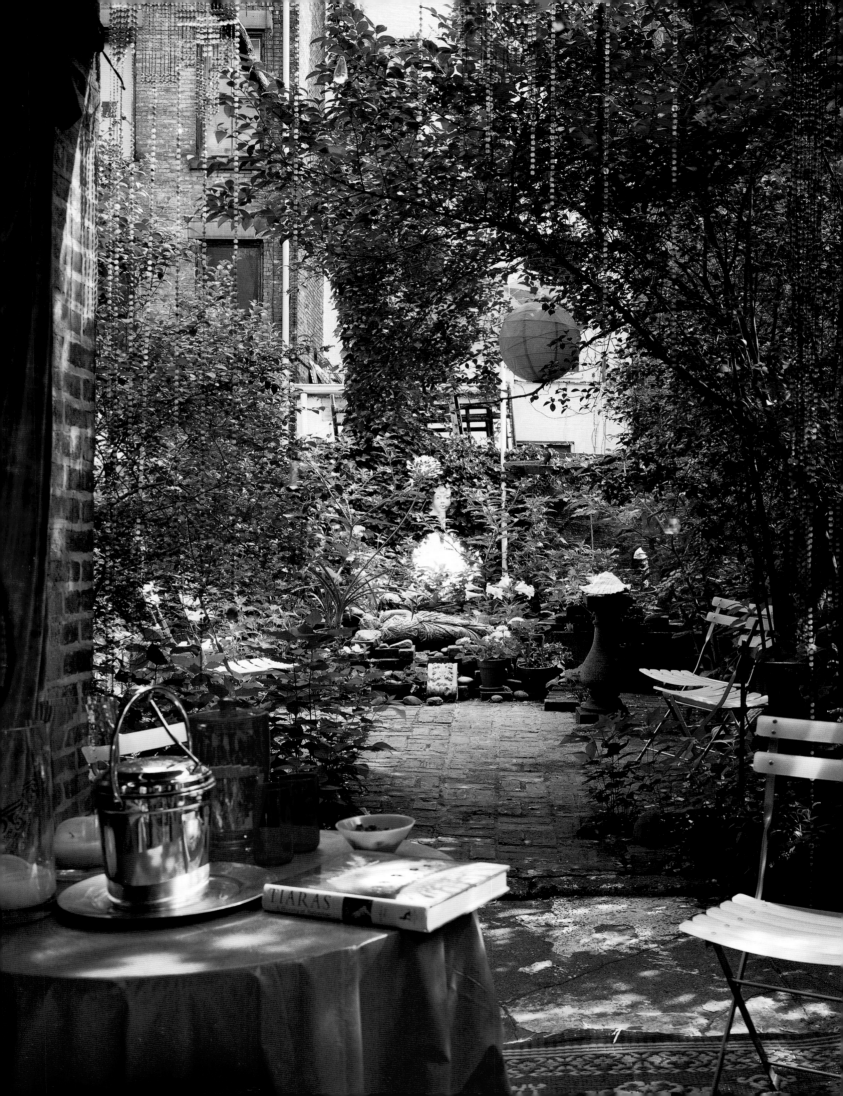

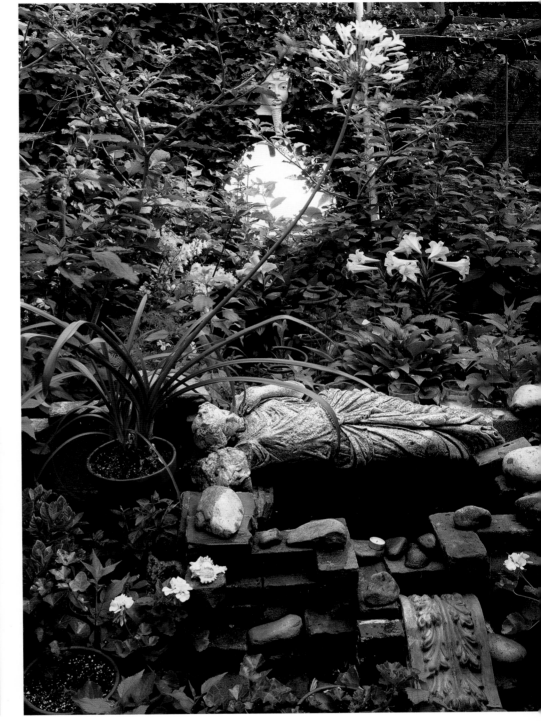

OPPOSITE: *Even more than spacious rooms, a private garden is a New Yorker's ultimate luxury. Adams' greenery is enlivened by paper lanterns and beaded fringe.*

ABOVE LEFT: *"Silver bells and cockle shells…" and a granite baluster rescued from park vandals adorn a verdant corner of the author's outdoor retreat.*

ABOVE RIGHT: *Aphrodite reclines among flowers and herbs, mirrors, a gold fish pool, and a plastic Halloween mask of an Egyptian pharaoh.*

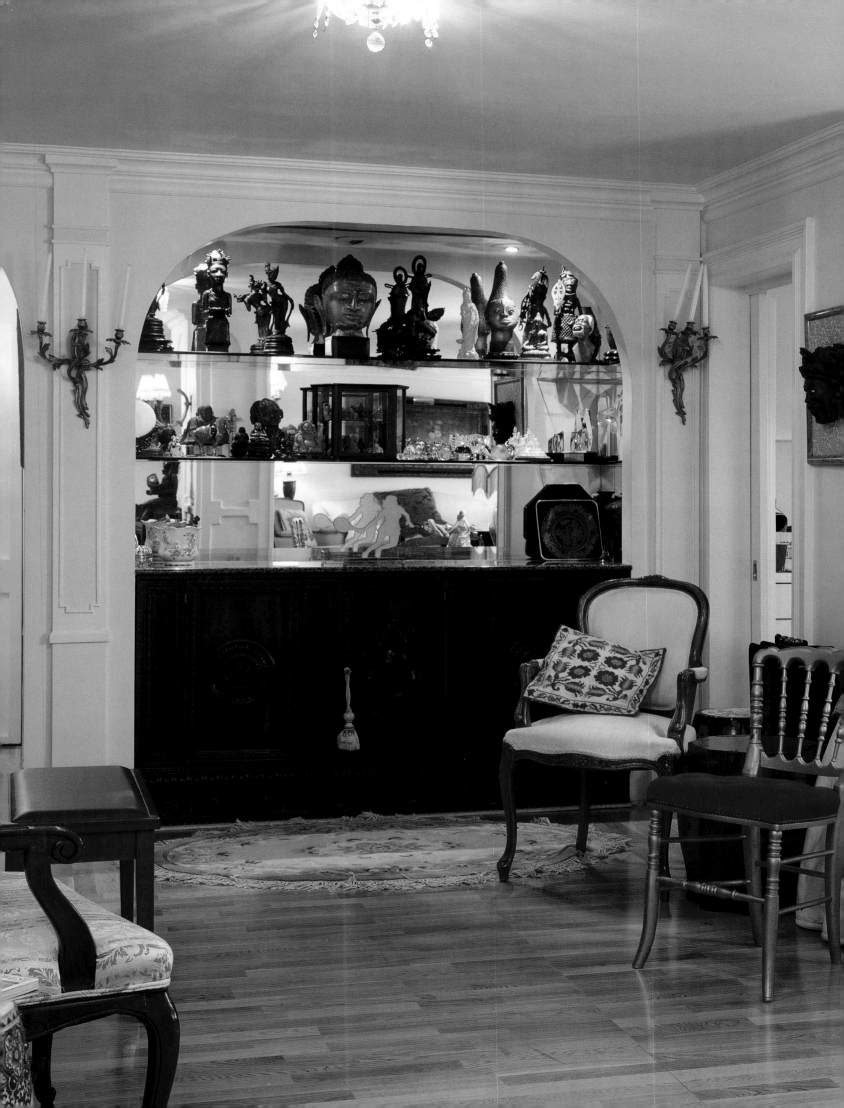

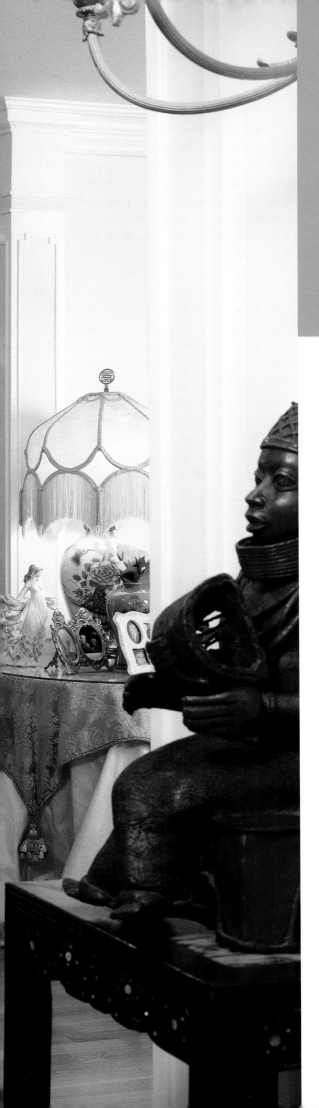

Alma Carter Rangel and
The Honorable Charles E. Rangel

ROOMS FULL OF YELLOW ROSES

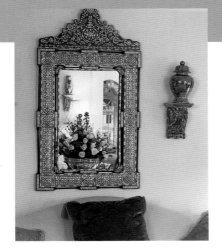

Yellow roses, voluptuous in their allure and over-laden with an irresistible scent, are emblematic of the Rangels' ongoing love affair. Their penthouse, like those bright blooms, glowing and golden, is a double portrait of their happy marriage.

Harlem's Congressman for the past thirty-two years, and that fabled quarter's greatest booster, Representative Rangel today lives mere doors from the brick-and-brownstone house in which he grew up on 133rd Street.

ABOVE: A shell-and-ebony-framed looking glass from India flanked by lusterware jars captures the sumptuous style of the Rangel home.
LEFT: Heralding a warm welcome, the foyer is ornamented with objects gathered by Congressman Rangel during his international travels. Shelves displaying African, Asian, and European sculptures are set into a mirrored arch flanked by gilded bronze sconces.

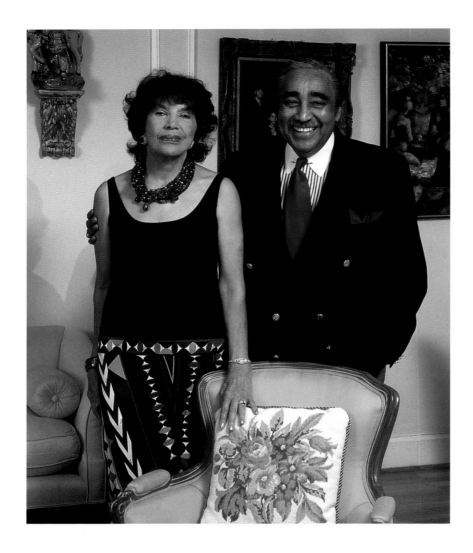

"I came up during the Depression," he boasts, happy to have survived those days. "I hung out on the streets and watched the gangsters and other big shots in their fine clothes and fine cars. Alma, she was a Sugar Hill girl from Riverside Drive. Fortunately, I got a little polish and she agreed to marry me."

A transplant from Florida, Alma Rangel's favorite flowers are roses, the yellow ones, with which her rooftop apartment is filled to profusion when she's entertaining. Rose bouquets are there in more reasonable quantities on the quiet days in between.

"Charlie has always given me yellow roses. When we were dating and he didn't have much money, he'd present me with a single perfect one, as faithfully as clockwork. Now he brings a dozen or two, whenever he shops

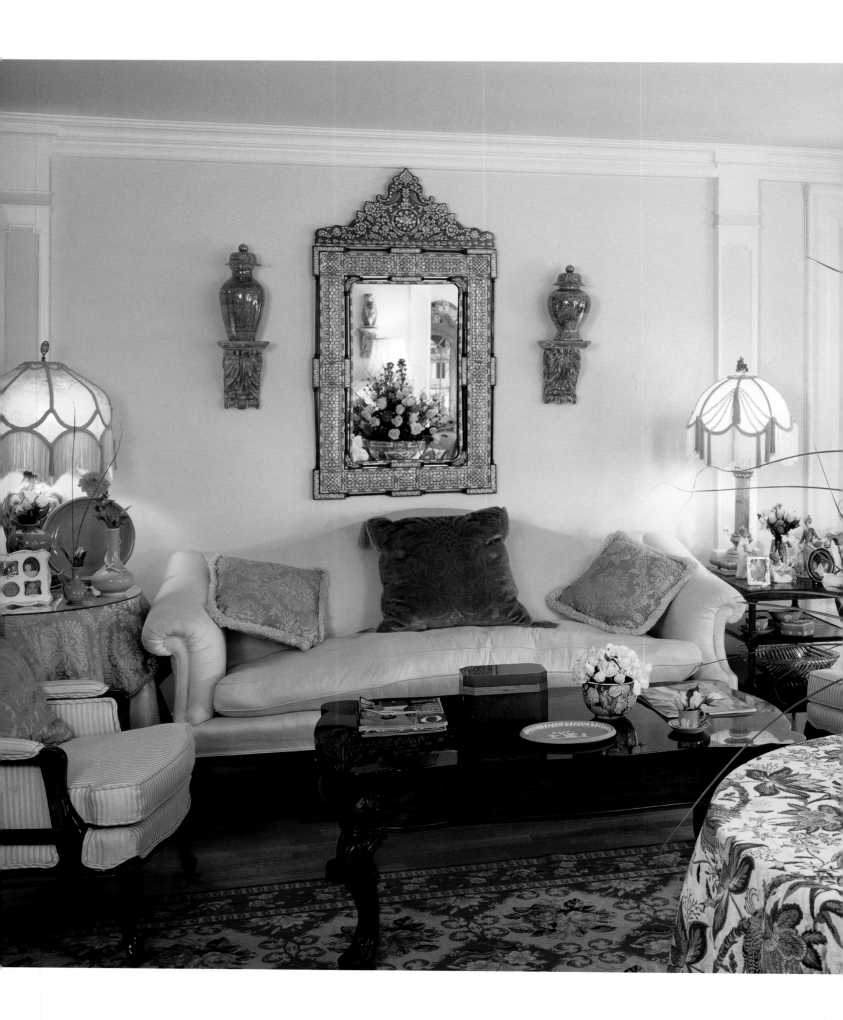

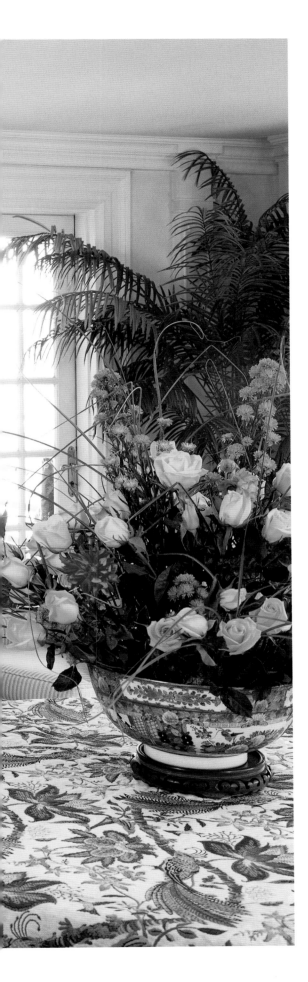

at Fairway [Harlem's megagrocer]. But if we're giving a party or on my birthday, watch out. Sometimes I think he's trying to compensate for when we were young and hard up.

"Charlie is the shopper in this family. He couldn't be happier than when he's shopping, whether it's a garden sale, an auction, or a flea market—he loves it. Since we gave up our house in Washington, I remind him that he mustn't buy a single thing more. But he never listens. He has such a fabulous eye. He found those cut-glass champagne flutes and the carved walnut chest that we had made into a bar. Thank goodness our kids appreciate old things; otherwise, we'd have to open a shop."

The Rangels have lived in the same apartment complex, at Lenox Terrace, for years. Their abode was made from two apartments, and the bright but traditional décor was devised by the late Willie Stone, one of Harlem's inestimable style makers of recent times. Stone's shop on Lenox Avenue, the most sophisticated emporium north of 110th Street, was an unexpected repository of superlatives. All of Willie's wares were rare, charming, witty, and exquisite, and some were elusive. Willie was known for dousing one's ardor for an object by stating matter-of-factly, "Yes, it is quite nice, isn't it? But it's not for sale. It's mine. It's only here for display, then it's back to my living room."

"Sometimes he'd just sit here, for hours on end!" Mrs. Rangel recalls. "When the pilasters and moldings were installed, he knew instinctively that they weren't right. He was an absolute perfectionist. So, he stayed put until he finally figured out how to correct the proportioning. He was an artist; what can you say? It was Willie who first suggested that we install hardwood floors ten years ago. It took time for us to be ready to do it. It's a shame that Willie never got to see the wonderful results, and it would have been less disruptive and expensive to do it earlier. He didn't have a telephone, neither here nor in his shop. He kept bistro hours that strictly suited his creativity and convenience. I miss Willie's friendship. So often I'd vaguely describe some item I wanted in the most abstract terms, and I'd return home to find the ever-thoughtful, always polite, and perfectly dressed Willie Stone had found the thing I'd only half known I wanted."

Among Mrs. Rangel's quiet philanthropic activities is a nearby senior citizens' residence that she and the Congressman collaborated on. Together they identified public and private funds for the project. "The décor," beams her husband, "the piano, china, fireplace—that's all pure Alma."

"It had to be nice," concedes Mrs. Rangel, "because you never know where you might end up, do you?"

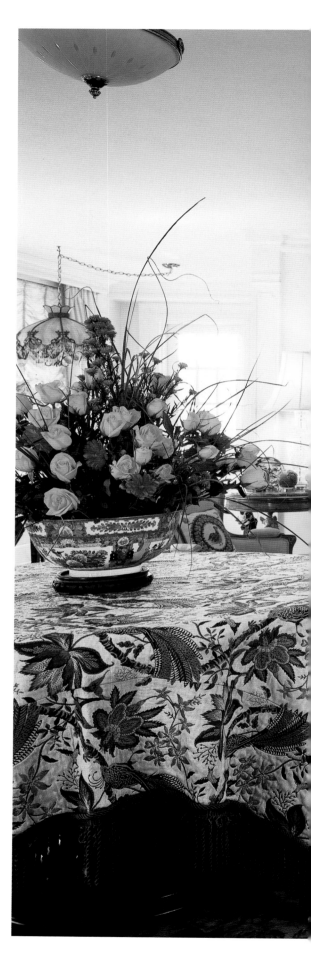

Loftlike with two dining areas and terraces, the Rangels' living space was planned with flexibility and a love of entertaining in mind.

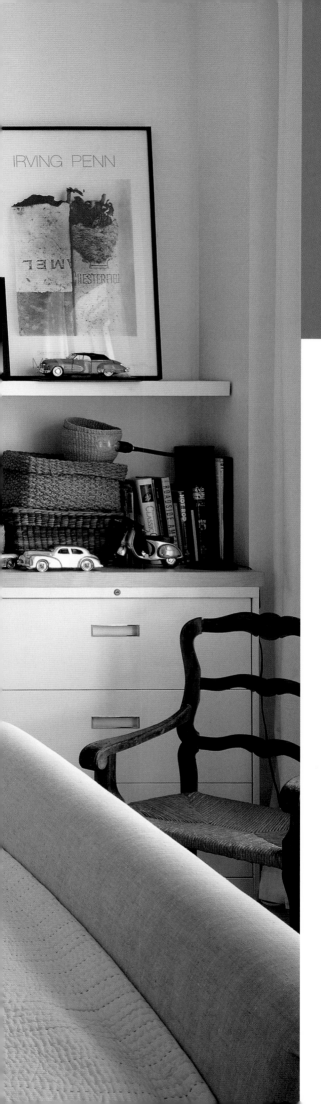

Phyllis Briley and
Rocky Baron Boler

LOVE IN A LOFT

Their initial encounter was from across a crowded bar during the disco era.

For the sake of their romance, he once sold all of his racing cars. She then reciprocated by agreeing to overhaul a Hamptons country house to make ample room for his hobby's requisite garaging—*and* a tennis court.

Their West Side mid-Manhattan loft at the Armory exemplifies Briley's abiding interest in design, décor, and architecture. She confesses that in college she considered a career as an architect, and this is apparent in her disciplined brand of decorating. A fan of interior designers Vincente Wolf, Jeffrey Bilhuber, and John Saladino, Briley appointed their neat, natty, monochromatic apartment unaided.

ABOVE: *Graceful tablescapes composed of flowers and branches, as well as carefully selected objects, are a feature in every part of Phyllis and Rocky's loft.*
LEFT: *A rush-seated chair from Normandy, an upholstered sleigh bed pristine in a pique coverlet, bamboo baskets, photographs, and model cars all express Phyllis Briley's very individual style.*

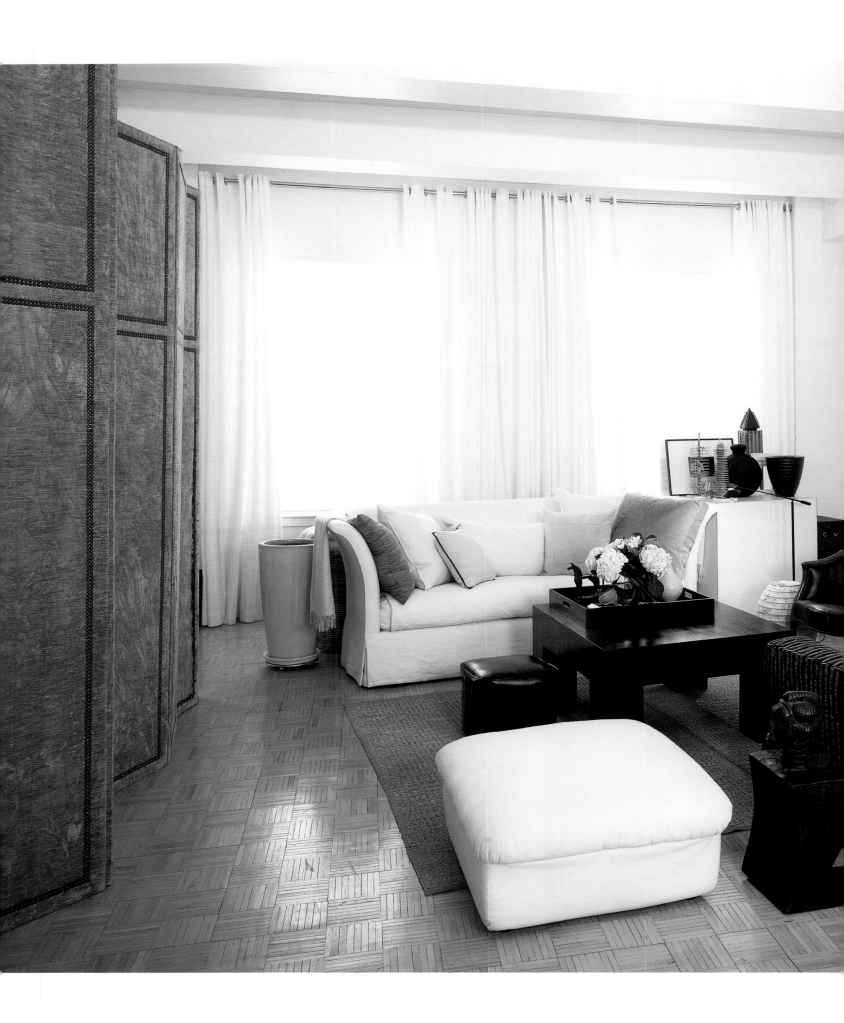

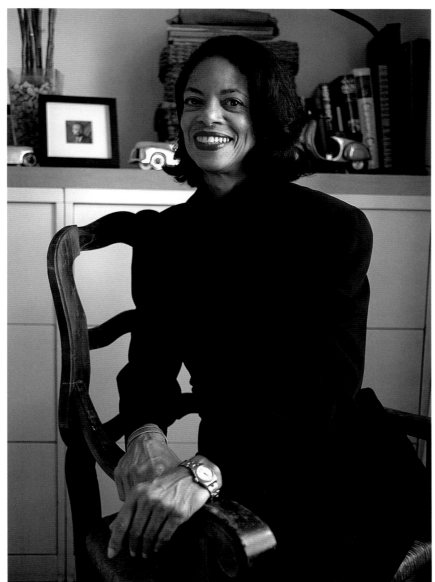

ABOVE: *Model-slim, Phyllis prefers understated but well-made attire as well as furnishings.*

LEFT: *An avid and resourceful amateur decorator, Phyllis found her living room's dramatic screens, pale-hued sofa, and graceful black wicker chair at thrift shops.*

Her color scheme has an unexpected richness; it includes the straw shades of the oak parquet floor, the gray of Japanese crackle-glazed porcelain, and the gold hues of an enormous velveteen-covered screen, bound by tarnished brass tacks, that separates the bedroom from the living space. A mahogany chair upholstered in black leather offset by silk-suede-and-cotton-covered cushions also provides a note of interest in a glowing sea of white. There is a white-covered sleigh bed, a cotton-duck-covered sofa, white walls, and black-and-white photographs everywhere.

Lush gatherings of white and muted-color flowers add a seductive quality to their high-beamed interior. Architectural models and other idiosyncratic elements, lit softly by sunbeams filtered through the white curtains, convey much that's seen and unseen. A sophisticated subtlety is the quintessence of Briley's élan.

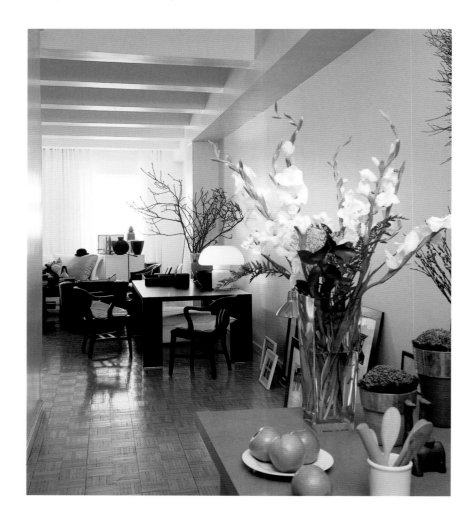

LEFT: *Amidst an envelope of white accented by high, beamed ceilings, clean-lined furnishings take center stage.*

OPPOSITE: *Like an Ansel Adams landscape, magnolia branches dominate a sleek Parsons table that serves as a desk by day and a buffet for social gatherings.*

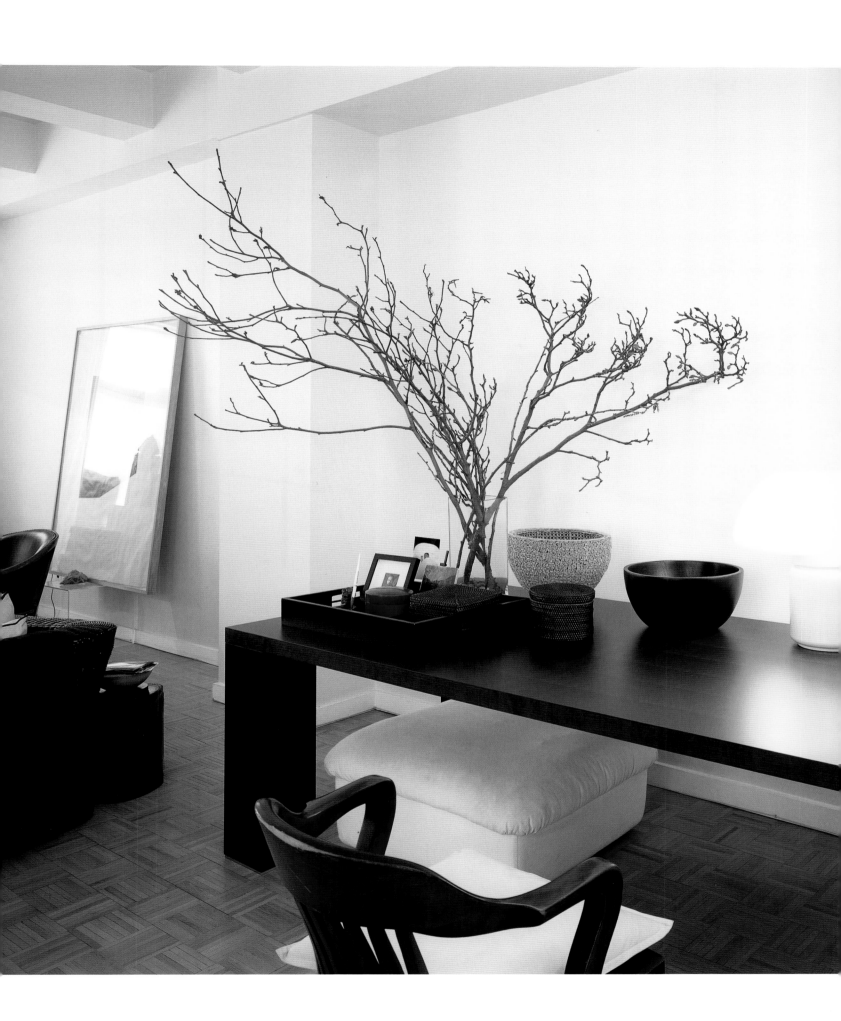

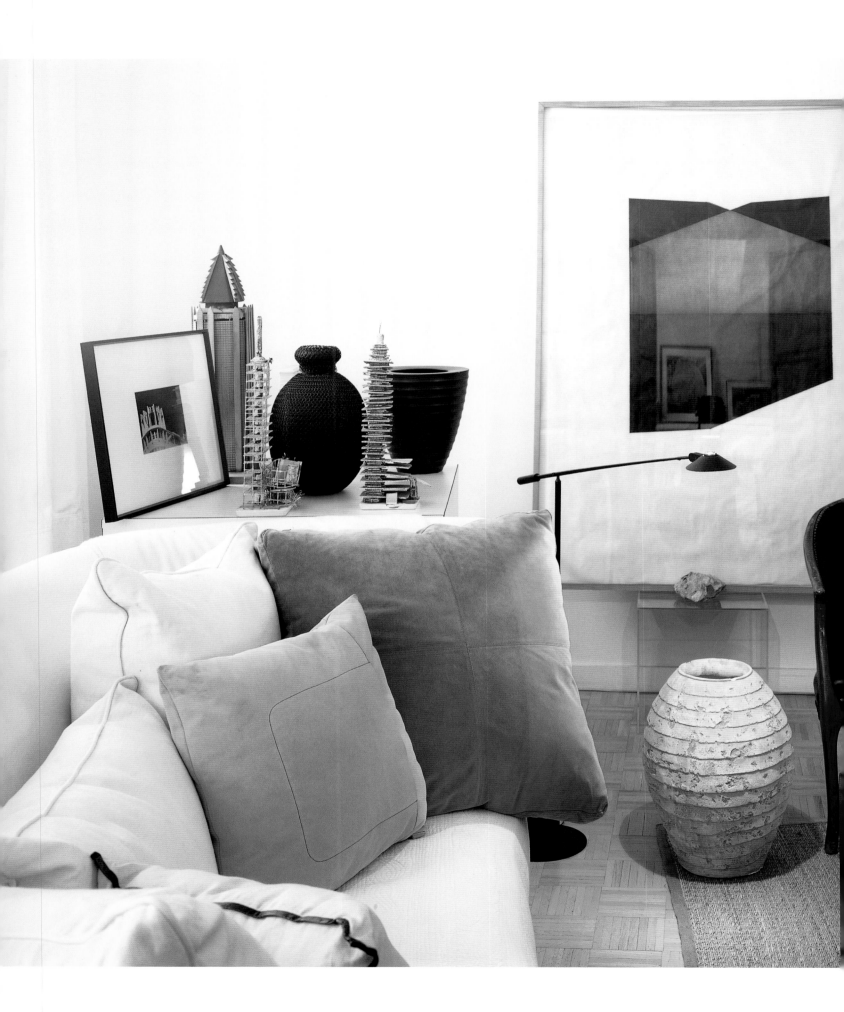

LEFT: *A palette of white, beige, and gray punctuated with black predominates in Phyllis and Rocky's tranquil space.*

ABOVE: *An overflow of prized books and photographs claims floor space, while an elaborate collection of architectural models (mostly gifts from friends) is displayed on pedestals.*

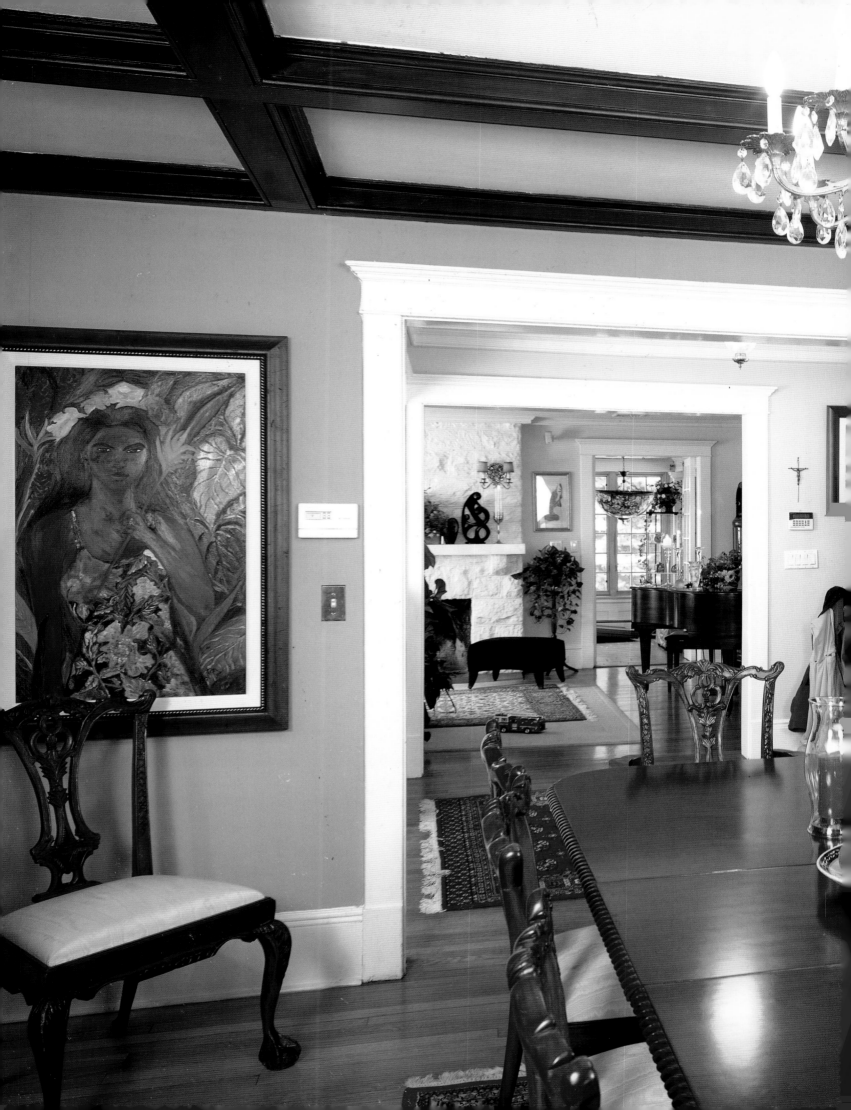

Donna and Peter Sanders

SUBVERSIVE SUBURBAN

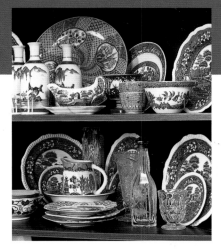

Imagine if George and Louise of *The Jeffersons* TV show had moved from Astoria, Queens to a suburban setting instead of to Park Avenue. Their home might have resembled Peter and Donna Sanders' Dutch Colonial center hall house in New Rochelle.

Surrounded by rolling lawns, shaded by stately trees, replete with two cars, six TV sets, four computers, a country kitchen, and a great room, it is home to the former Donna Wood, star of both the ballet stage and Broadway productions.

"As a dancer," she remembers, "I had very little time for anything beyond dance. Certainly I couldn't date, because I never sat still long enough to meet anyone." Everything changes, and during a blind date

ABOVE: *A collection of blue-and-white tableware includes Donna Sanders'*
grandmother's willow-patterned Staffordshire.
LEFT: *Entered through a graceful center hallway, the beamed dining room*
is the heart of the Sanderses' traditional home. The crystal drop chandelier
bathes the room's mahogany Chippendale furniture in a soft light.

on January 20, 1990, Donna Wood met a young corporate lawyer, Peter M. Sanders.

"Some of us are sentimental," insists Mr. Sanders, remembering that fated day. "From the moment I met Donna, I knew we'd wed and end up in a house." His gaze travels first to their newly built wing. "I hope never again to as much as see another contractor!"

The wing includes a great room with an open-gabled master bedroom alcove—his and Donna's sanctuary. It has a broad balcony and a fireplace but, by mutual agreement, no TV set or computer. On the awninged terrace, his father-in-law, who has traveled there to celebrate his grandson Adam Frederick's fifth birthday, relaxes in an Adirondack chair. Behind massive rocks and ferns down the hill at the property's edge, Adam and four-year-old Christian Michael have created their own play station, obviously enjoying themselves.

BELOW: *The Sanders family in the garden, relaxing in country-style Adirondack chairs.*

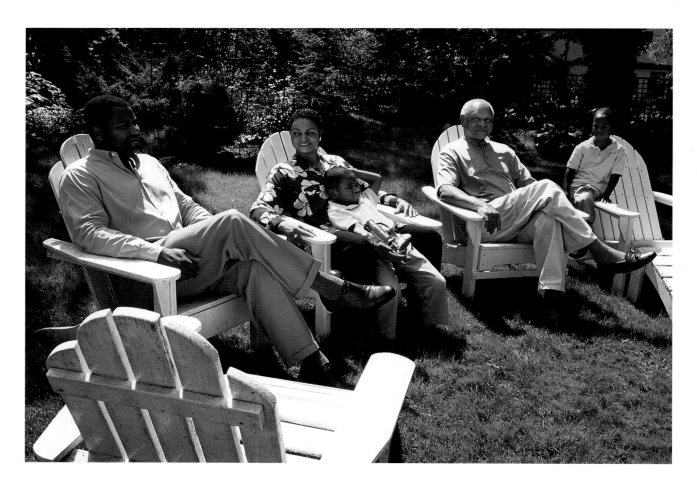

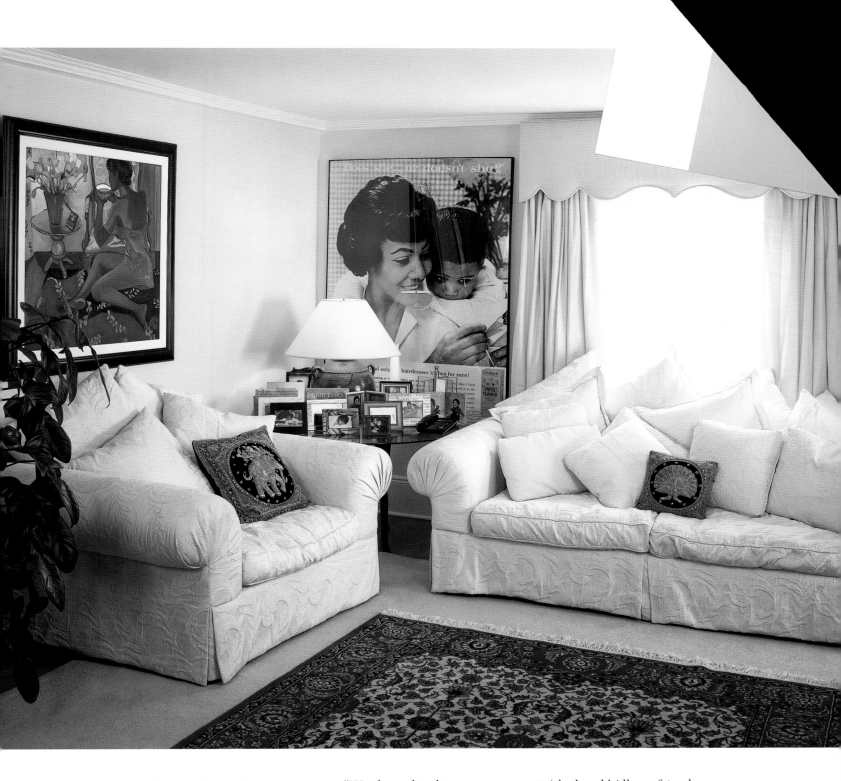

ABOVE: *A blowup of an ad featuring Peter Sanders and his mom, a model in her younger years, dominates a corner of the white living room furnished with an enormous settee and sofa, overflowing with pillows. Family photos vie for space on a corner table.*

"We always lived in an apartment in 'the hood.' All our friends, everyone we knew, lived in apartments, so this, this was a big step—big. But now I couldn't be more pleased."

Stone fireplace, grand piano, monochromatic color scheme, overstuffed, oversized sofas with a superabundance of cushions, multitudes of photos, portraits, prints, and posters that show Mrs. Sanders dancing—all

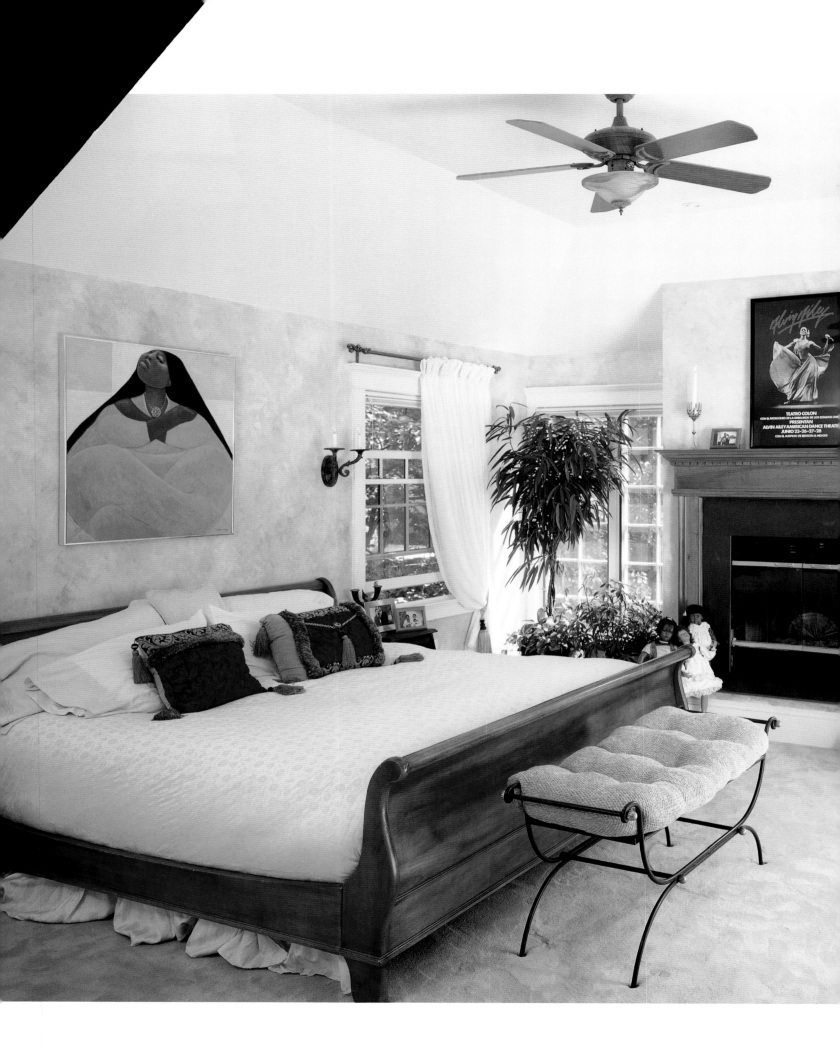

make this space something greater than an illustration of showroom décor. The room's most striking element is its most sentimental. Among New York's first black models, Peter's mom often took him along to photo shoots when he was young. That's how he happened to join her in a Clairol advertisement when he was just four years old. Blown up to pop art proportions, his souvenir holds much irony, for Peter Sanders today works as an attorney for the very firm that gave him his first preschool job!

Twin corner cupboards in the ochre-colored, beamed dining room showcase a collection of Donna's grandmother's blue-and-white Staffordshire porcelain in a scenic pattern along with antique Imari platters and the Danish pottery made especially for her, both gathered while touring.

Of all their treasures and mementos, whether an African saddle from Judith Jamison or a family of lifelike dolls that Donna inherited from Peter's mother, it's Chris and Adam that they value most. "I'm glad I had a career first," Donna says. "But family is what's finally important, it's the kernel of life."

A light- and plant-filled sanctuary where TV and laptops are banned,
the Sanders bedroom includes such personal touches as a poster of Donna
over the hearth and a growing doll collection.

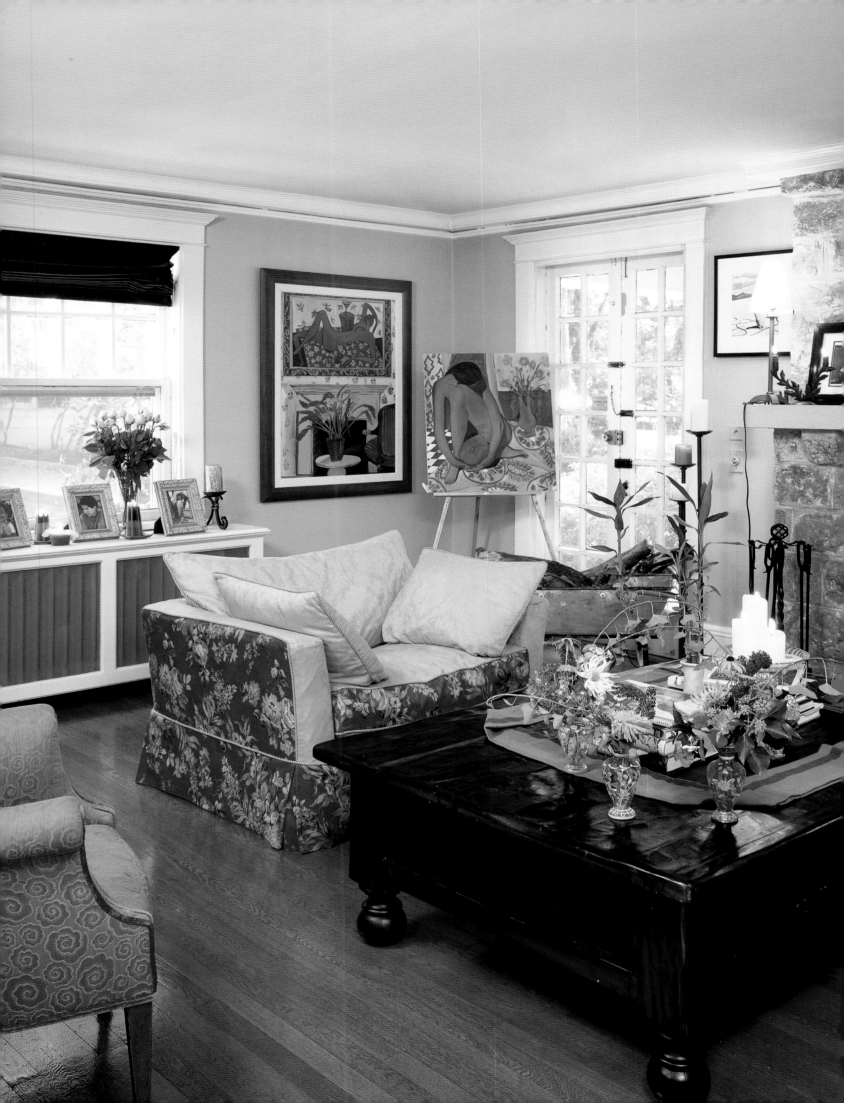

Gwen and Alvin Clayton

LOVE OF LIFE IN BLOOM

Traversed by circuitous, tree-lined roads with charming olde English names, New Rochelle Heights, where painter Alvin Clayton and his wife Gwen live, was always meant to be a conveniently close retreat from New York City. It was one of the nation's first planned communities.

Soaring oaks and maples shade the Clayton lawn. Built circa 1915, their shingled house with a gambrel roof evokes the farmhouses of New York's seventeenth-century Dutch colonists. In the early twentieth century, such dwellings were especially popular among those eager to escape the city's multicultural makeup and congestion. Blacks were prohibited from buying houses here for many years by restrictive deed covenants.

LEFT: *With its rugged stone fireplace, yellow-cotton-and-chintz-covered settees, and walls the color of pea soup, the Claytons' vibrant living room frequently appears as the background in the painter's work.*

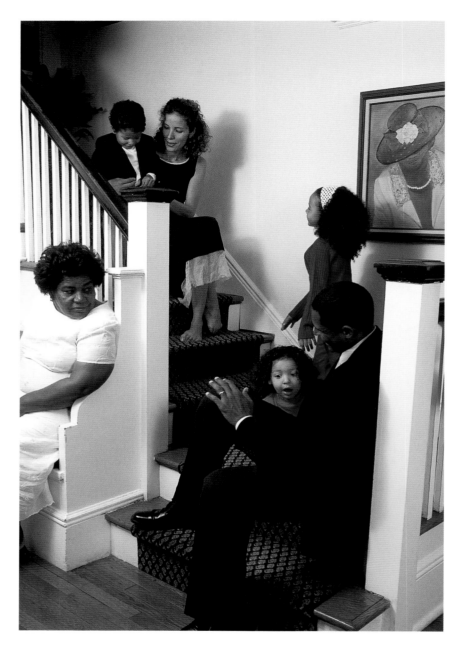

ABOVE: *The Clayton clan grabs a moment of fun on the white-painted staircase.*

OPPOSITE: *In keeping with the mood of the exuberant household, the children's room is painted a bold pink.*

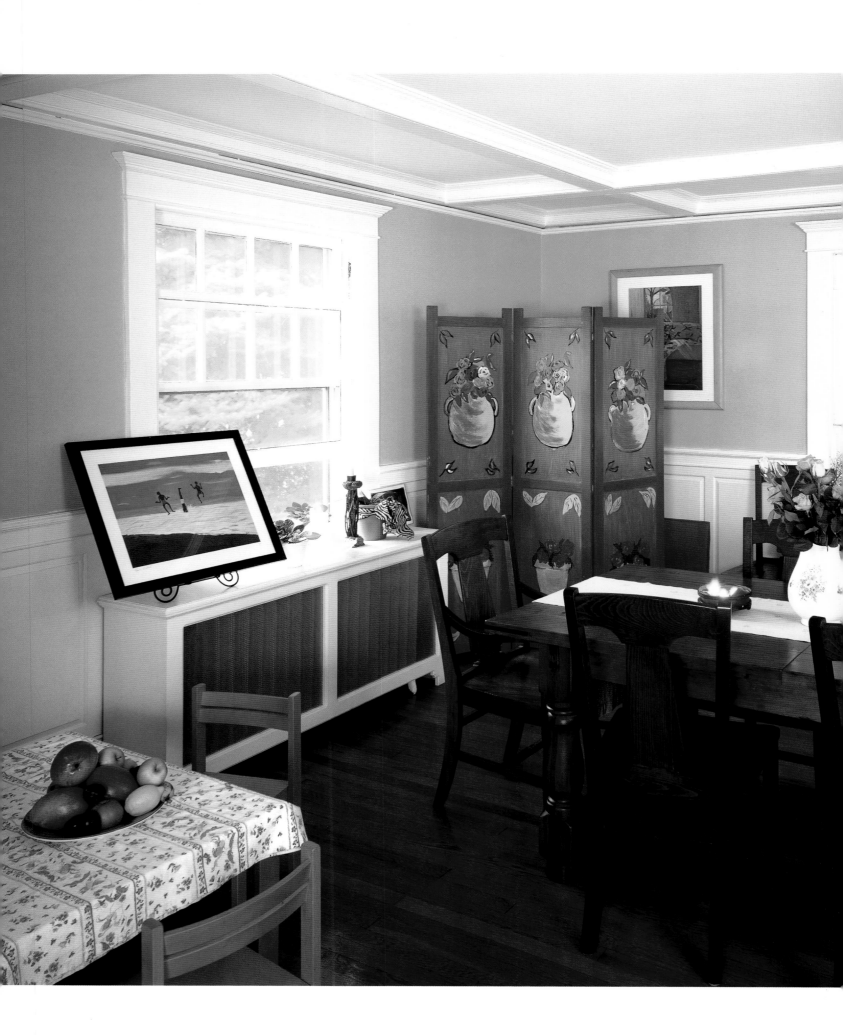

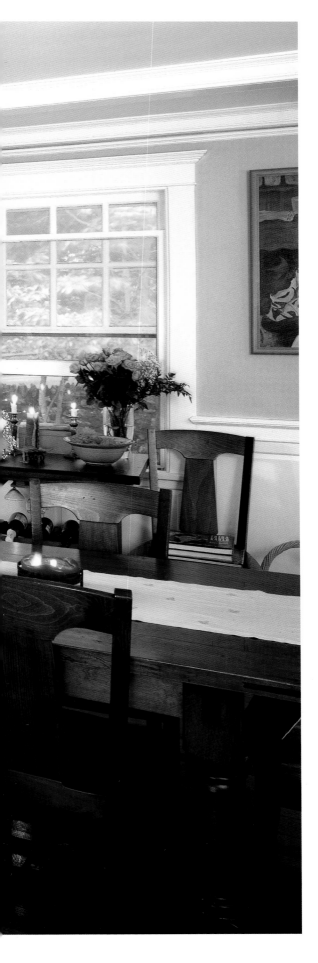

New Rochelle's first African-American residents, in fact, worked in houses like Gwen and Alvin's as servants. In the thirty years following the Second World War, all of this changed. As black residents arrived, white families fled the area. Property values plummeted. Some single-family mansions were even turned into rooming houses. During this era, Louis Farrakhan was the community's most famous homeowner. Today, this honor goes to the veteran actors Ossie Davis and Ruby Dee, and realty agents insist "the only color that matters here is green—money."

Like an ideal country cottage, the Clayton home is filled with color, flowers, light, and charm. Alvin Clayton's hero is Henri Matisse, but stylistically, the décor is indebted to the Omega Workshop of the artistic Bloomsbury group of England. It also recalls the Swedish artist Carl Larsson's Arts and Crafts interior decoration. Simple, direct, sturdy, old oak chairs and chest are augmented by floral-chintz-covered sofas. Lampshades, screens, and paintings, all vividly decorative, are examples of the artist's work. Elements as disparate as a profusion of family photos, burning candles, and an antique cradle used to hold logs—and even the lettuce-green living room walls or the vivid pink favored by Matisse seen in the children's room—are used here to transform spaces into living still lifes.

The Claytons are never quite still or ever silent for very long. Perhaps that is why their success extends like an unbroken string of pearls. Alvin has been a model, movie actor, and partner in a California restaurant, and Gwen has also been a model. Now they are model parents. Invigorating them are two-year-old Isabel, four-year-old Oliver, and fourteen-going-on-forty Timothy and their playmates. It all amounts to an earthly, arty, highly jolly paradise.

Complete with white woodwork, oak furniture, garden flowers, and a quaint screen by Clayton, the dining room might well have been created by the turn-of-the-century Bloomsbury-era Omega Workshop in England.

Kimora Lee and Russell Simmons

GRANDDADDY HIP HOP'S HOUSE

Dubbed the "godfather of rap," he quickly counters, laughing, "that's *grand*father!" acknowledging just how far he and the art form have come. Simmons is dressed in his own distinctive, but decidedly casual, line of sports clothes. It is his habitual attire, and accompanied by Kimora, his entrancing, bejeweled, haute couture-clad wife, Simmons easily gets away with his trademark dispensation of the conventional, even at weddings or premieres.

So, an absence of any similar rule-breaking makes the Simmons' East Hampton summer house a surprise. Charming and quaint, yet sprawling over perfectly groomed and rolling lawns, framed with a wooded perimeter,

ABOVE: *Each room in the Simmons home has an enchanting view.*
LEFT: *In the Colonial Revival living room, pine chests, steel tables, wicker chairs, and chintz upholstery and curtains invigorate what might otherwise have been an overly stately space.*

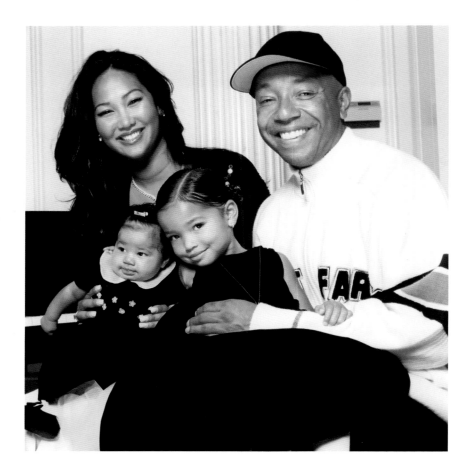

their shingled Colonial Revival house dates from the turn of the nineteenth century. An embodiment of high achievement—but not in modern-day terms—it conjures up scenes from *The Great Gatsby*.

And although it was thoroughly renovated to provide every convenience and technological advance, the aura of tradition displayed here is no accident. In the sitting room, finely paneled wainscoting and a bracketed shelf, forming an ideal place to showcase Simmons' platinum records, are painted a crisp cream color. This contrasts effectively with the forest-green walls. In the living room, a leather ottoman and a wider wing chair flank the fireplace. The informality of such pieces considerably lightens the mood of such iconic elements as the Federal-style mantelpiece and wallpaper border.

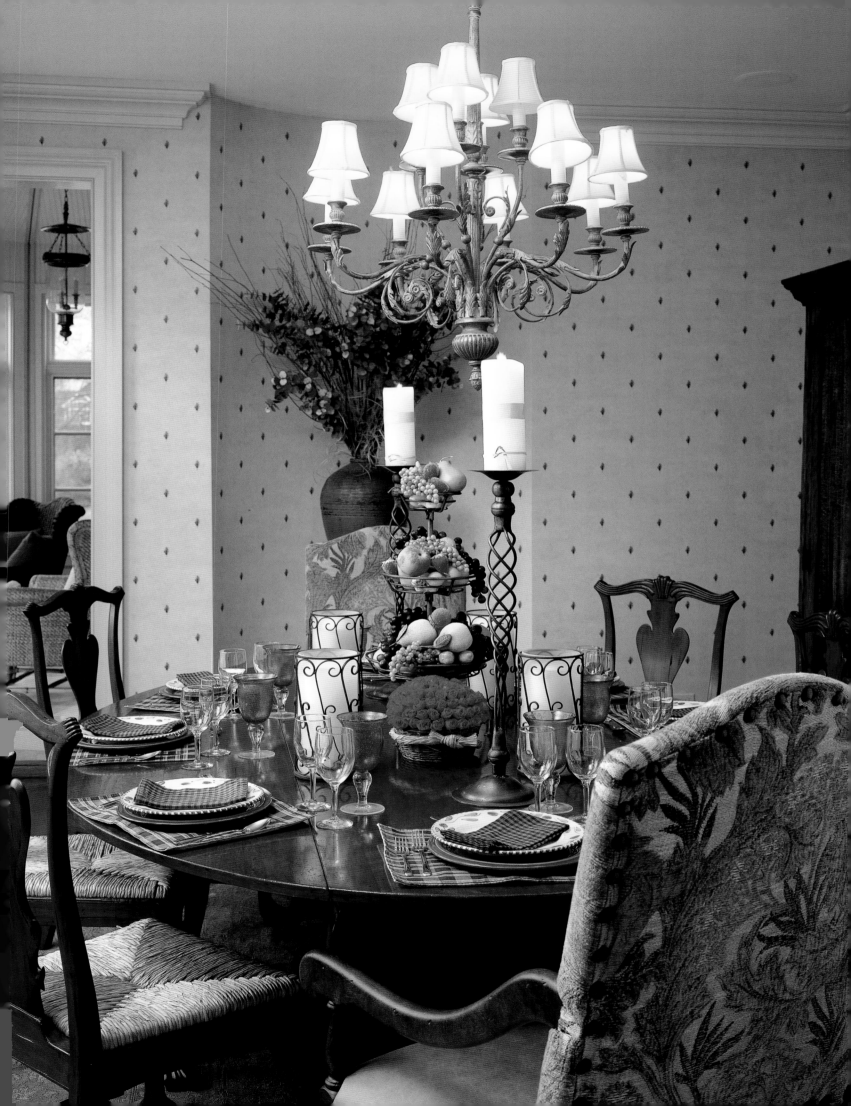

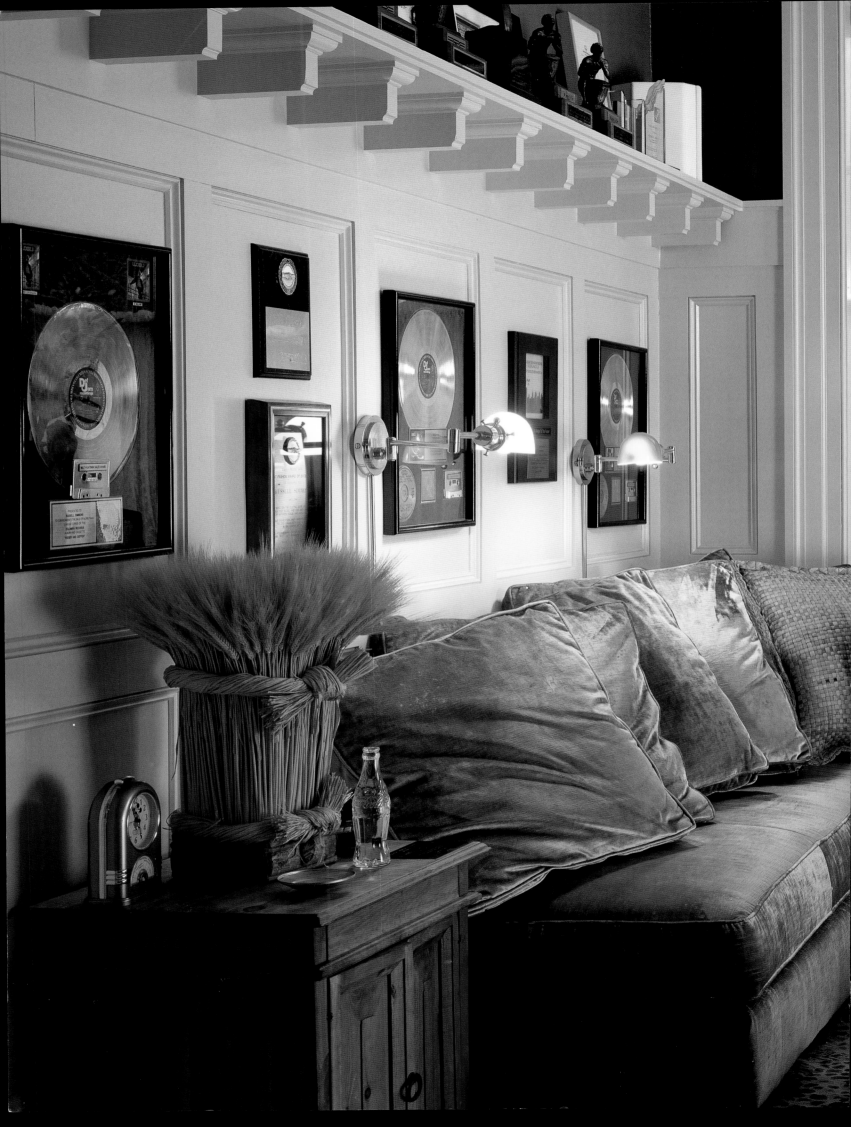

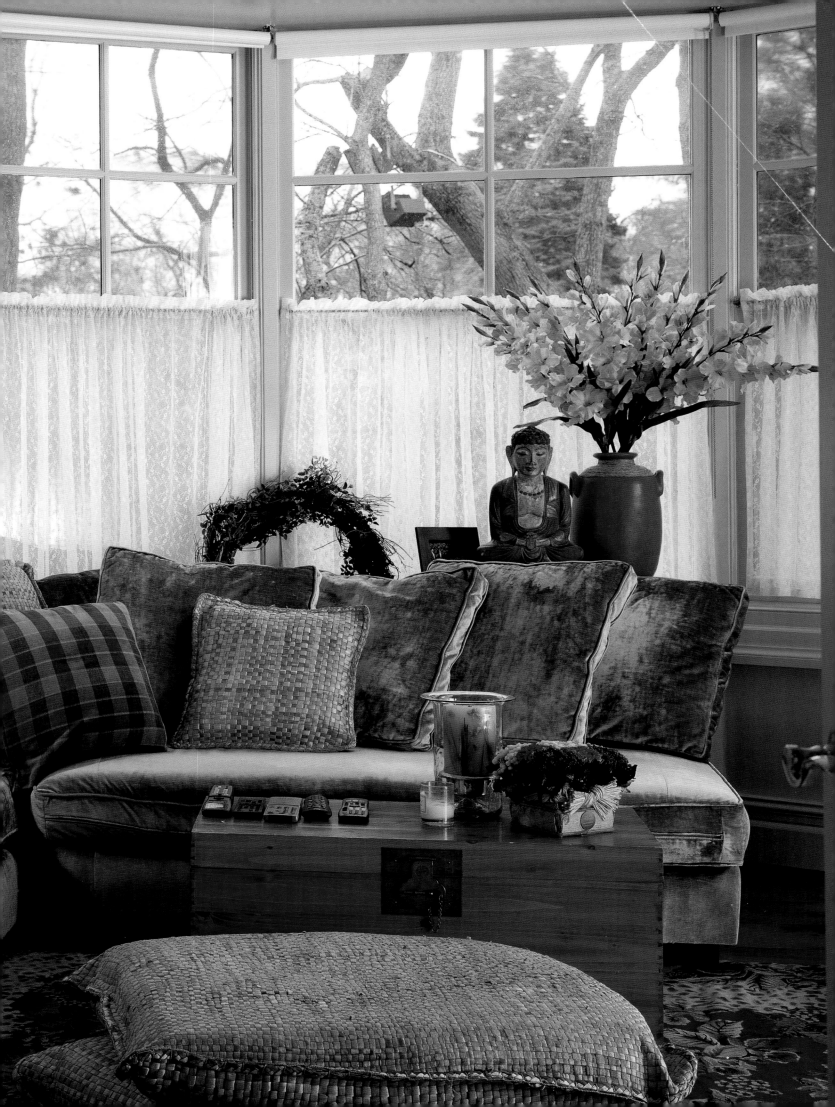

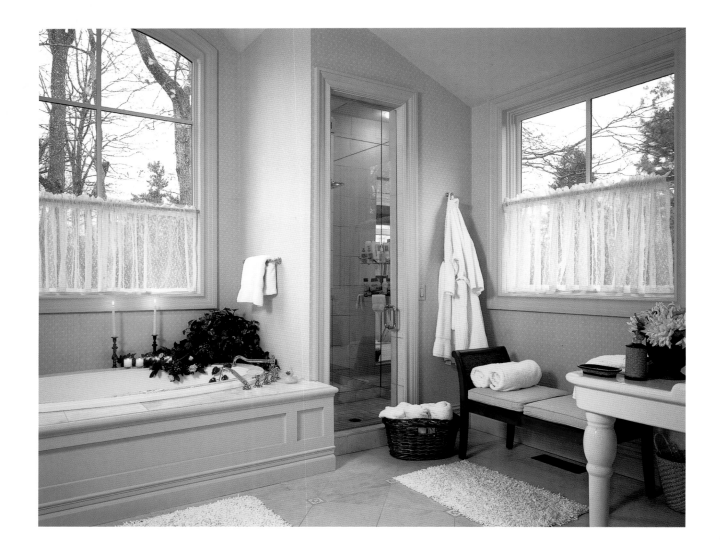

Country Chippendale chairs with rush seats, contrasting mixed chintzes and plaids, as well as lace curtains, all contribute to an aura of extravagance, but nothing here is just for show.

"Our bed," says Mrs. Simmons, "has to be so massive, because our little girl likes to climb in and snuggle on Sundays."

The Simmonses' aesthetic is rooted in the past, yet just right for a family whose future is golden.

ABOVE: *A study of white tonalities, the gabled master bath commands an expansive view of the surrounding garden.*

OPPOSITE: *In the tradition of Mario Buatta, the prince of chintz, the master bedroom incorporates at least six different textiles.*

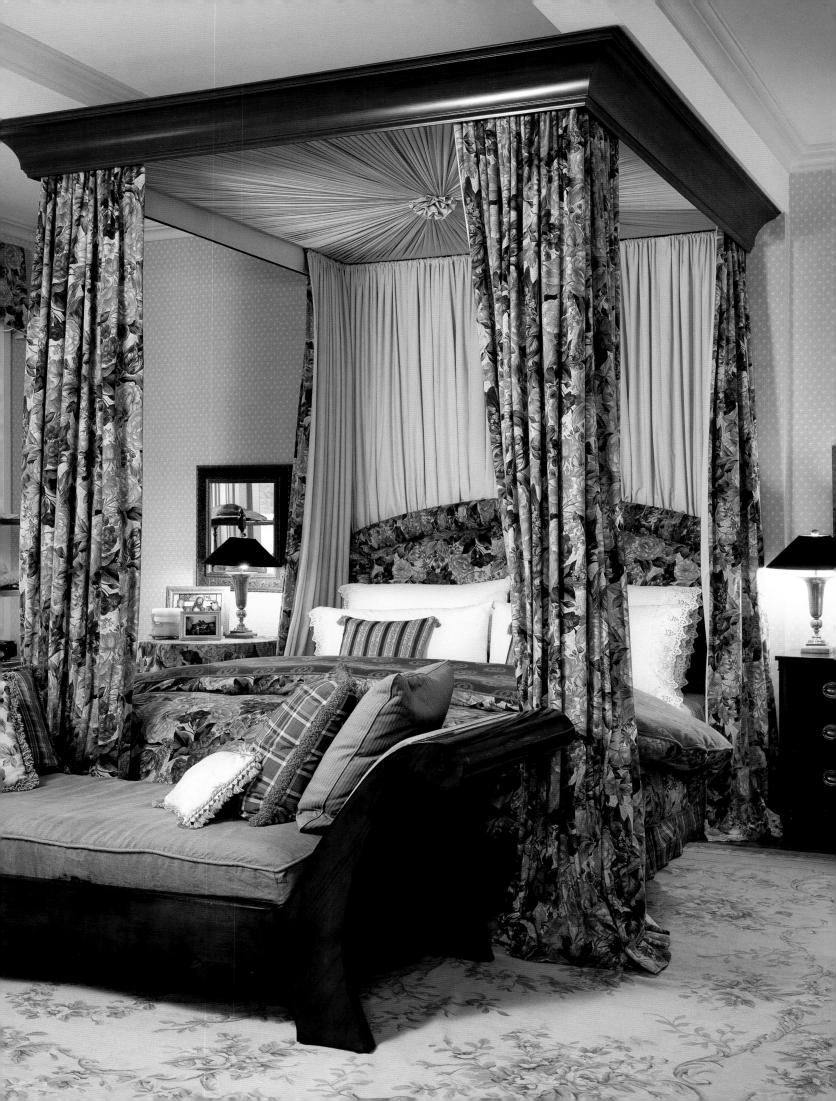

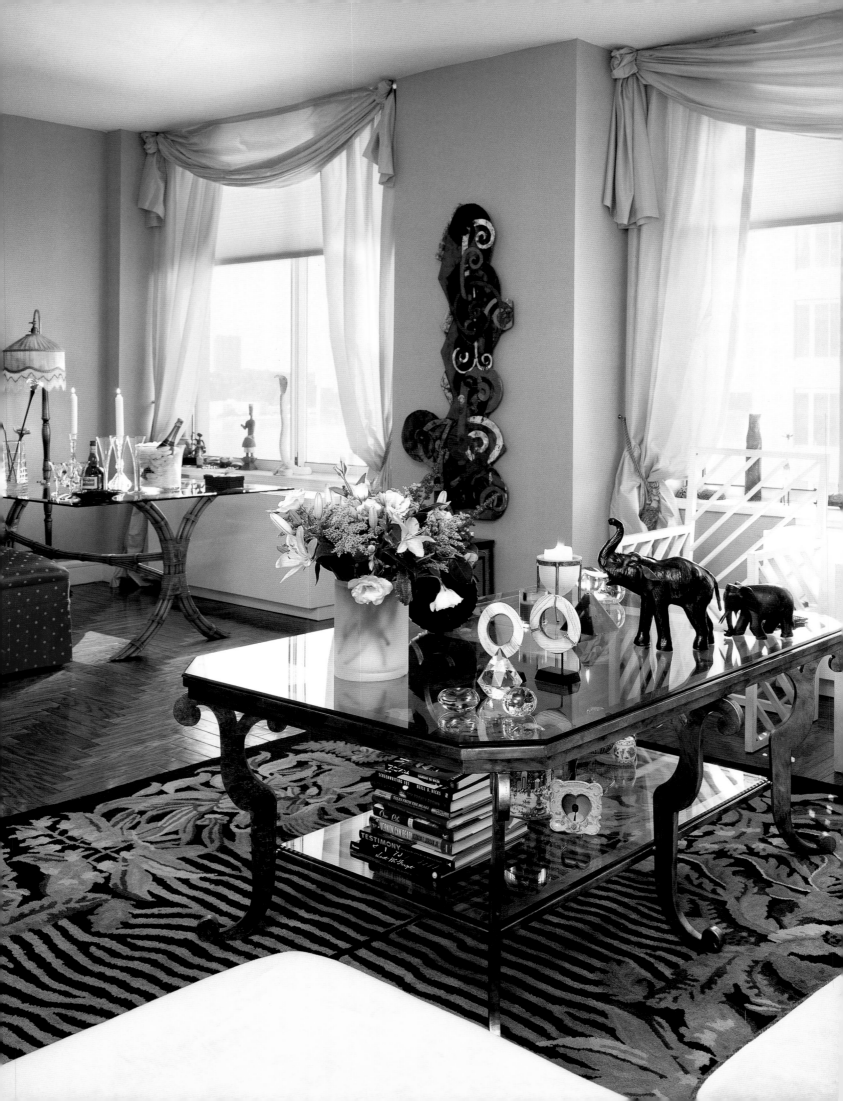

Norma Jean Darden
and Joshua Givens

LOST AND FOUND OUTLOOK

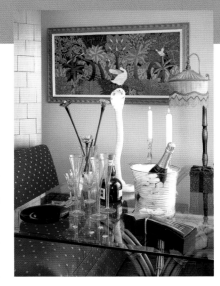

"**A**s a Revlon executive, I was used to dating tall, beautiful models," says Joshua Givens of Norma Jean Darden, proprietor of two of Harlem's most popular eateries, Miss Maude's and Miss Mamie's, as well as Spoonbread, the region's leading African-American catering firm. But food is not the secret ingredient that elevates beyond the ordinary an otherwise modest apartment overlooking the Hudson River at Trump City.

"It seemed hopeless at first," she recalls. "Everything was cold and impersonal. All my mother's lovely collections were in storage. The only things this place had going for it were that its fixtures were brand new and worked, and it had a spectacular river view. So I knew it could be made nice."

Consulting a well-known interior designer was at first helpful but in the end only confused matters. With the help of her sister, Carole, and

ABOVE: *In the dining area a folding screen behind a satin banquette on wheels allows for maximum flexibility, while a mounted cobra, Haitian landscape, and beaded lampshade exemplify gaiety.*
LEFT: *Flamboyant taffeta window hangings, Chinese-inspired chairs, and glass-topped tables make Darden's living room festive and spacious.*

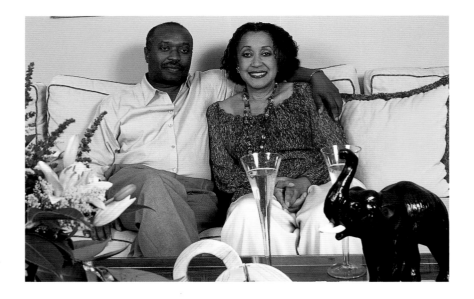

her companion, Josh—who says, "I was smitten long before I knew she could cook"—the entire project finally came together.

The satin dining room banquette on wheels, the brilliant Haitian paintings, cushions shaped like roses, and everlasting bouquets made of sparkling glass made what had been "an empty, boring box" into a home. Light reflected off Manhattan's mile-wide estuary "brought it to life," says Darden. "It was the perfect place for Josh and me to relax during those all-too-brief times we're not working and even for the very occasional family party."

Norma and Joshua's perfect place with its perfect view framed by dramatic silken draperies didn't last. "They built a new building that blocked my view and a lot of light," complains Darden. "I used to be able to see way past the George Washington Bridge. Now, we're left with just a sliver of water and the Palisades." Ever resourceful, the assault on their river view only strengthened her resolve to act. "So, we're moving next door."

Says Joshua, "It's a bigger, better place with an even grander view that's protected by the park. Now we'll have enough room to get all of my family heirlooms out of storage, too. I'll finally have a home office that's bigger than the dining room table." For Norma Jean Darden and Joshua Givens, if nothing lasts, at least everything is always improving.

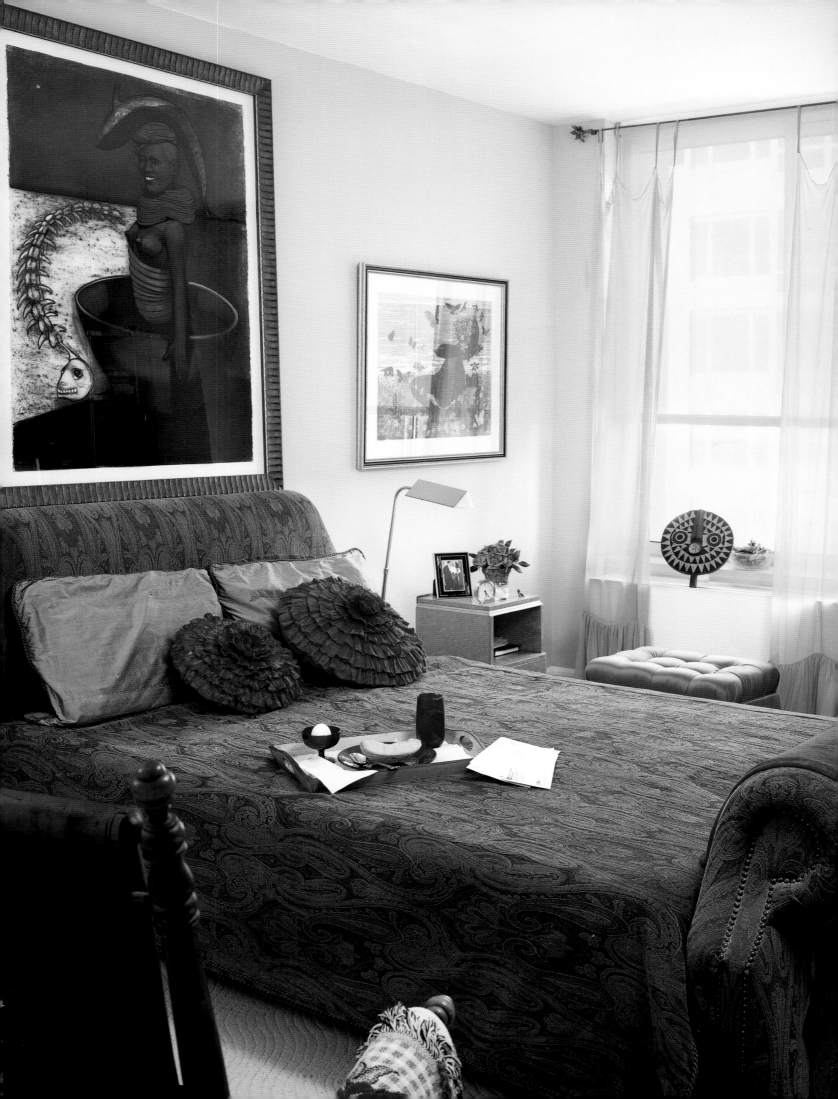

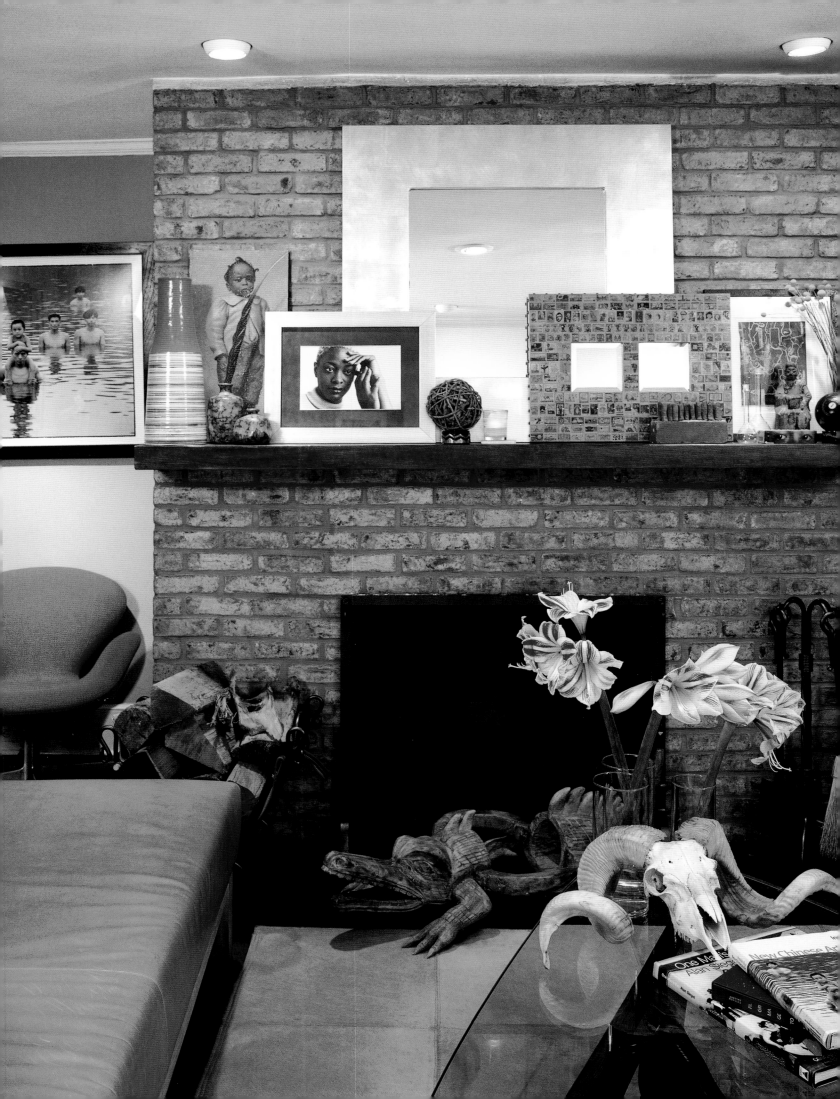

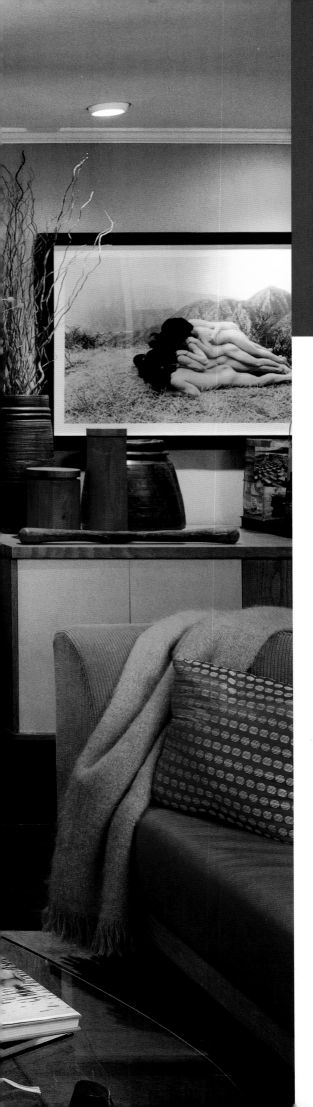

Courtney Sloane and Cheryl Riley

THE INTERIOR OF INTERIOR DESIGNERS

Both greatly influenced by design when they were young, Sloane comments, "We had a decorator when I was a kid. She was my role model," and Riley remembers, "My grandfather designed our house. He was Shreveport's leading contractor." Even today African-American interior designers are a relatively rare species, and it is a delight to peer into the personal retreat of a pair of New York's top decorators. Their firm's efforts on behalf of Sean "P. Diddy" Combs and Queen Latifah are admired, so the lack of razzle-dazzle here might not be what some would expect.

The emphasis is on mood instead of cheer, and serenity reigns. Easygoing wit, warmth, and charm are exhibited in their intimately scaled garden apartment, consisting of the entire ground floor of a mid-nineteenth-century brownstone in Chelsea. The space is planned to

LEFT: *A Mexican wooden crocodile, a ram skull, amaryllis, and mystical images by Zhanghaun are perhaps inscrutable but make this environment highly appealing.*

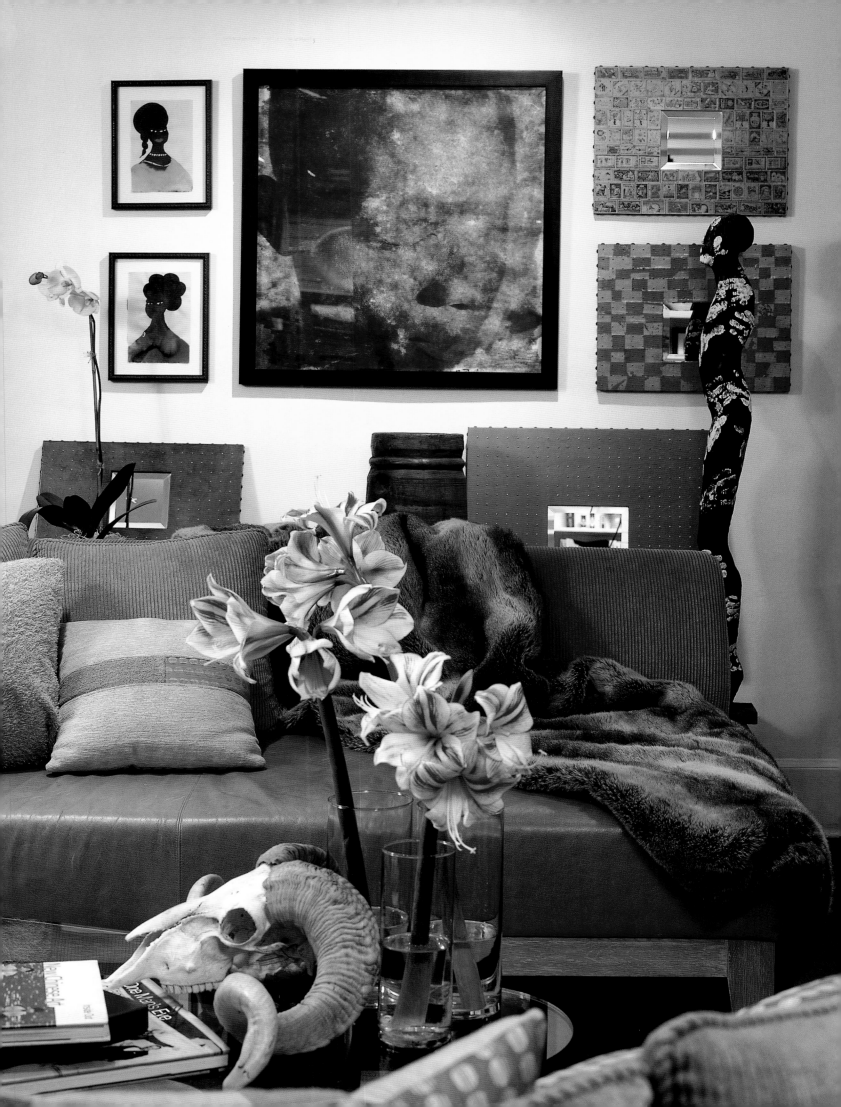

OPPOSITE: *Mirror frames designed by Riley are composed of postage stamps, squares of gilt, and other luminous substances.*

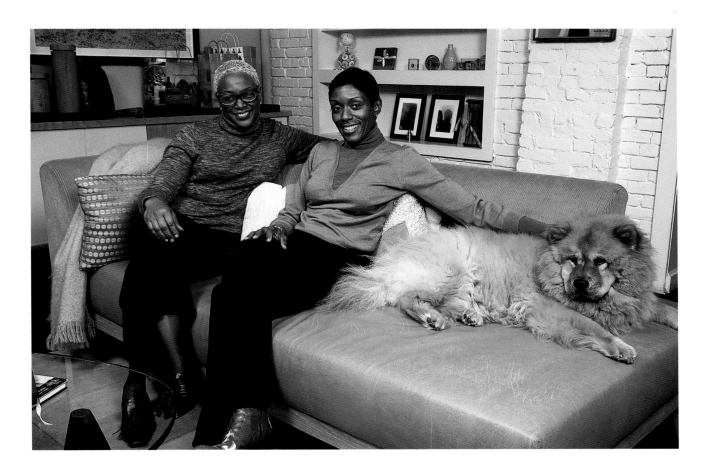

ABOVE: *Aware of each other's work and success for years, Sloane and Riley met through mutual friends and have collaborated ever since.*

provide maximum seclusion in the living quarters, which open onto a shady garden, and easy access to an office facing the street.

Their distinctive aesthetic approaches are complementary. They are equally happy seated among lilies or sunflowers at the garden's ample table, or before a blazing fire surrounded by art and masterpieces of modern furniture.

Cheryl Riley and Courtney Sloane's clients—and friends—have much to be grateful for in these interior designers who are unafraid to express a compelling world all their own.

ABOVE: *Courtney Sloane is a staunch advocate of the notion that "art enhances everything, even breakfast."*
OPPOSITE: *It's five steps up from the cool slate-floored kitchen to the backyard's ample table, the scene of many warm-weather meals.*

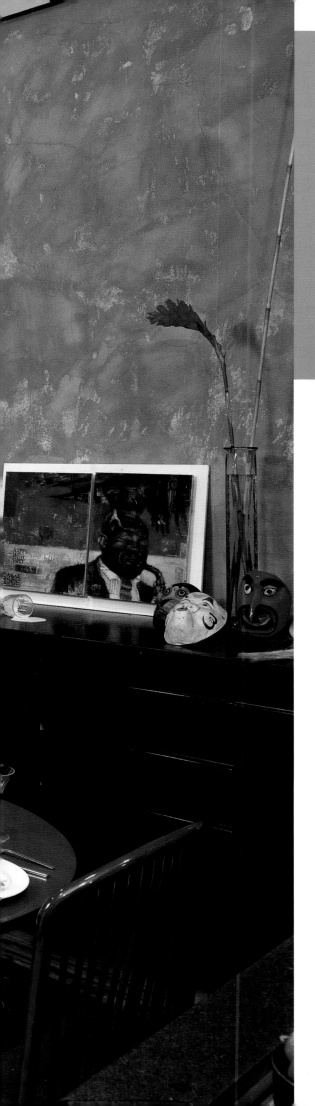

Sylvia Waters

A DANCER'S MOVES

Because she was born and raised in Harlem, it's pure destiny that Sylvia Waters returned after she had made homes in a Parisian garret, a Cabrini Boulevard flat, and a Chelsea loft.

Having pursued a dance career while very young under the tutelage of Anthony Tudor, Martha Graham, Mary Hinkson, and Donald McKayle, her brilliant career has led her to directing the second company of the Alvin Ailey American Dance Theater. A passionate devotee of history, her Harlem home seamlessly combines the best of the old and new in absolute harmony.

That harmony was achieved in partnership with architect Chauncey Jones, also a Harlem native as well as Waters' good friend and former husband. A dedicated modernist with meticulous standards, he juxtaposed

ABOVE: *A clear glass vase with delicate flowers is juxtaposed with the carved wood of an African sculpture.*
LEFT: *Notwithstanding its Victorian architecture, a concrete wall, lacquer cabinets, and unadorned furnishings give the dining room both an Eastern and modern sensibility.*

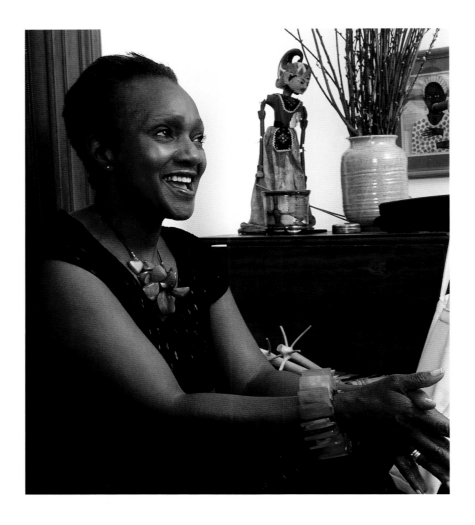

unexpected materials and finishes—antique and futuristic, smooth and textured. Much of the carpentry, such as the top floor's glass-paneled parapet, he assembled himself.

But Waters herself painstakingly, through trial and error, mastered the art of stripping paint from the scarred, multicoated woodwork. Appreciation of the relative merits of heat guns versus Rock Miracle and other solvents is now among the many accomplishments that make up her repertoire. Her understanding of the myriad ingredients that make a space luxurious in the absence of obscene riches makes her house a palatial home.

"Neither Chauncey nor I are fancy people. We both love sharing with our friends. We want them to go away having had a fun time. Unavoidably, this means preparation and work. It is the same as with dancing. You smile, you spin, you leap. As a dancer or a hostess, you can't

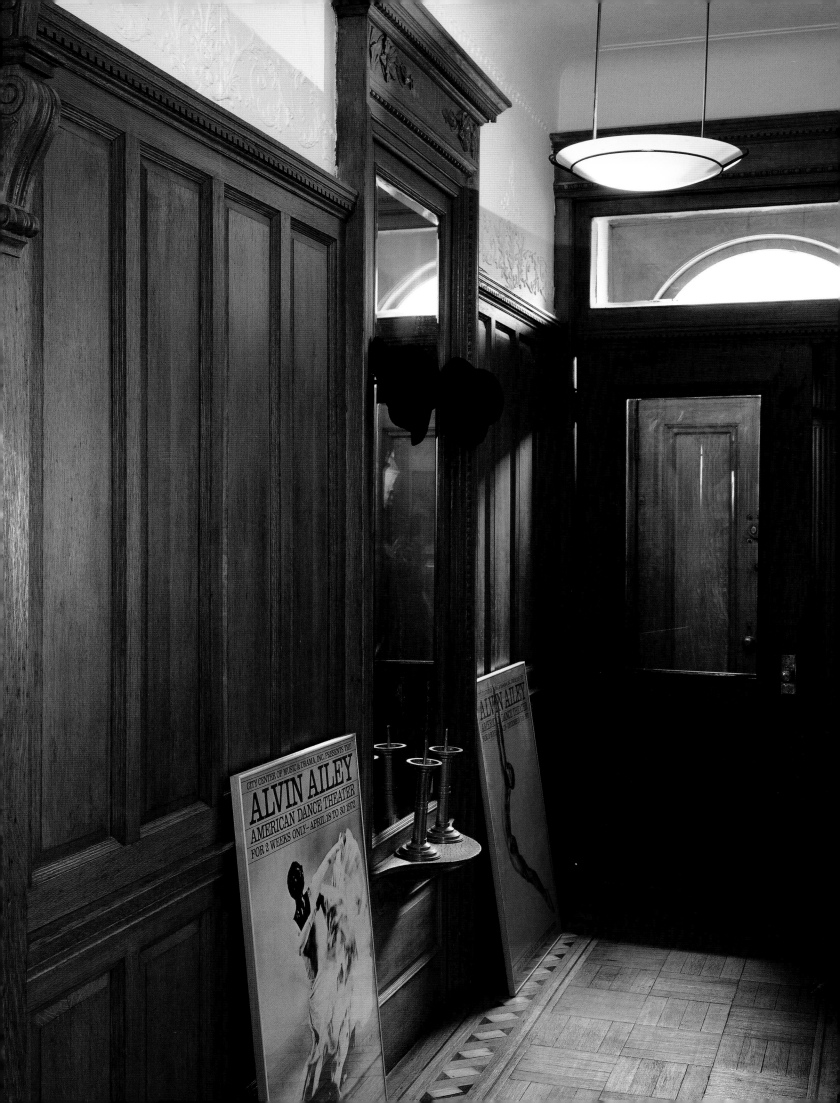

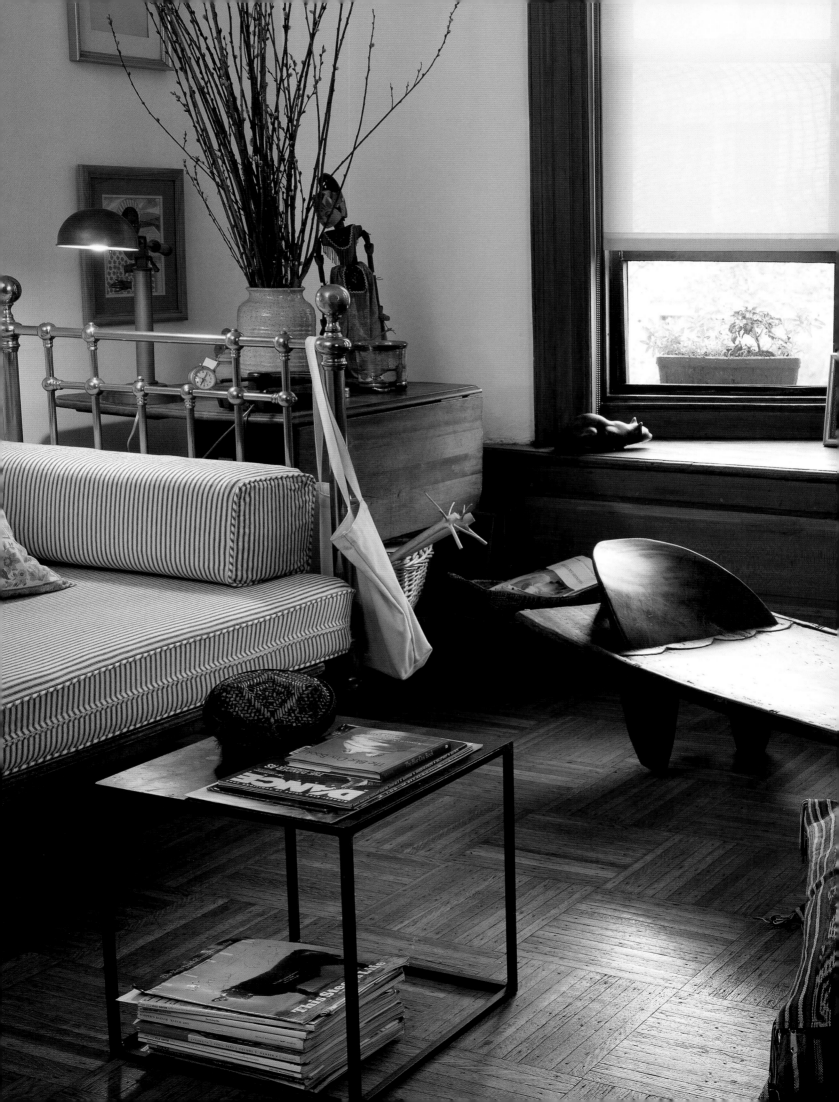

Two beds, one African,
carved from a single piece of wood,
one machine-made of brass in
America, indicate Walters' eclectic
and unerring taste.

let people know that you're tired or you ache; you mustn't show your disappointment even when the lemon cake falls. You'd only kill the magic and spoil their enjoyment. Artful deception, disguise, that's the true secret to successful entertaining."

Designed by John Hauser, completed in 1896, Waters' Convent Avenue Romanesque Revival house was turned into a rooming house in the 1930s. When Waters and Jones came on the scene in 1981, they were among the young, ambitious blacks and a minuscule number of whites who sought to revive Uptown. It was rough going at first. Waters says, looking back, "We had a beautiful loft. We were downtown, close to the theaters and the best restaurants. This house was half destroyed or at least it looked

LEFT: *Ms. Waters' exuberant antique fireplaces have a sculptural presence.*

OPPOSITE: *Retaining the dolphin-footed tub and oak woodwork, architect Chauncey Jones utilized polychromed inlaid marble and sheets of mirror to amplify the bathroom's grandeur.*

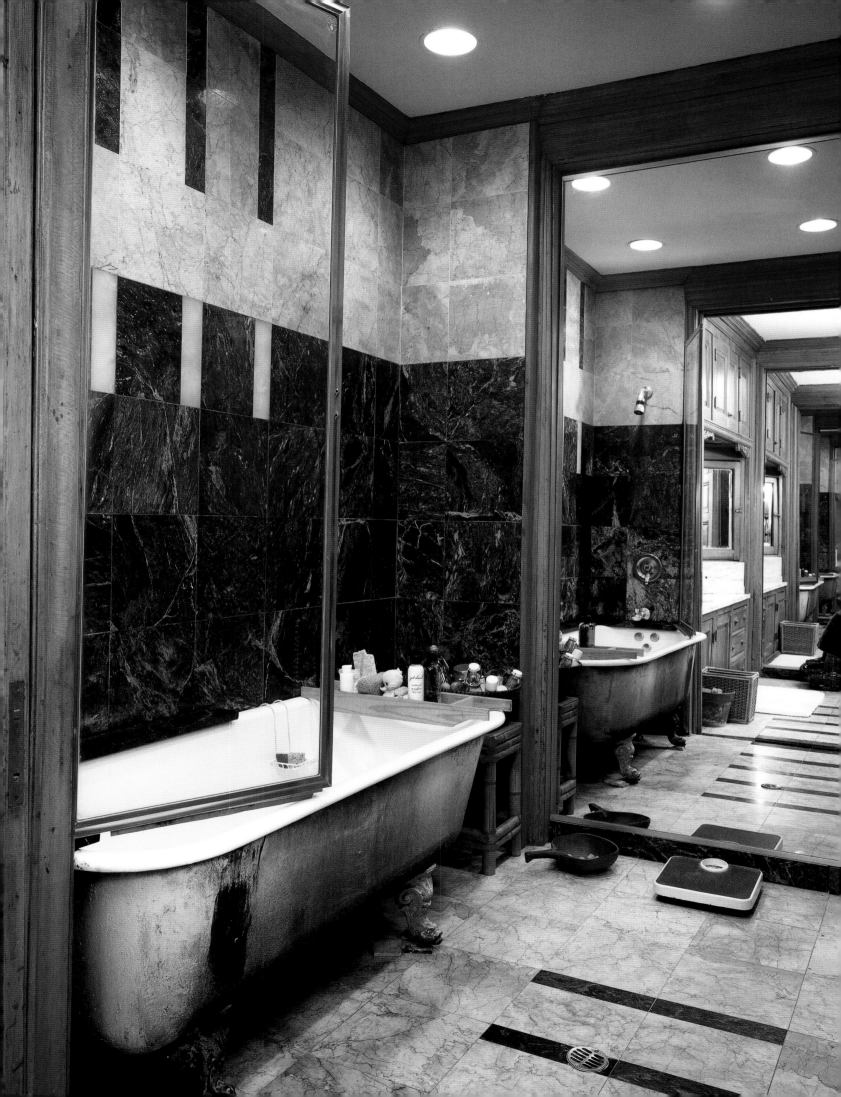

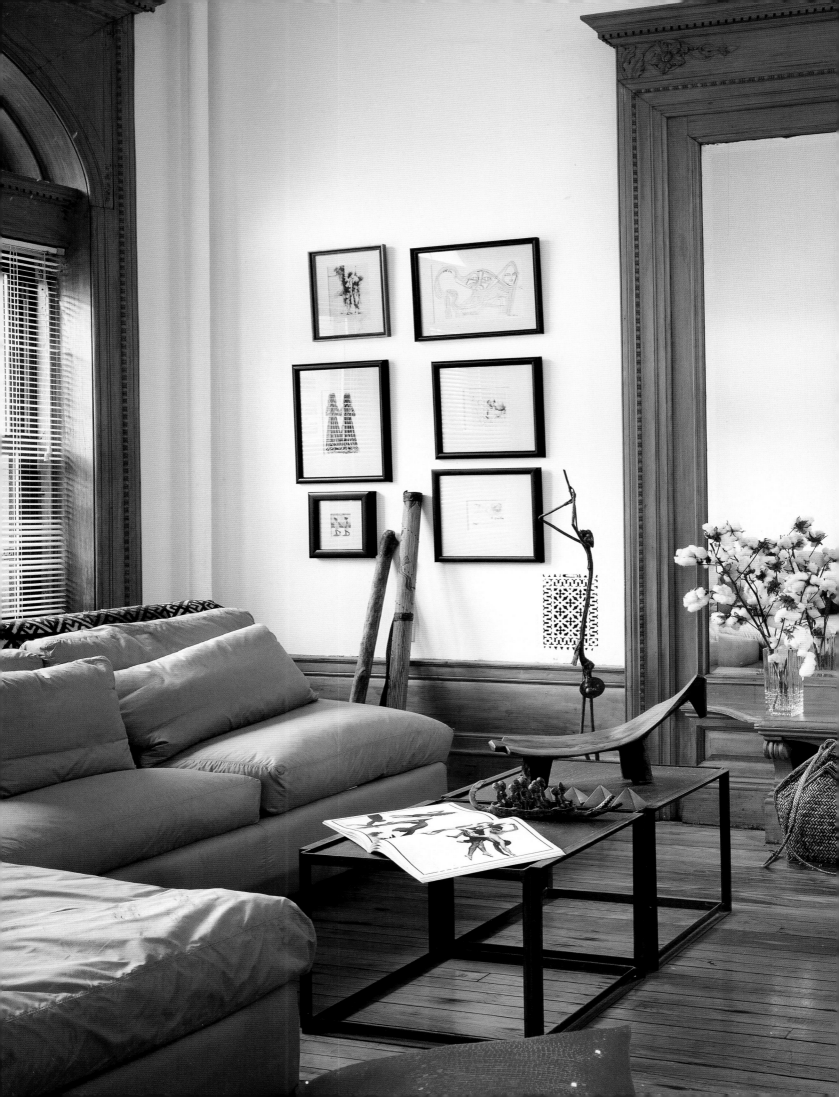

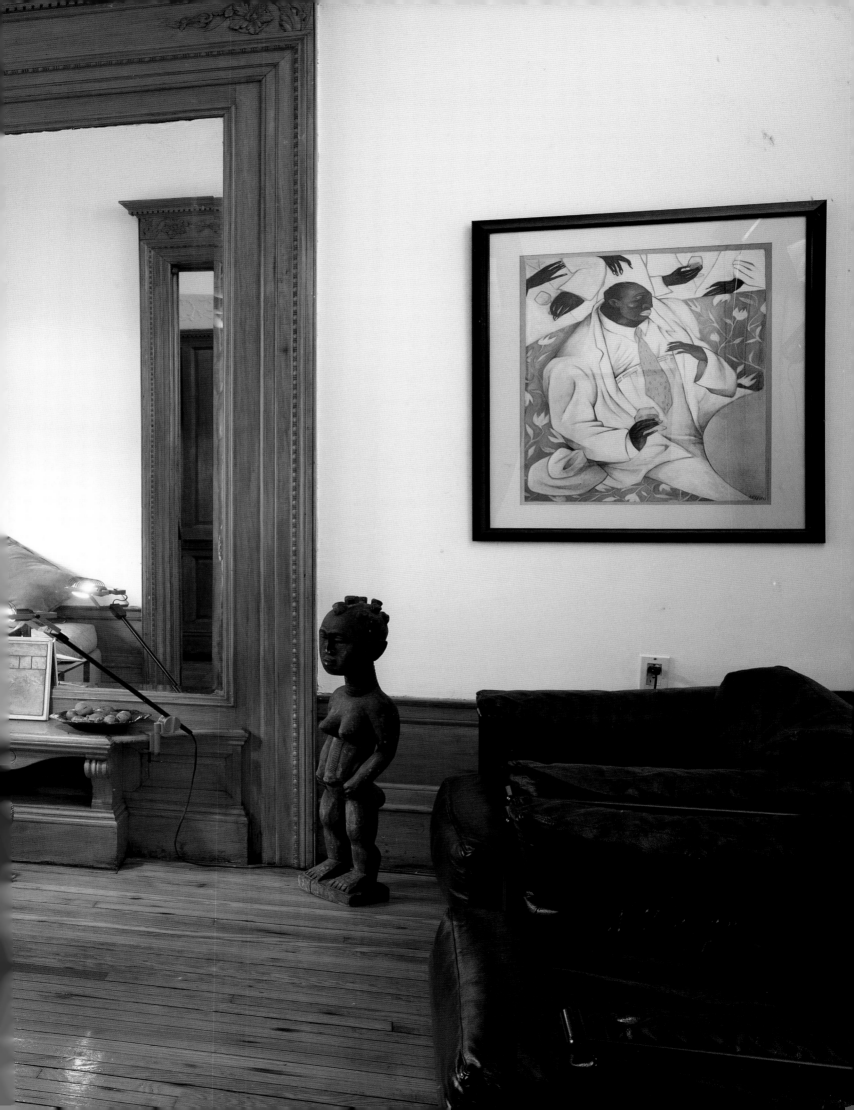

that way. Our friends, my mom and aunt thought we were nuts. And in a way, we were. Renovating our house was the hardest work I've ever done."

The original basement kitchen had to be turned into a rental unit to defray the mortgage, so room had to be found to squeeze in a new one somewhere else. Behind a matte-black granite-topped counter, in the westernmost sun-filled quarter of the formal dining room, stands a Garland range, Sub-Zero refrigerator, and every implement devised to facilitate food preparation. Here Sylvia mixes many flavors to make her famous bouillabaisse. She applied much the same approach to decorating. She mixed sculpturelike Victorian architectural elements with glass, mirrors, a brutalist wall of concrete, sleek expanses of contrasting marble, and bare hardwood floors. Expertly, in her hands, every introduction of color has a spicy emphasis. Pottery, prints, posters, flowers, Japanese masks inherited from Alvin Ailey, blue tiles, and Indian cushions—all are shown to advantage. Against a starkly white background, treasured collections add notes of relished piquancy in each room.

Seated in the parlor beside a bouquet of sprouted cotton, Waters is smiling, reflecting on happy times spent here and the necessity of leaving her former downtown home behind in pursuit of new challenges in the newly fashionable Harlem. Then she throws up her arms and, half singing, half sighing, exclaims, "Another opening . . . another show."

PRECEDING PAGES: *In the compact parlor "peopled" by a reed-slim musician, a cognac connoisseur, and an African mother, Waters has created a world uniquely her own.* RIGHT: *The allure of Waters' top floor office is due as much to its view of greenery as to quixotic ornaments and Bauhaus-inspired furniture.*

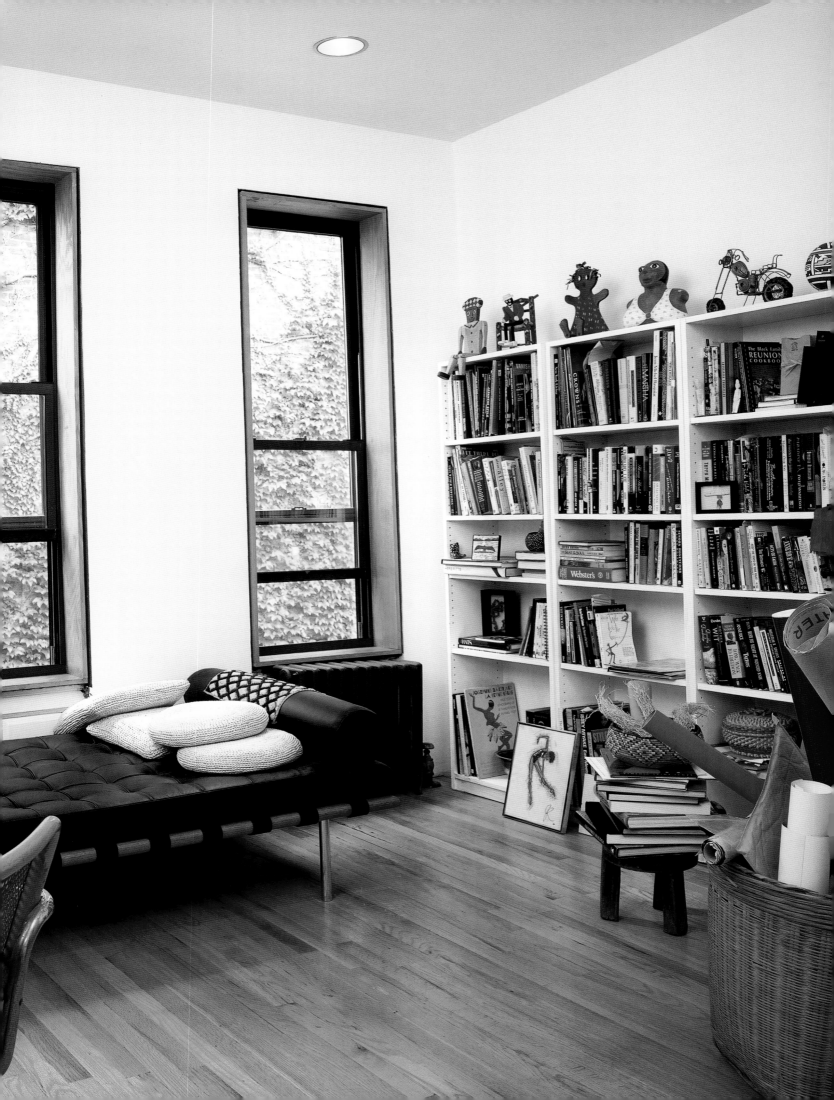

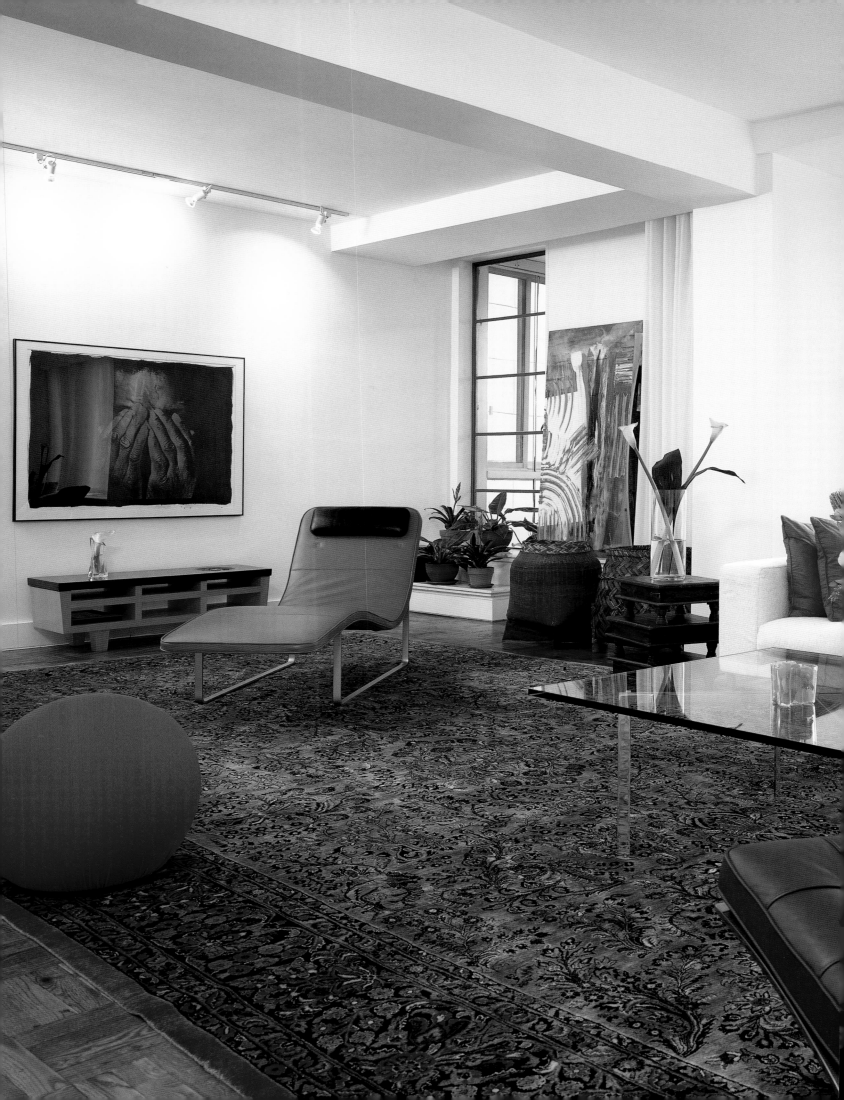

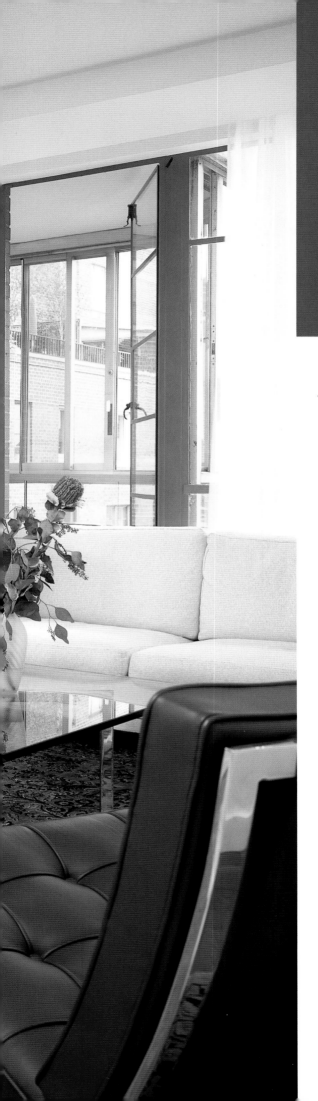

Nancy Lane

RENOVATION FOR ART'S SAKE

"In order to get what you want," says Lane, "you've got to consider what you do and do not need." She's ruthless, and her spare, spacious, cleanly designed apartment, sparkling with sunlight, leads one to concede the point. This is particularly so at twilight when the last flecks of gold and orange are glinting along the upper extremities of the distant Empire State Building.

A low, sleek white divan, cushioned by coral-colored cotton pillows, allows contemplation of numerous works of art. Like their surroundings, these works are strictly modern. Most were done by living artists like Willie Cole, Chakia Booker, Sam Gilliam, and Frank Stewart, and their work here shares a marvelous quality—they invite momentary amusement

ABOVE: *With playful irony, Kara Walker's animated figures etched on glass containers capture motion and light.*
LEFT: *Space, color, and light are thoughtfully orchestrated to showcase a collection of museum-quality modern art, such as Rashid Johnson's introspective self-portrait.*

or thoughtful reflection. This quality, by design, extends to the entire environment, the tranquil sanctuary Lane devised.

Her way of decorating with flowers is like a calligrapher's art. Routinely, more is revealed through less, through a few well-chosen objects.

Her art collection includes a number of unwieldy works, a few made from unusual materials like foam rubber or steel, that demand special arrangements. Showing this art to advantage required specialized assistance and Lane wisely found it. Her apartment is at Butterfield House,

LEFT: *The eye of a connoisseur distinguishes Nancy Lane's personal style as well as the élan of her home.*

OPPOSITE: *Lane's spacious home features the best of the modernist movement with an air of warmth and welcome, boasting works by Sam Gilliam and photographs by Elizabeth Friday.*

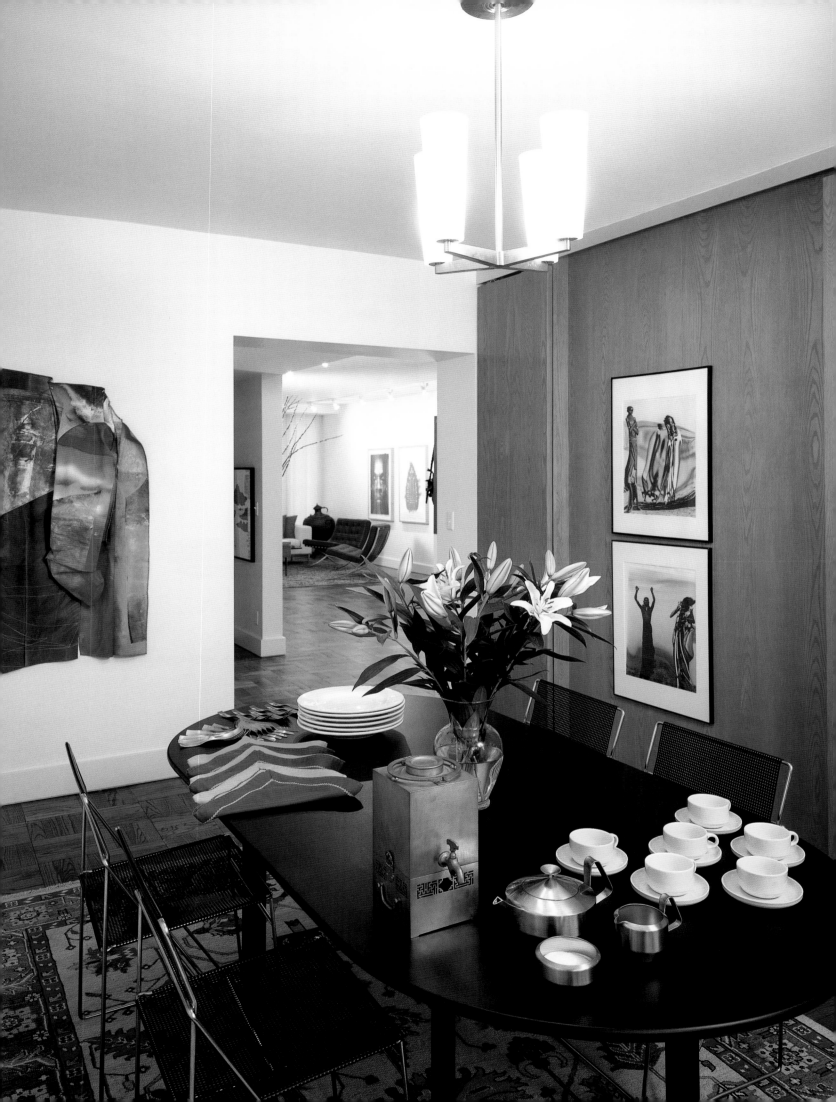

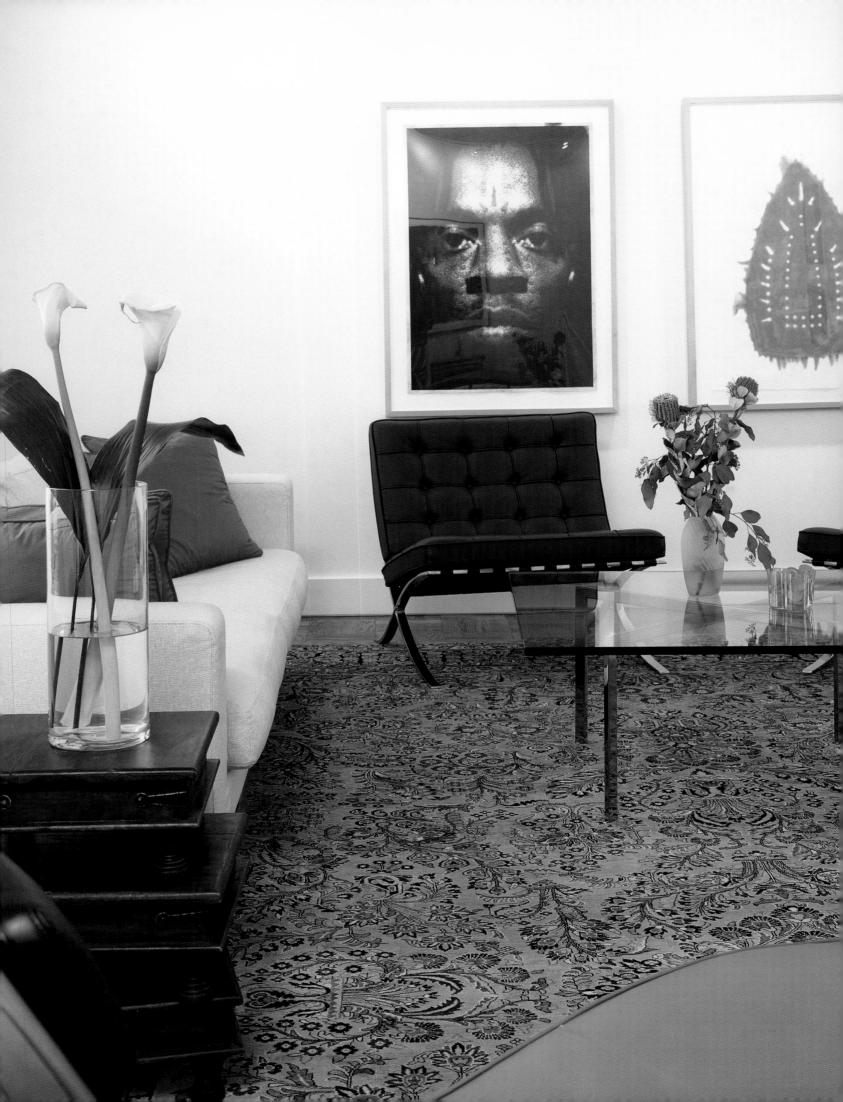

a handsome, many-bayed building designed by Mayer, Whitt, Lesey & Glass in Greenwich Village near Fifth Avenue. Completed in 1962, the complex surrounds an Arabian-inspired interior fountain court. Its sensitive scale and fine workmanship caused it to be singled out for praise by architectural historian Robert A. M. Stern in his book *New York 1960*.

Her current suite is Lane's third in the building. The first occupied an upper story. The second was larger but located on the third floor, and despite a quiet courtyard outlook, its low position made the interiors dark. Seeking help to brighten her space and properly accommodate her collection, Lane was led to Jeff Sherman of Delson & Sherman, a small design practice specializing in residential projects. "Ms. Lane," says Sherman, "is a dream client." They all but gutted flat number two's many small rooms and made a few spacious ones. Darkening doors were removed or replaced with translucent glass, resembling sliding panels in traditional Japanese houses. To everyone except an uncertain Ms. Lane, the metamorphosis she'd brought about was a sheer triumph.

She still had doubts when she learned that a large apartment near the very top of Butterfield House was to be sold by the Fashion Institute of Technology. It seemed foolish, even rash, having just undertaken an extensive, drastic renovation, to even contemplate a new apartment that would also need an overhaul. Dare she do it?

Rashid Johnson's provocative series of paintings hovers above a pair of classic Barcelona chairs.

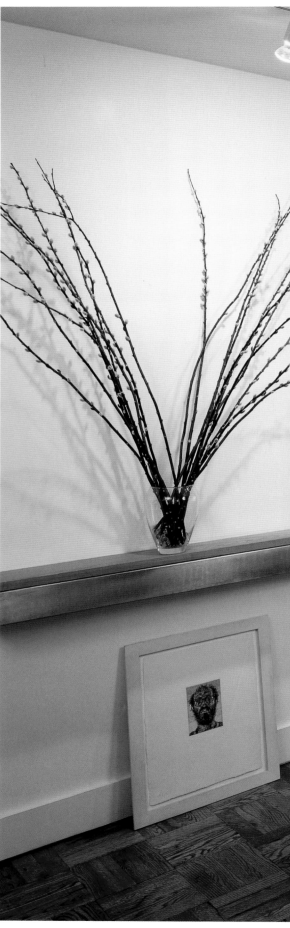

She did. And given the thoroughness of her "dress rehearsal," apartment number three is the best one yet—with fewer, larger rooms, a more open yet meandering layout, and sliding walls of polished woodwork, which appear and disappear, revealing cupboards, a bar, and, of course, still more art.

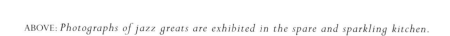

ABOVE: *Photographs of jazz greats are exhibited in the spare and sparkling kitchen.*

RIGHT: *Carrie Mae Weems' iconic heads based on traditional South African portraits dominate Lane's gallerylike entrance.*

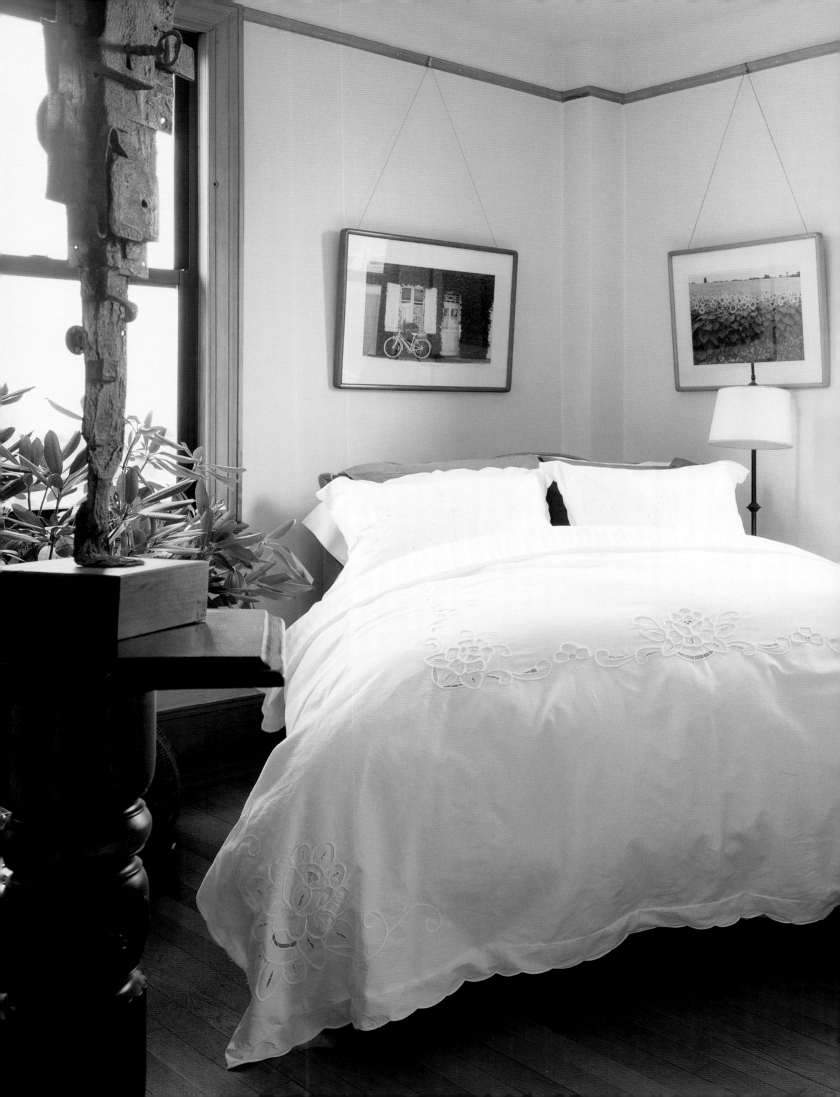

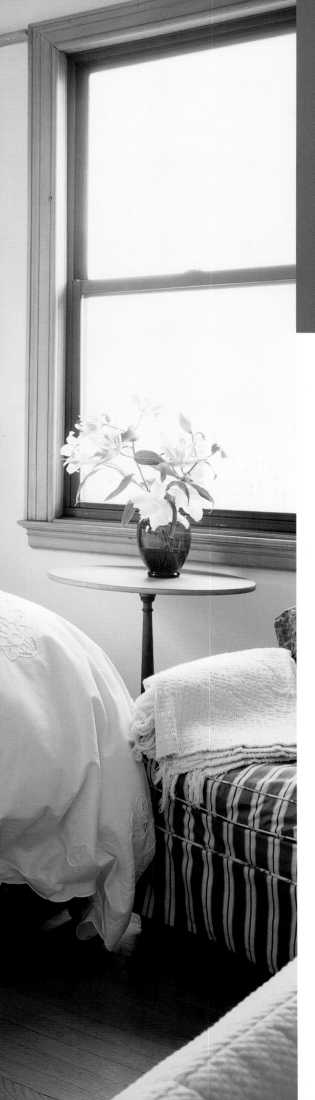

Lana Turner

THE ZEN OF STRIPPING WOOD

Atop a Sugar Hill apartment house built in 1916, Turner's suite of intimately scaled rooms boasts expansive views of both the George Washington Bridge and Yankee Stadium. Acquired in 1939 by Caribbean immigrant Augustine Austin, Turner's building was once home to such black notables as artist Hale Woodruff, journalist George Schuyler and his prodigy daughter, Phillipa, and jazz greats Lucky Roberts and Roy Eldridge. Such associations make her home of three decades all the more dear to her, as do innumerable mementos of Harlem history, her family, and friends.

ABOVE: *African and African-American art provides a statement of continuity.*
LEFT: *Lana Turner's sunny, curtain-less bedroom features pristine hand-embroidered linens.*

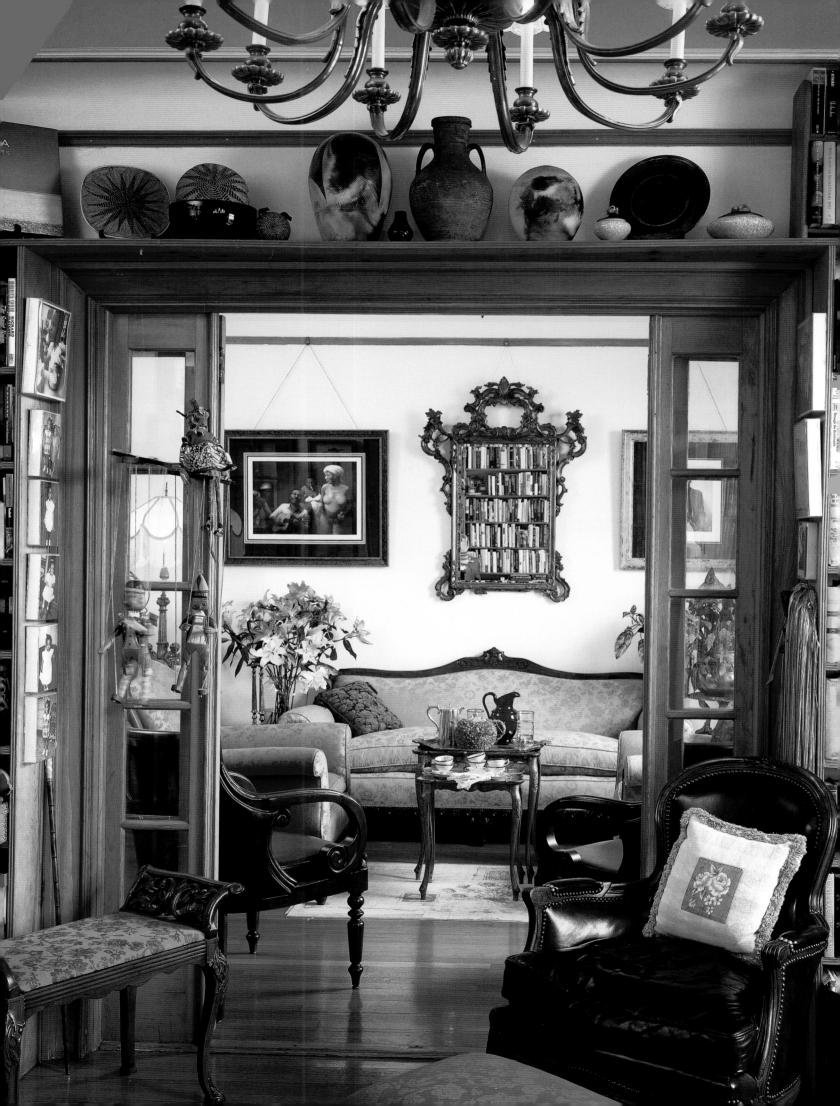

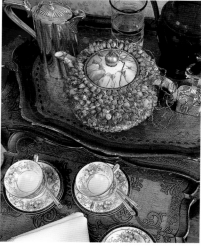

The living room's gilded neo-rococo looking glass, for instance, belonged to Turner's mother, who in turn received it as a present while working as a lady's maid for Betsey Cushing Roosevelt Whitney. Similar to items in Harlem apartments of the 1930s, the living room's matching over-stuffed davenport and easy chairs were originally upholstered in mohair. Their rose-colored damask coverings today are telling examples of

Turner's taste, as is her rosebud-cozied teapot, an array of highly fired Japanese earthenware, curtainless windows, and complex yet highly organized collections of implements, toys, and books.

Nothing else identifies Turner's refinement and patience as much as the waxed whitewood door cases, baseboards, and window surrounds. When she first saw them as a young mother, they were all painted, as were the ceiling moldings and even the glass panes of the French doors. Occupied for some years with what she now merrily calls "the Zen of stripping," Turner's decisive action produced an entirely new outlook, a perfect setting for music, flowers, photographs, antiques, laughter, history, friends, and fun.

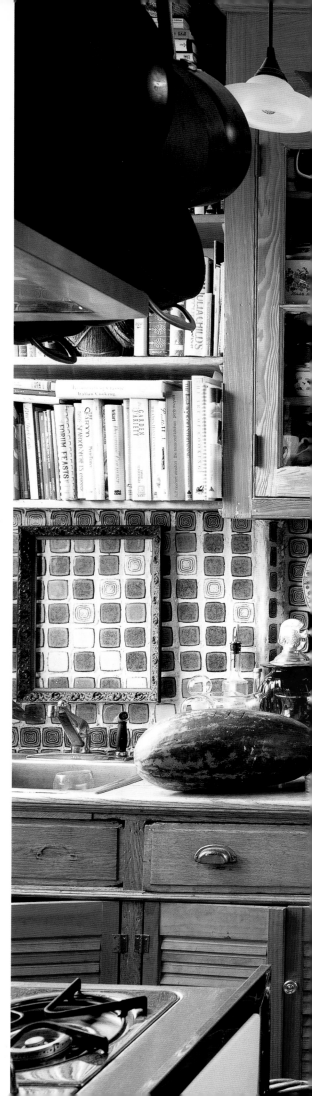

A laboratory from which memorable meals are produced, Turner's kitchen, where she stripped the woodwork and tiled the walls herself, is continually evolving toward greater functionality.

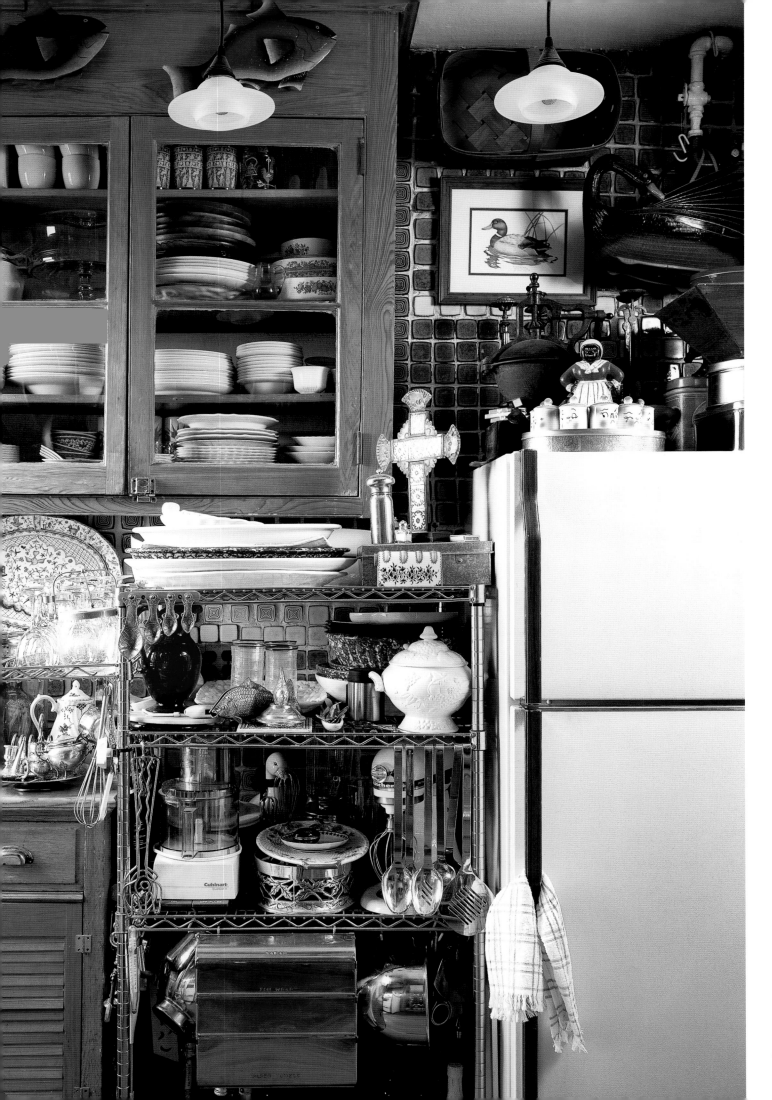

Joy and Kesha Crichlow

AFRO-CARIBBEAN SPLENDOR

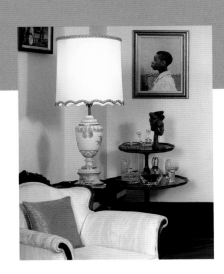

In the aftermath of the Manhattan draft riots in 1863, when at least a dozen African Americans were slaughtered by marauding throngs of immigrants who resented having to fight for the abolition of slavery, many well-to-do blacks abandoned the island and made nearby Brooklyn their home. They formed a presence that grew until today this borough boasts metropolitan New York's largest African-American population. Nothing better expresses the aspiration of Brooklyn's black elite than the fine Victorian brownstones they inhabit in Bedford Stuyvesant and Fort Greene.

In a large corner house in Fort Greene, Ms. Crichlow, a native of Jamaica, is part of an extensive Caribbean immigrant population that began arriving in New York at the turn of the nineteenth century. While her home embodies English taste, there is a distinct absence of any English aloofness. Every room and object has been arranged to facilitate the warm reception of guests—an antique grand piano, a gleaming fire, glittering chandeliers,

BELOW: *Joy and Kesha Crichlow enjoy cocktails on the veranda.*

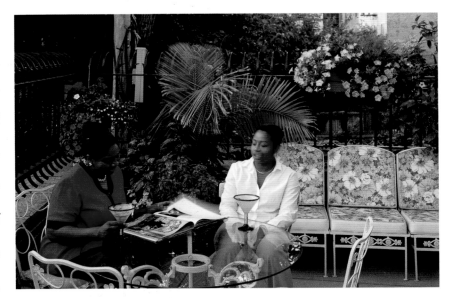

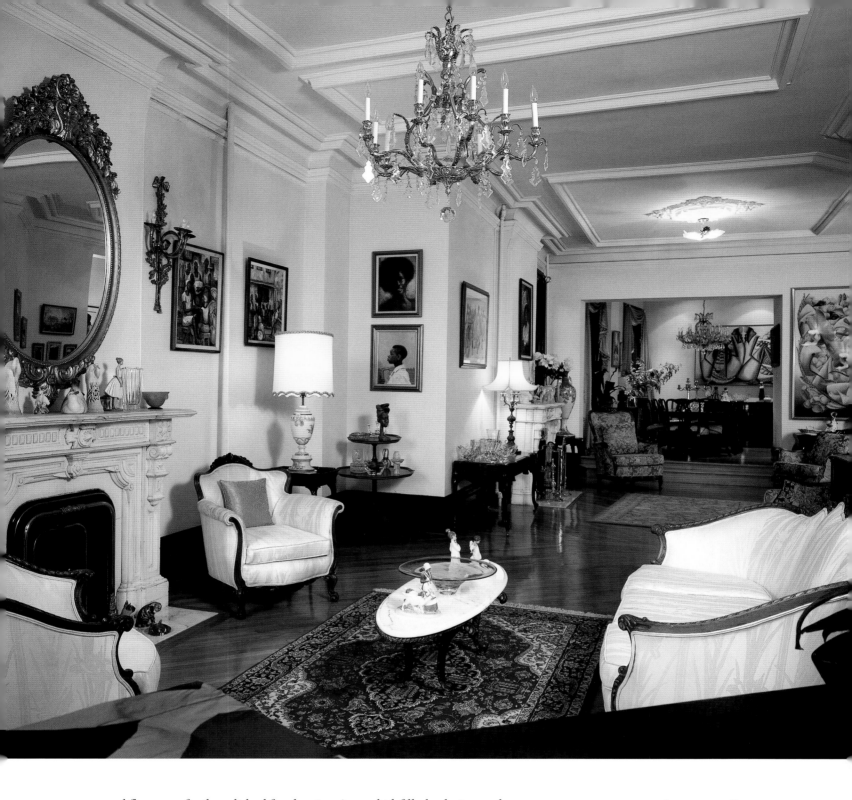

and floors perfectly polished for dancing. An orchid-filled solarium as large as most living rooms, an adjoining landscaped terrace as ample as many urban backyards, and a side garden with hydrangea and roses bordering a lily pool, covering a full city lot, extend the homeowners' good fortune to guests.

Her mother's daughter, Kesha attests, "Here and at our house in the Hamptons, Mom is always inviting people to visit. It takes a lot of effort, but it's fun and it's worth it. It's a continuous celebration."

ABOVE: *By removing obstructing walls, an endless enfilade with two Italianate Carrara marble mantelpieces and a large collection of works by black artists was formed as a prelude to the dining room beyond.*

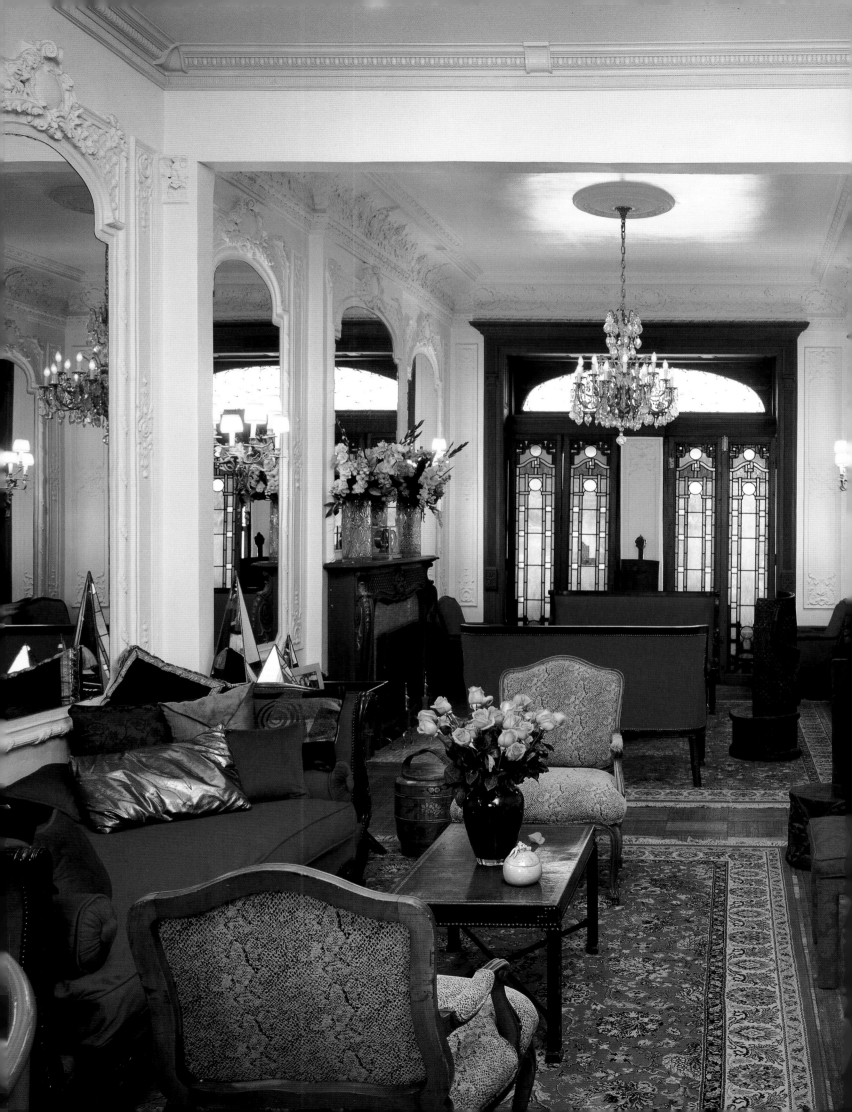

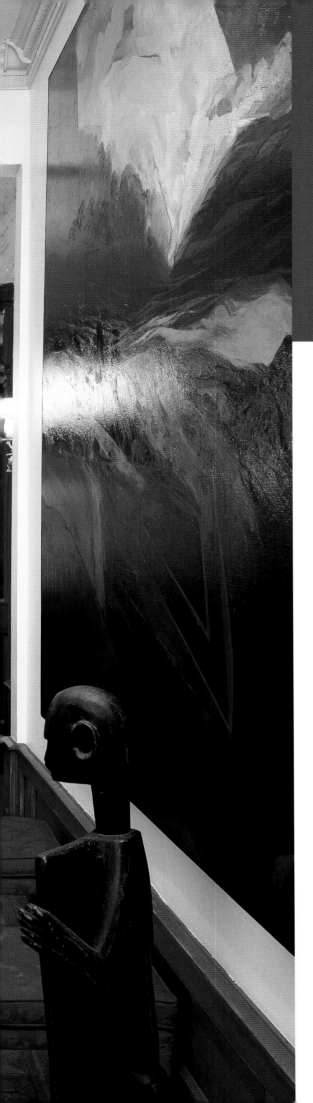

George Faison

HIGH-STYLE HOSPITALITY

O
n a corner of West End Avenue sits one of New York's grandest Victorian brown-stone houses, designed by Thom and Wilson and erected in 1888. But an imperious house with massive scale and ornate appointments does not automatically guarantee anything beyond a frigid, impersonal interior with reverberating echoes. Starting with the foyer, everything here that might easily have been somber and dreary is cheerily welcoming, an extraordinary accomplishment, especially since it was achieved without the assistance of a decorator.

ABOVE: *Elegantly attenuated, these figures reflect Faison's flair for the theatrical.*
LEFT: *Expanses of mirror, stained-glass panels, bold paintings, and West African thrones are part of the dramatic imprint that George Faison has imposed on what otherwise would have been a conventional French-style salon.*

This is where George Faison, author, director and choreographer, resides with his companion of the past thirty-five years, Tad Schnugg, and two affectionate dogs. Exploring the world has provided many of the incomparable objects that ornament their commodious rooms, while pets, on the other hand, have helped to keep any temptation toward excessive gorgeousness in check. Says Faison, "One must know when to let go and when to hold back."

Working with myriad stunning elements from disparate cultures, epochs, styles, and materials, discipline is at play throughout—from the garden floor dining room, with latticed chairs and French faience, to the parlor floor's double drawing room and music salon. The latter is dark

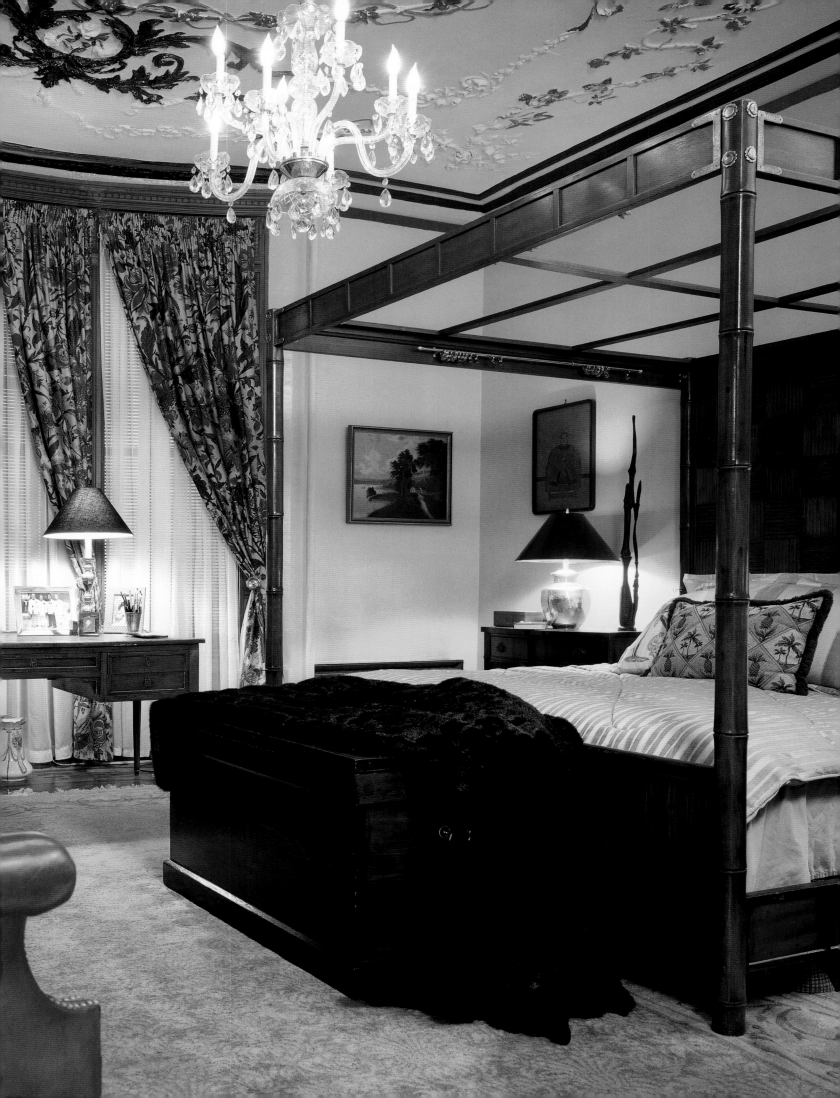

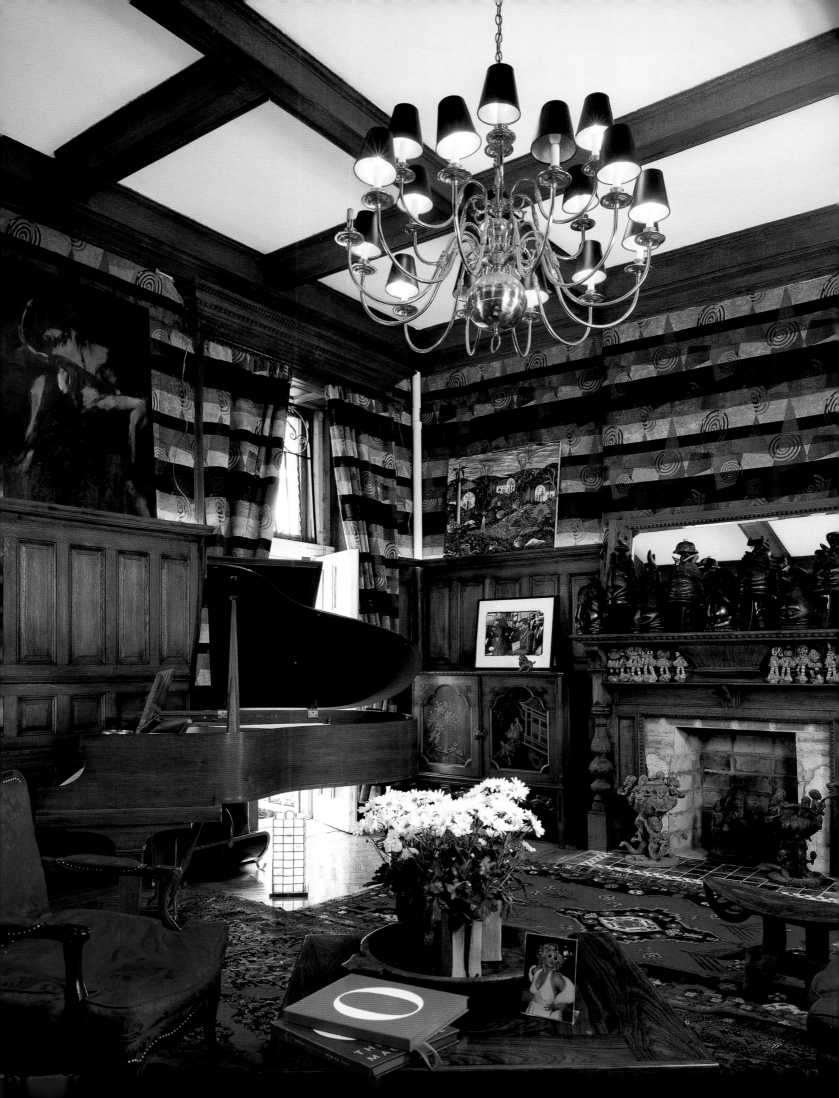

and restful and features a magnificent mask collection. The former is sparkling with Louis XV framed mirrors and features thronelike chairs. A restraining hand also prevails on the second floor, where slender warriors guard the spiral stairs' landing. An imposing four-poster bed dominates each bedroom.

All together, the palatial structure is a harmonious home where splendor and *gemütlich* are compatible.

OPPOSITE: *The oak-wainscoted music room derives its feeling of intimacy from compelling works of art and an arresting textile that is used as both a wall covering and for curtains.*

ABOVE: *Lattice-work chairs, a plumelike crystal chandelier, brightly colored paintings, and French faience all contribute to the gardenlike quality of the dining room, which is immediately adjacent to a conservatory and a landscaped terrace.*

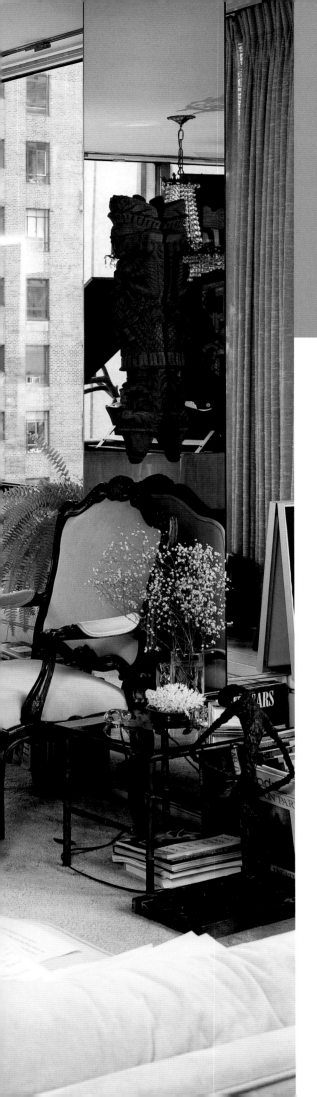

Gordon Parks

MEMENTOS

A bove the East River's placid serenity, Parks' luminous home for the last quarter century at the United Nations Plaza is well lit by a long band of tall windows intensified by mirrored piers. The living room is adorned by artwork and artful images everywhere. It's also liberally littered with stacks of books, some of which seem like man-made mountains in a beige landscape. Specially made, buff-colored, tufted cotton-velvet sofas and chairs are augmented by Louis Quinze beechwood fauteuils and side chairs. A piano stands, shrinelike, in front of a Coromandel screen and a sprawling mature rubber plant, and a diminutive chandelier is suspended above it. Swirling for an hour at a time, balanced on a slender column, a group of bronze

ABOVE: *Filled to capacity with books and images, Gordon Parks' apartment offers an intriguing self-portrait.*

LEFT: *Commanding pride of place before a mature rubber plant, Gordon Parks' piano sits below a diminutive chandelier.*

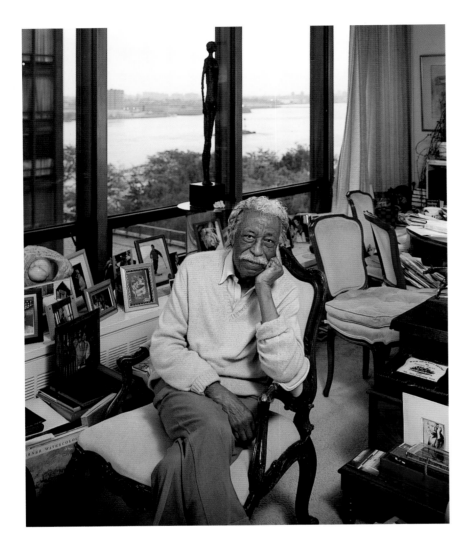

LEFT: *Considering that Gordon Parks is a living legend at age ninety, it is fascinating that he did not acquire his first camera until he was almost thirty.*

RIGHT: *Paintings and mementos of a stunning career tell the story of a great creative force.*

BELOW: *An abundance of awards and honorary keys to more than twenty-four American cities are even more significant considering how many of the institutions and municipalities were still legally segregated during much of Parks' life.*

dancers by Matisse moves like a metaphor for the unending circle of time and memories lovingly housed here.

Almost every inch of every surface of his apartment is crowded with tributes—among them his fifty honorary degrees and countless city keys. They are as proudly and prominently displayed as other far more valuable possessions.

One senses that spirits of Parks' friends linger here—Arthur Ashe, I. M. Pei, the architect who designed this space, Parks' one-time neighbors Johnny Carson and Truman Capote, stars like Lena Horne, artists like Michael Bannarn and Giacometti. All are represented and each is present.

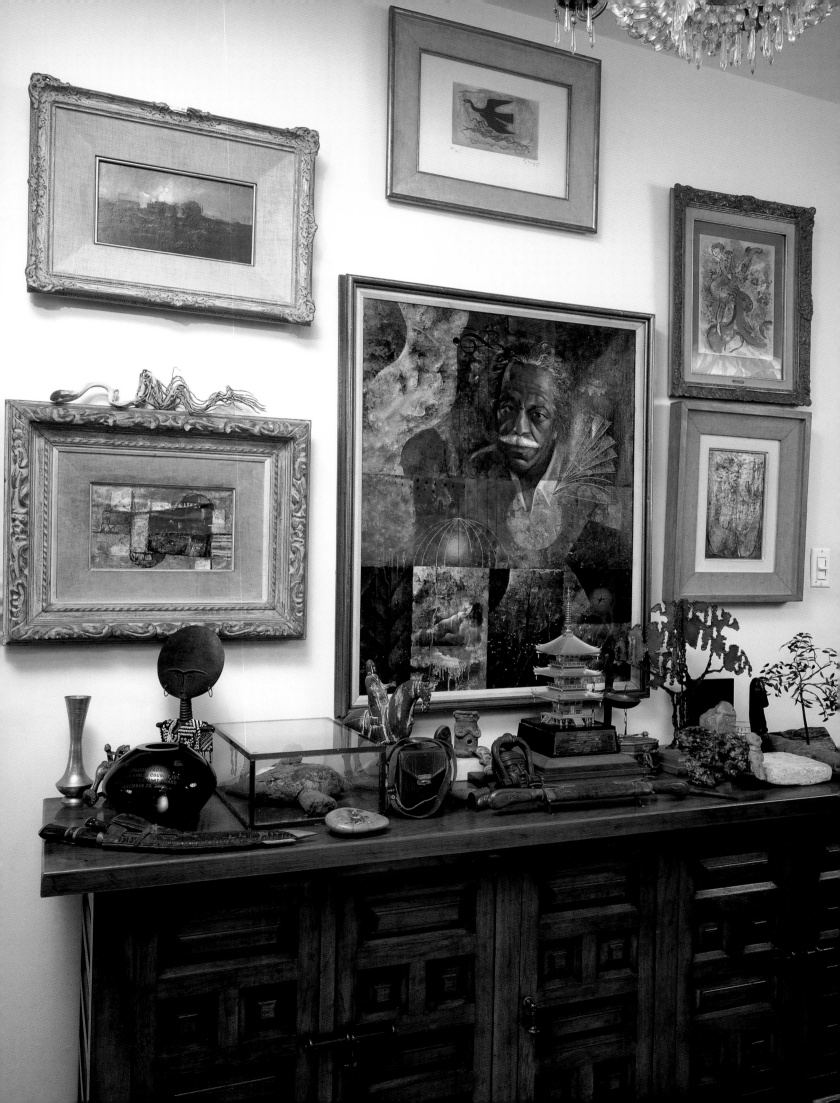

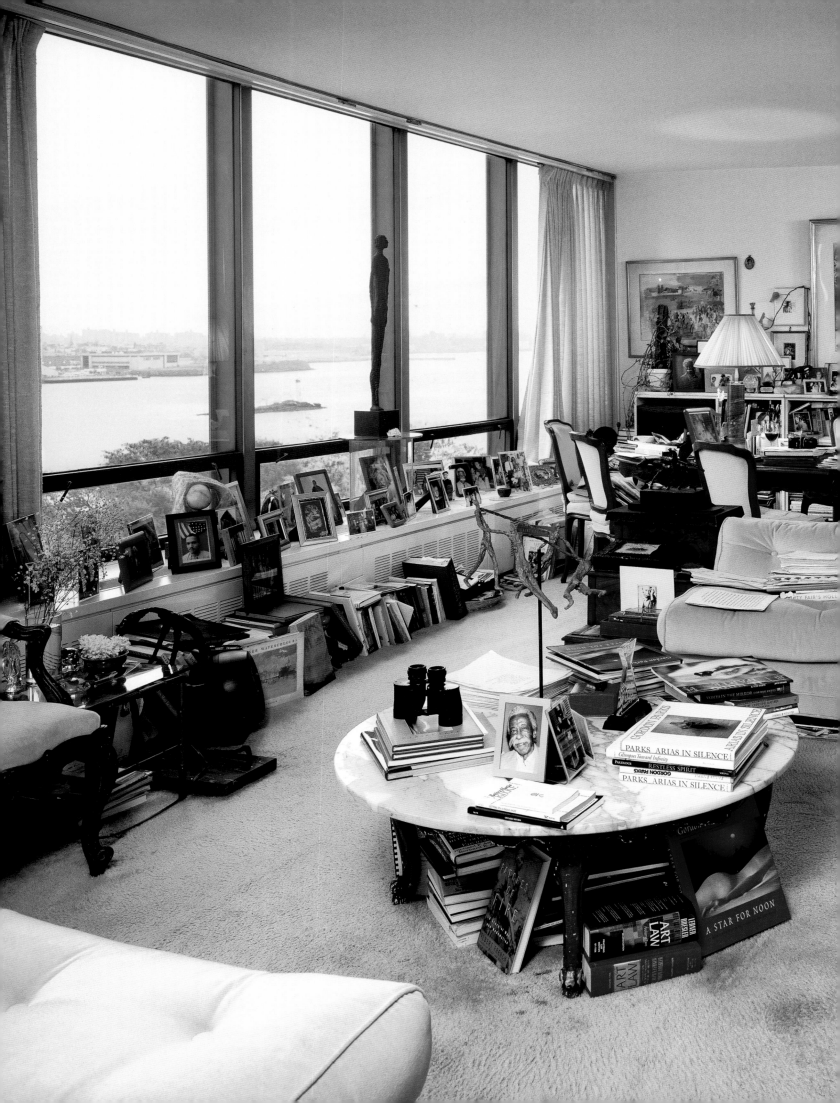

Sculptures by Matisse and Giacometti, and paintings by Chagall and a host of other masters, provide focal points.

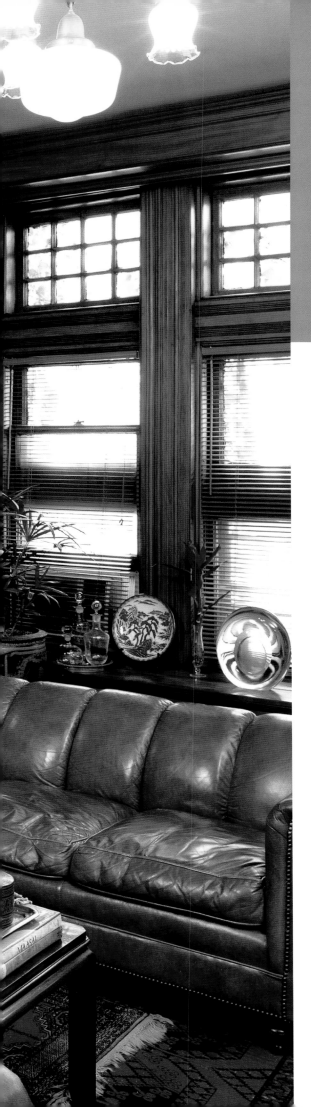

Richard Dudley

TWICE BLESSED

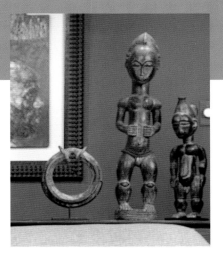

Delicately balanced, Dr. Dudley's taste is like an act of magic and makes his houses in historic Harlem and rural Pennsylvania delightful. Both are appointed in accordance with their owner's fastidious standards, yet they could not differ more in their historic associations, stylistic treatment, or atmosphere.

Designed by William Mowbray, a young architect who would apprentice with McKim, Mead & White, the four-level neo-Gothic Harlem house was built at the start of the 1890s. Ivy-clad and formal, occupying a portion of Alexander Hamilton's former estate, it epitomizes Victorian decorum. Coolly shadowed, the interior here is a refuge in which the city's bustle and stresses seem far removed. Having had only four owners, it retains innumerable original elements, including a varied group of

ABOVE: *West African sculptures take center stage in a lighted alcove.*
LEFT: *Deep green walls, leather-upholstered sofas, and an intricately carved Victorian mantelpiece capping an iron and brass Franklin stove contribute to the serene atmosphere in Dudley's library.*

picturesque fireplace mantelpieces, rare for having never been altered. Wherever such features were missing, they were skillfully reinstated with the capable assistance of interior designers Ron Wagner and Timothy Van Dam, who are the doctor's neighbors. Their restoration is an example of the judicious eclecticism of the Aesthetic Movement, including wide-ranging

elements. Dudley's extensive collections of art are from many sources, and paint and fabric color schemes are authentic to several periods.

His superb Japanese prints, sculptures, and porcelains are so fine that they could be displayed in museums, but here have been so artfully introduced into their settings that there isn't the least feeling of preciousness. Mellow jewel-colored walls and deep Oriental carpets complement the dramatic stairs, lined with nineteenth-century woodcuts by the Master Toyokuni I, his student Toyokuni II, and the student's apprentice Toyokuni III, depicting kabuki stars from the 1820s through the 1850s.

Lighted by a bay of mullioned windows admitting dappled light between ivy leaves, the doctor's second-floor office and library is painted a soothing deep green. In winter, it is warmed by a fire ablaze in an antique Franklin stove. Above the stove is the room's most arresting ornament, an intricately carved bas-relief panel of a grotesque mask amid swirling arabesques.

BELOW: *Standing guard on the staircase landing, a wooden ram sits below a nineteenth-century Japanese woodblock print.*

RIGHT: *In the stair hallway at the center of the house, an imposing pair of chairs is carved with the same eclectic and whimsical motifs found on the chimneypiece.*

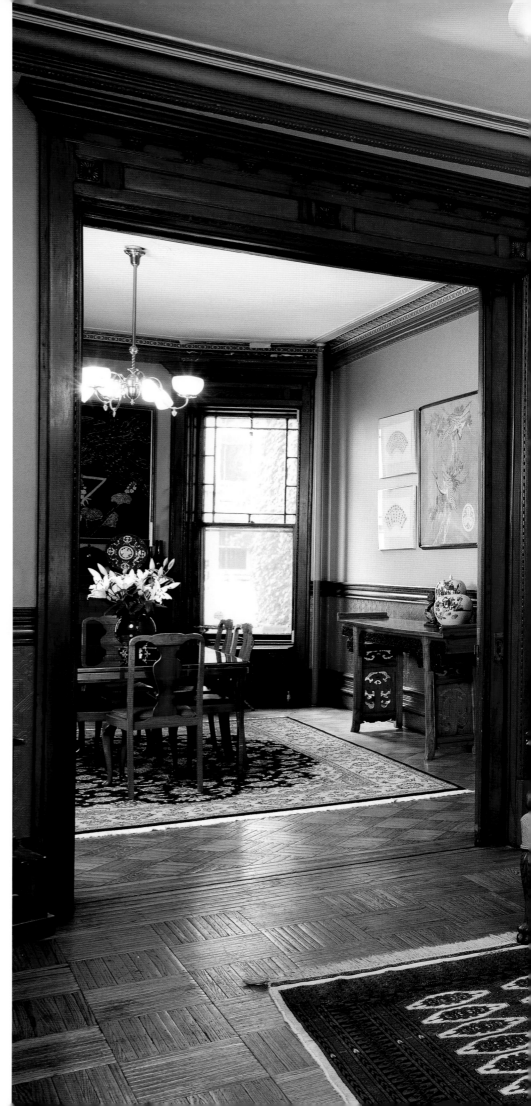

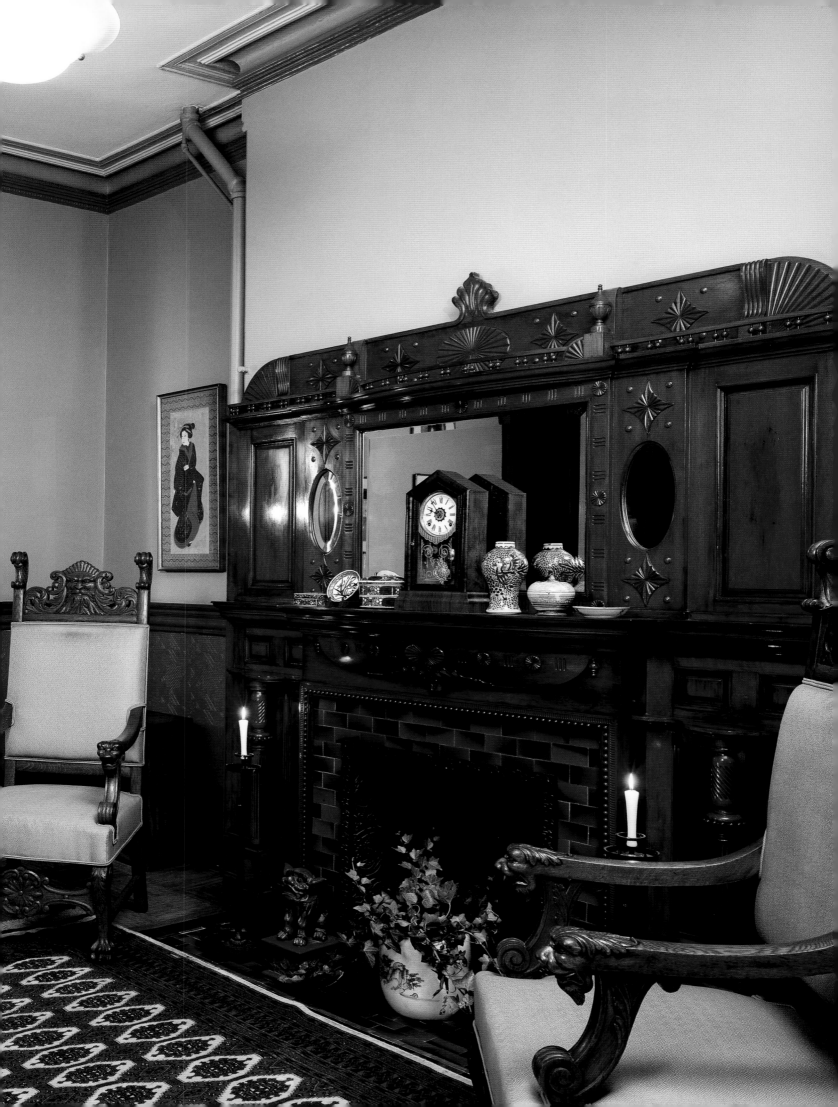

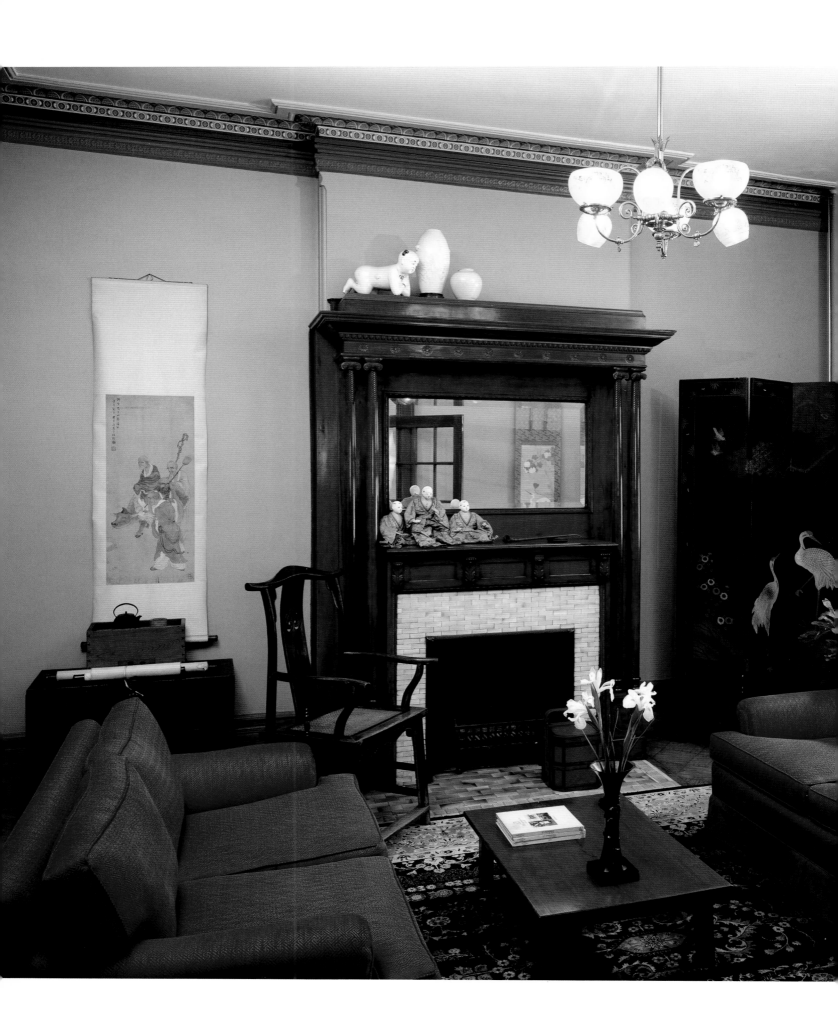

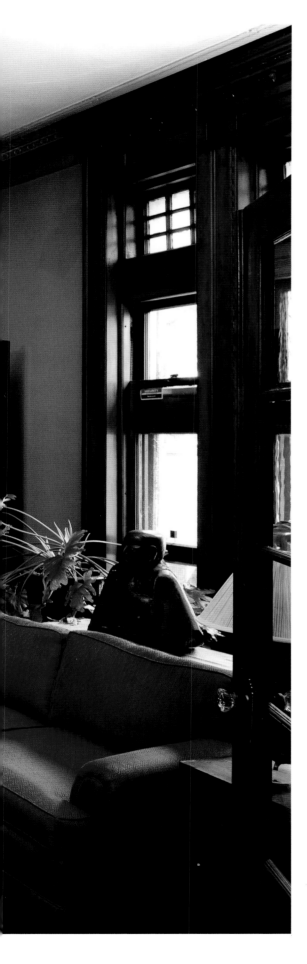

"Crucial to my being able to maintain a demanding workload is the ability to wind down someplace quiet and private. That's not here in Harlem," says Dudley.

In the country, a nineteenth-century clapboard-covered lock keeper's house is perched between a lazy river and an unused canal—Dudley's second home. He can launch his canoe into the water from the garden-side dock or hold forth with a few friends seated before the fireplace in the "big room," sheltered in an inglenook.

Where the Harlem house is furnished with handsome, substantial Edwardian tables, chairs, and cabinets, the country house employs Arts and Crafts pieces from the same era. Sparingly embellished, they're made from quartered oak stained dark and simply waxed.

ABOVE: *The foliated screen at the entrance of a dressing room came from an older house.*

LEFT: *A lacquer screen, Japanese hand scrolls, and porcelains found in the parlor today are exactly the kinds of objects that might have been used here when the house was built during the aesthetic movement 125 years ago.*

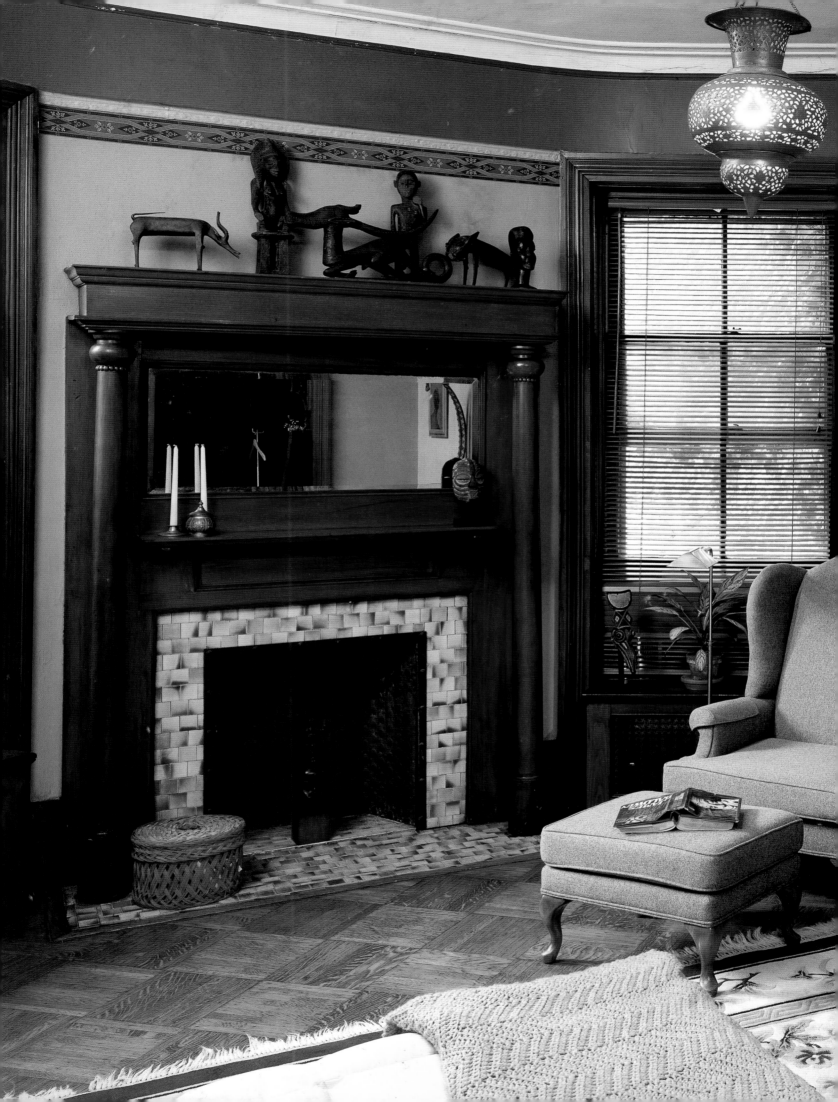

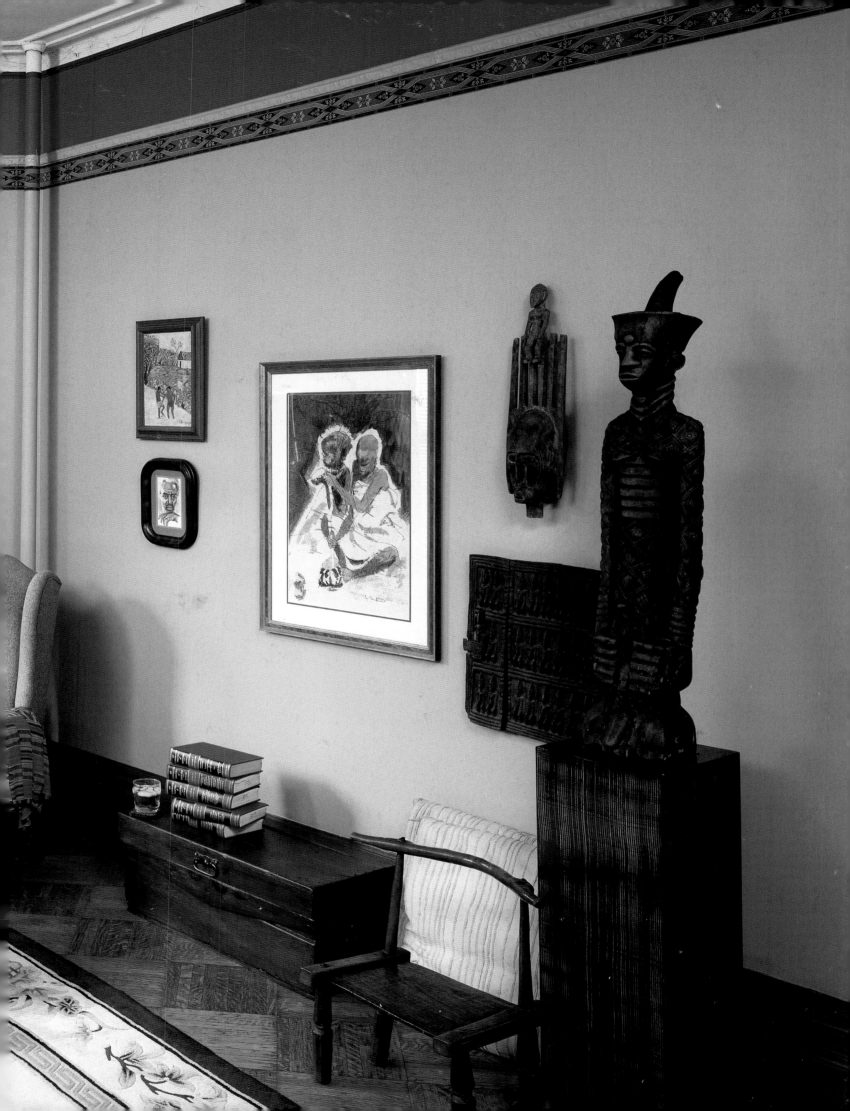

Curiously, they bear a striking resemblance to the refined aesthetic of Oriental furniture also found in these cheery rooms.

Of his two domiciles, Dudley says, "Both have prominent displays of West African and Japanese art. But Oriental works predominate in the city and out here African pieces do."

Whether in Harlem or in the heart of Bucks County, Dudley's homes are filled nearly to overflowing with marvelous objects, and each place fundamentally reflects its owner.

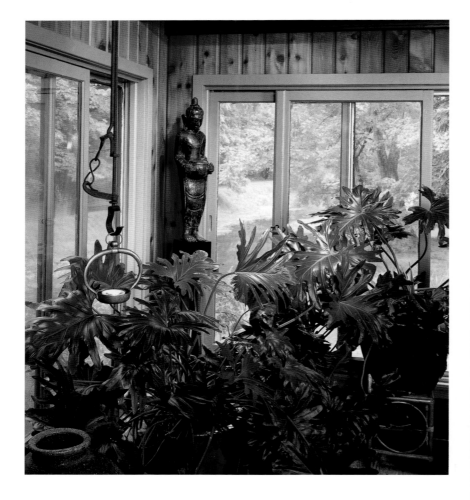

PRECEDING PAGES: *Lit by a pierced-brass Levantine lantern, the blue and white bedroom contains a Chinese carpet and West African sculpture.*
LEFT: *Tropical flowers help bring the outdoors inside and create a setting for an antique scale and a burnished Buddha.*
RIGHT: *Japanese furniture and art are a feature of both of Dudley's handsome homes.*
OVERLEAF: *In the open-gabled living room, exciting works of art are skillfully juxtaposed with large, uncurtained windows looking into a serene landscape.*

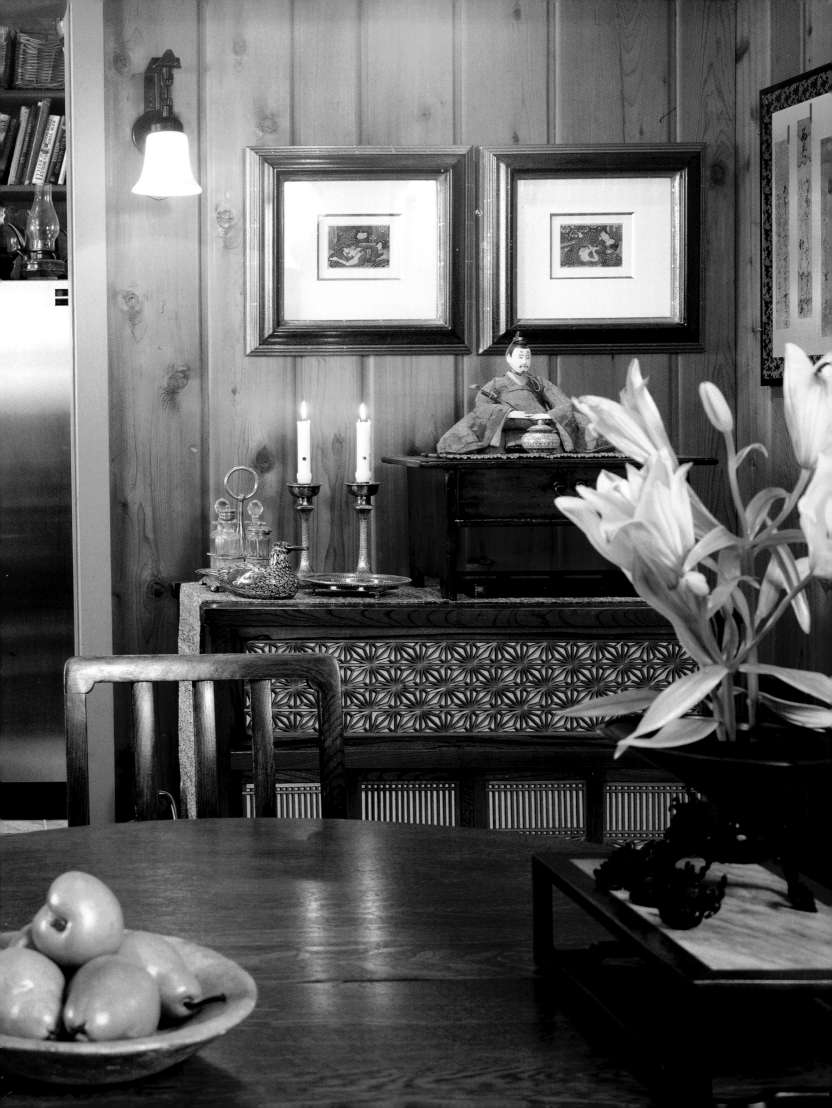

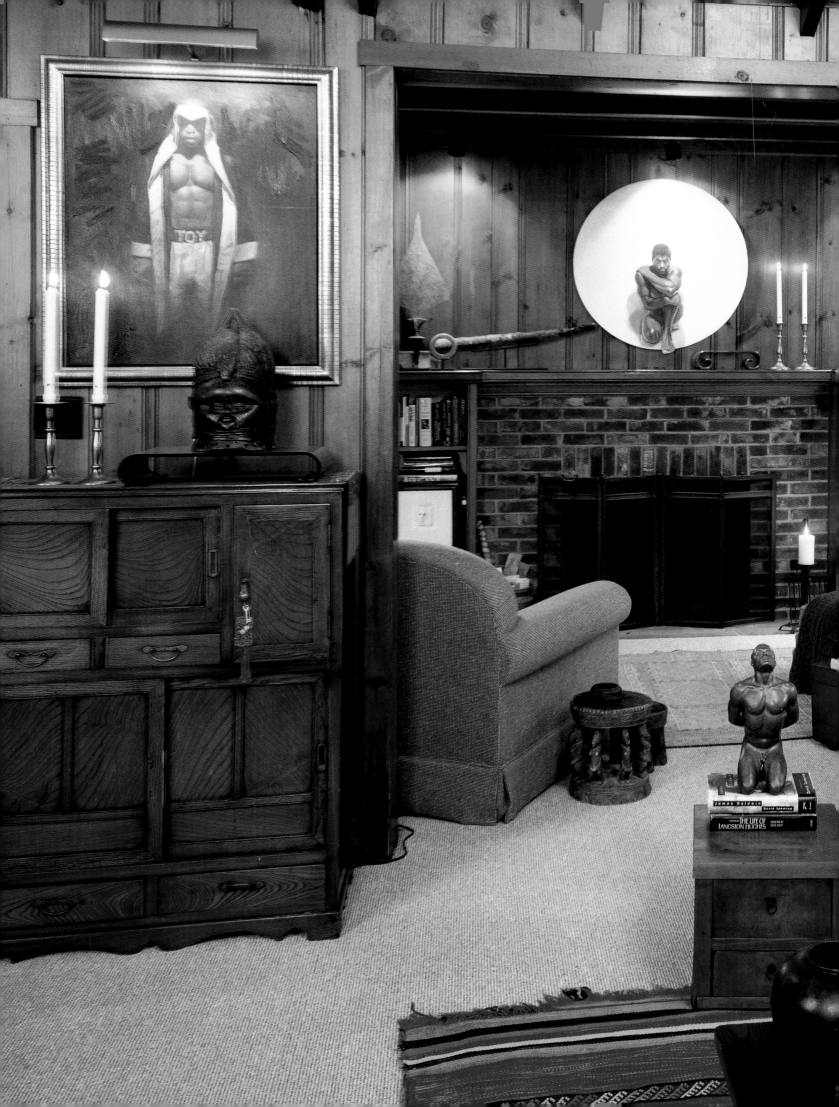

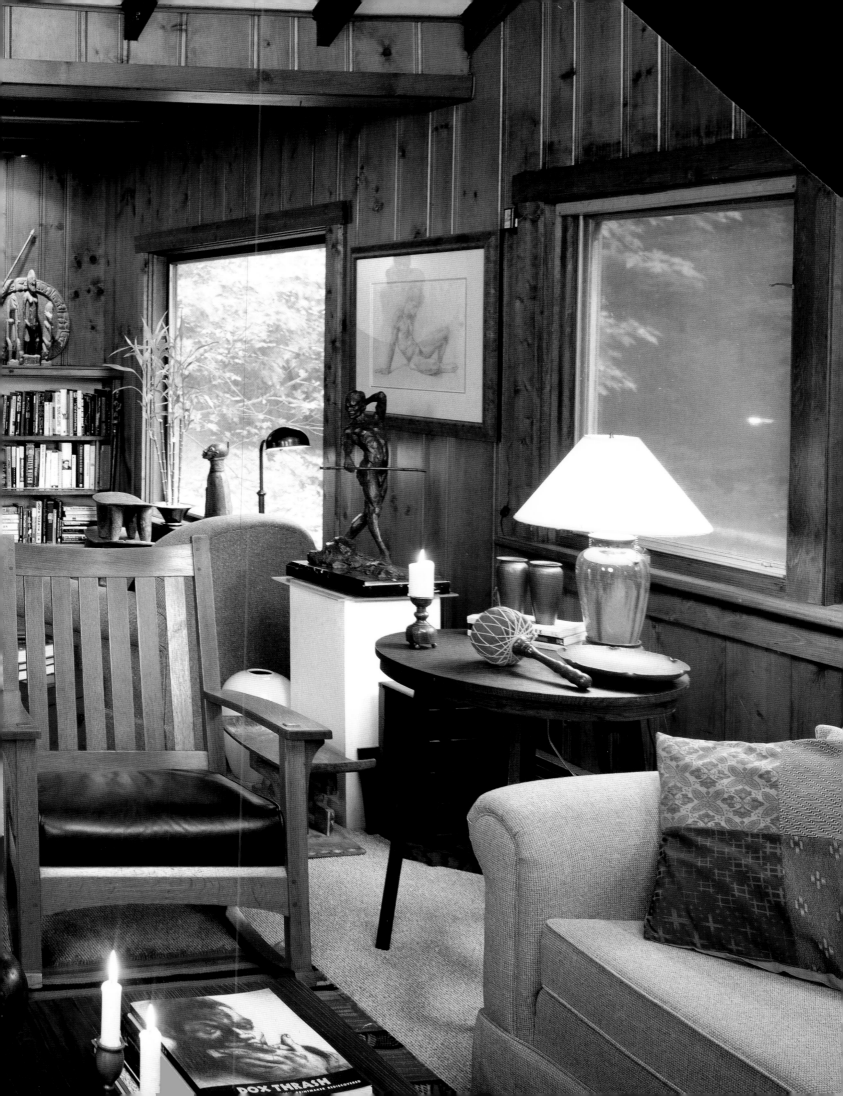

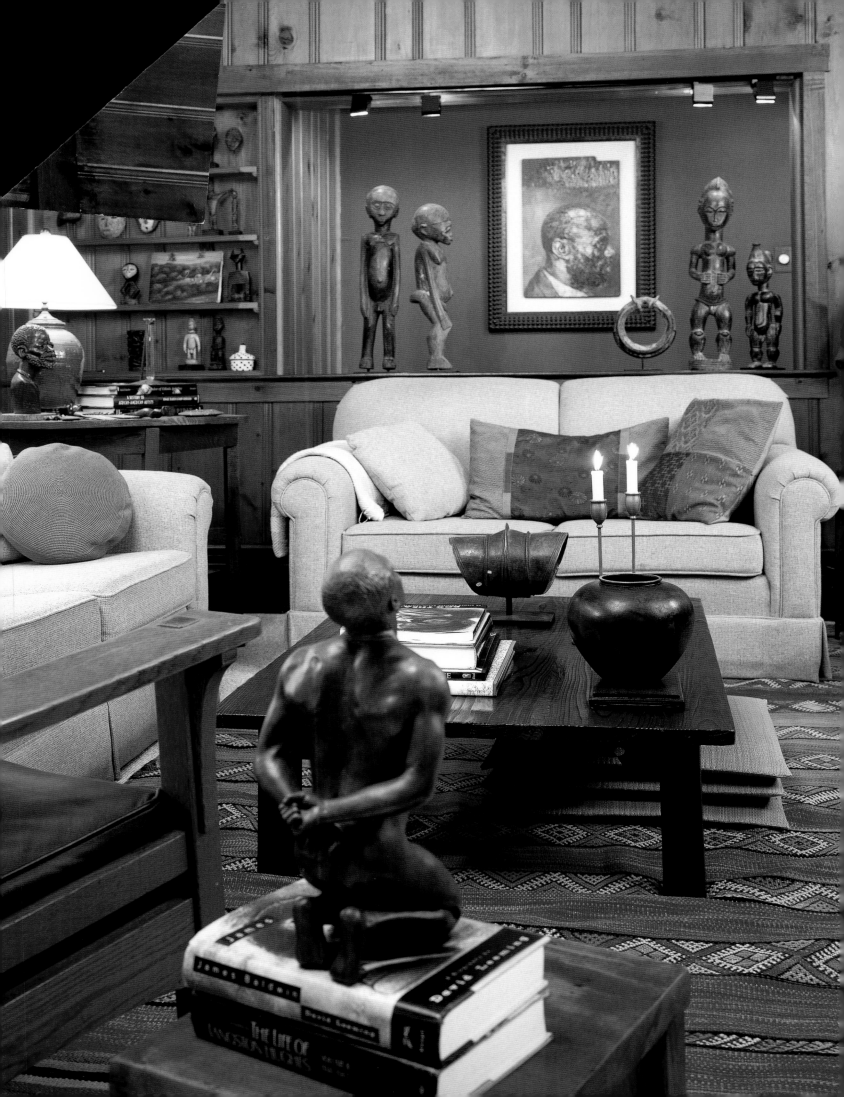

ABOVE: *Assembled over a period of many years, Dudley's collection of Oriental tableware, as vast as it is valuable, is in constant use.*
LEFT: *Solid, comfortable, and in quiet colors, the upholstered furniture in the living room forms a pleasing counterpoint to dynamic art and antiques.*
OVERLEAF: *In the rustic dining room, a beamed ceiling, pinewood walls, Stickley Morris chairs, Asian art, and, above all, a broad brick fireplace create an atmosphere of warmth and serenity.*

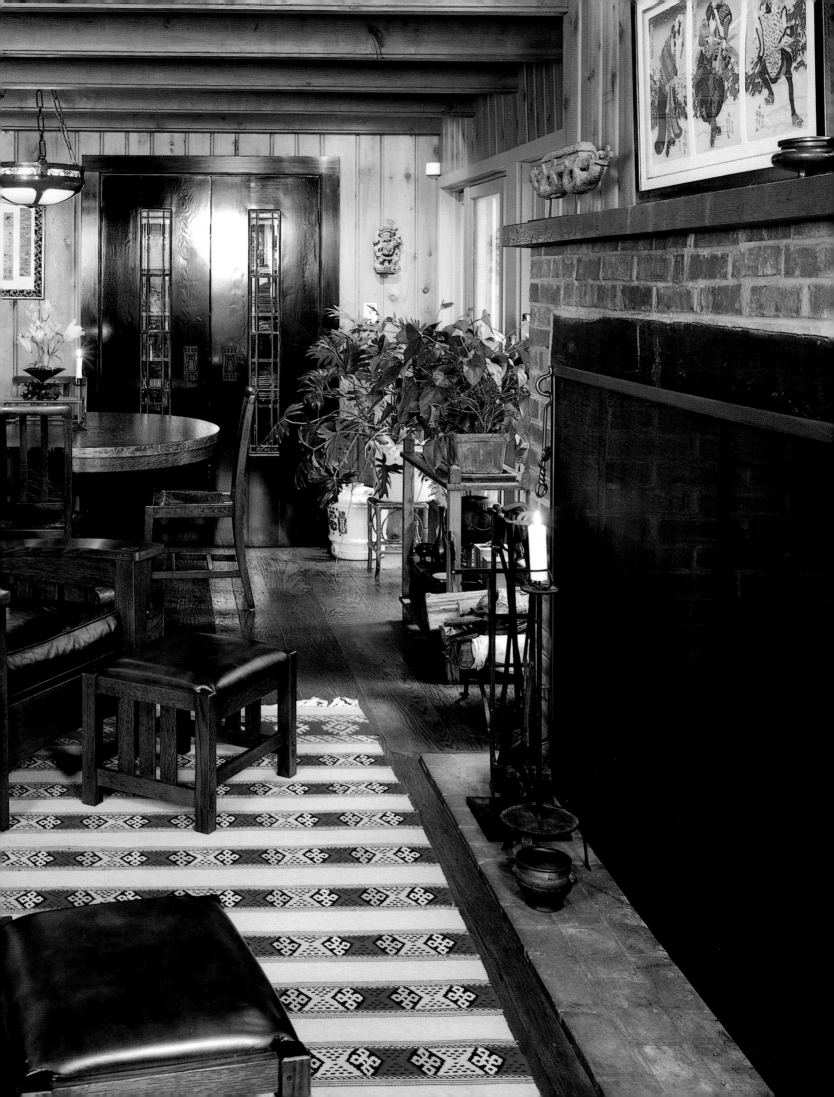

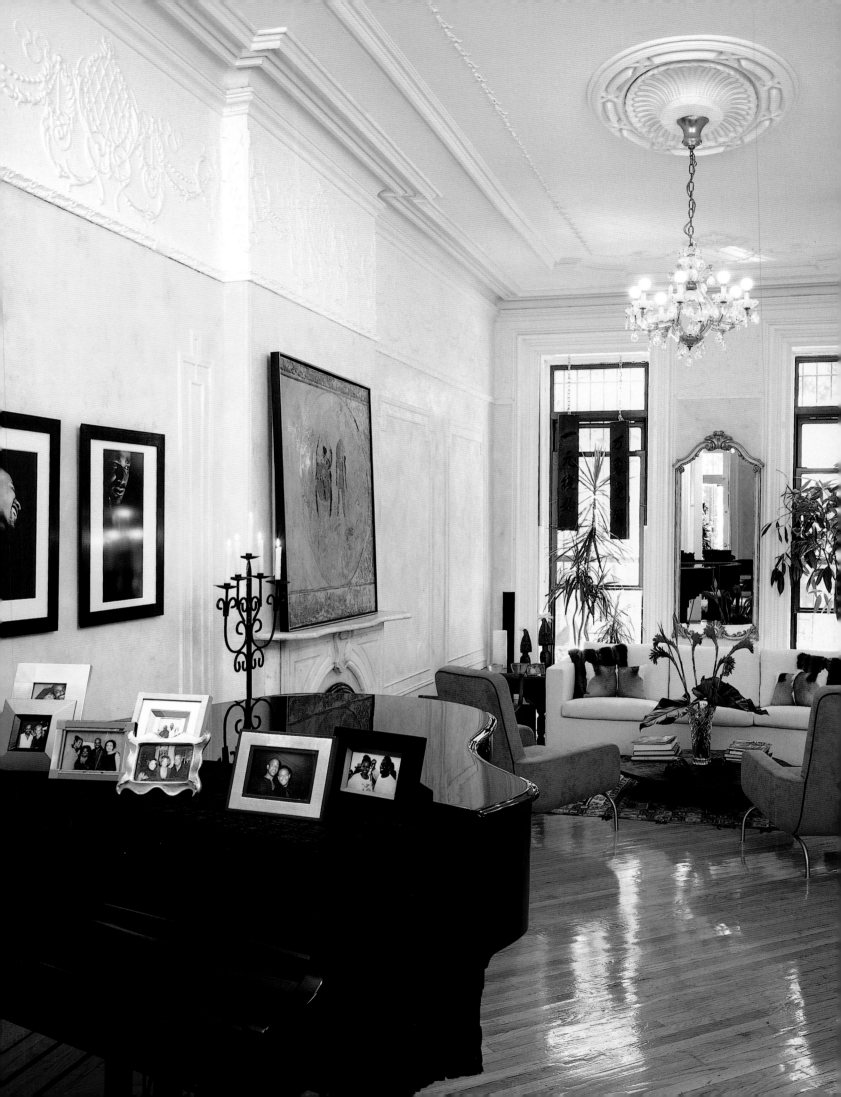

Gordon A. Chambers

A New, Old House

The whiz who wrote the Grammy-winning hit "I Apologize," and who routinely collaborates with megastars like Whitney Houston and Brandy, inhabits a handsome Italianate brownstone house of circa 1865, on Adelphi Street in Fort Greene, near downtown Brooklyn. Always quick to share credit when collaborating, Chambers insists, "It's due to Henry Mitchell," a young black interior designer. "After I bought this house, I put apartments on the top floors to rent, but then I wasn't sure how to proceed with the basement and first story where I would actually live. I wanted everything! And I wanted it yesterday. Henry had the time, patience, knowledge, and skill to help make my vision into reality."

The results speak for themselves. The deep rear garden, planted to effectively recall the composer's Jamaican lineage, is focused on a rectangular lily pool. It also has a broad wooden deck. Below, just outside his pale

ABOVE: *Open-air dining for twelve or a hundred twenty is a feature of Chambers' Brooklyn home life.*
LEFT: *Retaining original architectural elements like the molded plasterwork frieze and marble mantelpiece in his 1860s Brooklyn brownstone, Chambers achieves a stylish space that is decidedly today.*

green and white bedroom, it offers a shaded retreat beyond the sun's glare and potted banana trees.

At the parlor floor, this platform becomes the setting of a second, open-air dining room, immediately adjacent to the one inside. Amid tubbed oleanders and fuchsias, the teak chairs and an immense table can accommodate a

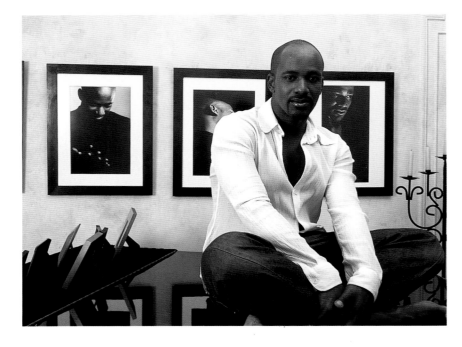

seated dinner for twelve or a buffet supper for ten times as many guests. Providing for utility as well as display, the dining room's counter, clad in translucent glass and topped in marble with a grill and gas burners, functions exactly as a Victorian sideboard did.

For all its conspicuous modernity and streamlined steel and polished aluminum–legged furniture, Chambers' interiors have an overall traditional ambiance. The furnishings were designed by a legendary

ABOVE: *Good taste and talent are combined in Grammy Award-winning homeowner Gordon A. Chambers.*

LEFT: *Leading to the garden on the ground floor, a long corridor is used to display awards and photographs of friends. Mahogany doors in the opposite wall conceal extensive storage space.*

OPPOSITE: *In Chambers' kitchen/dining room, art treasures gathered during world travels and given as presents by friends provide a sophisticated backdrop for neoclassical furniture.*

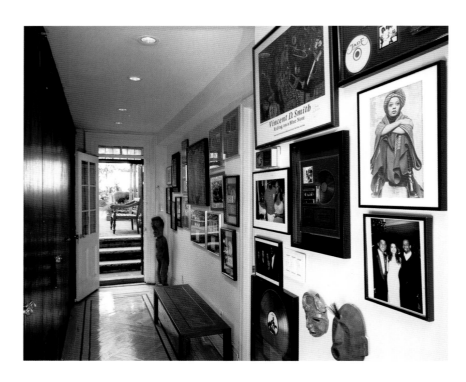

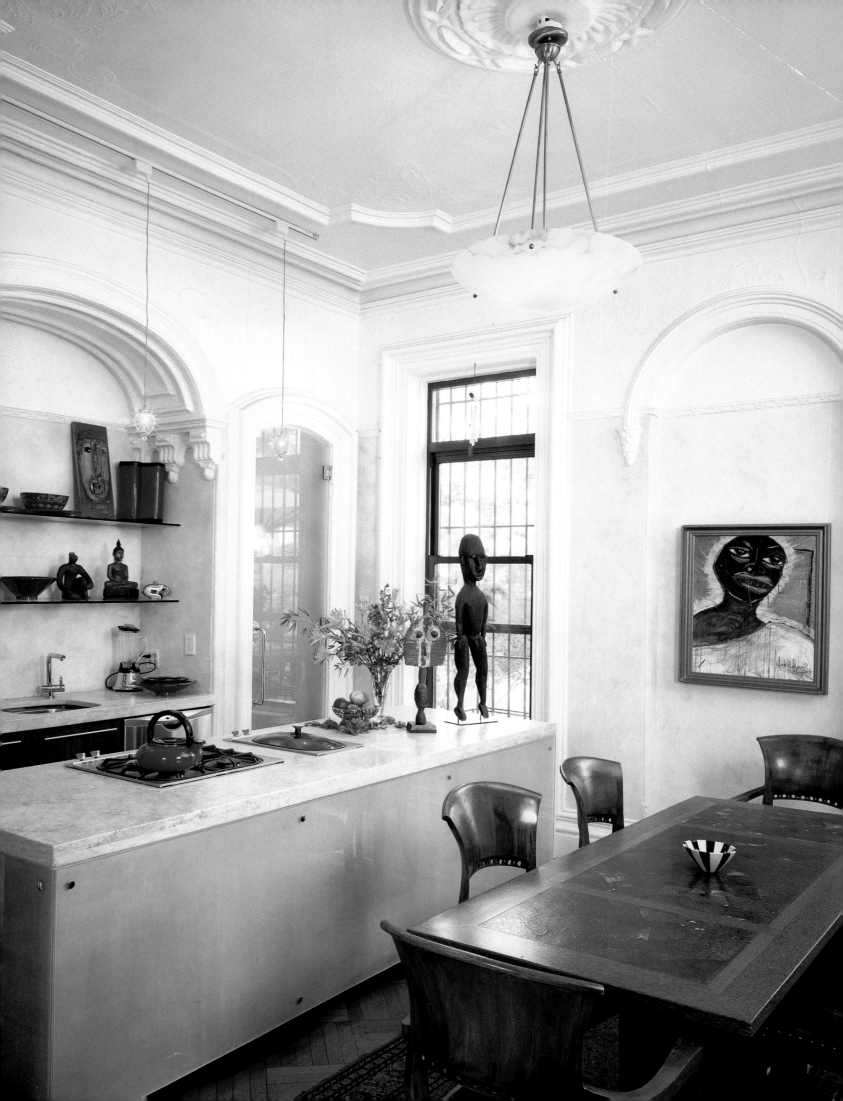

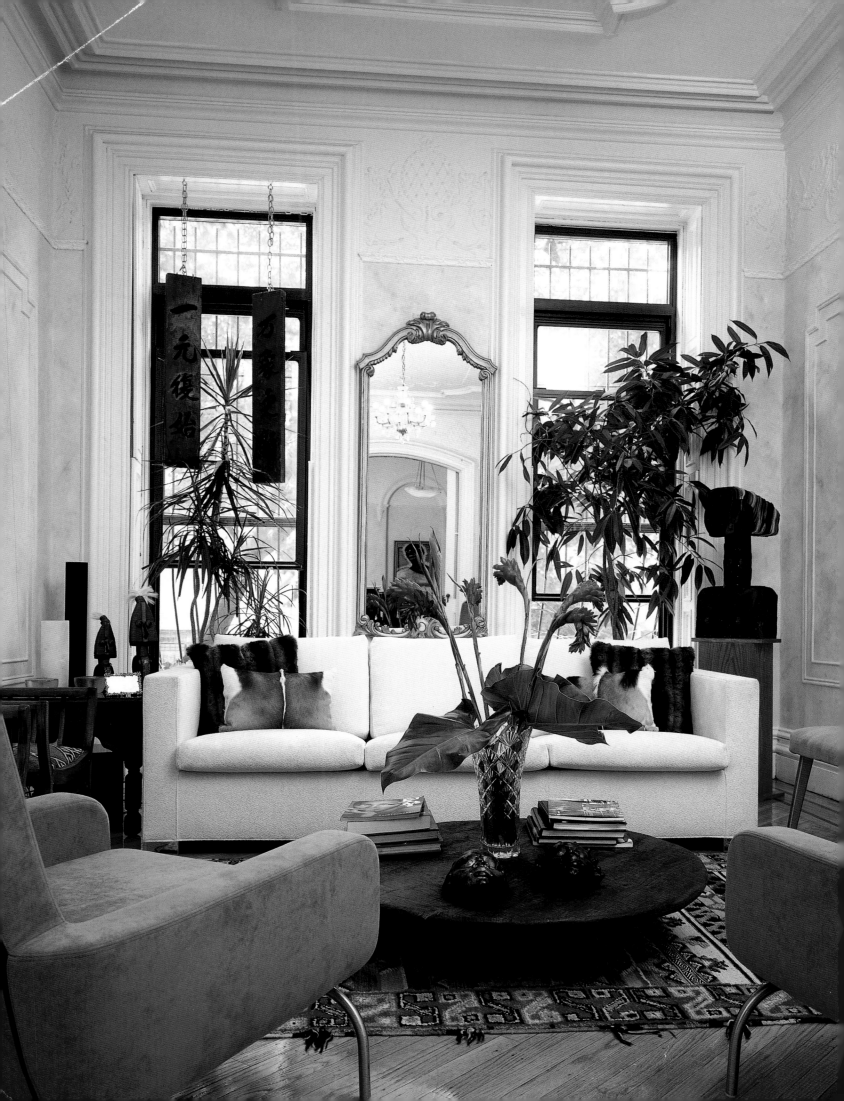

modernist, upholstered in leathers, velvets, and vinyls, and well cushioned with cowhide and fur-covered pillows. Combined with modern photographs and paintings, exotic bouquets, and Oriental and African artifacts, the interiors could not be more au courant. Yet the way everything has been arranged and the eclectic mixture of textures and finishes evokes decoration principles promoted a century ago.

A context of continuity has been achieved. Lofty, lengthy double parlors, the original elaborate plasterwork, a marble mantelpiece, a small grand piano, and cut-glass chandelier might all have been here when the house was new. A restrained gray, black, brown, beige, and tan color scheme is at home in the same space with pink and white walls. Sofas and chairs are grouped in conversation clusters, not unlike their rosewood forerunners of once upon a time.

The powder room is hung with pendant ceiling lights, its surfaces swirled with a metallic coating, except for a shrinelike, variegated-glass mosaic and wall. An antique, Near Eastern atmosphere is achieved out of entirely modern components. The walls shimmer like hand-hammered ore, although they are merely textured plaster.

Such is the alchemy by which Gordon Chambers has made of his old house a modern masterpiece.

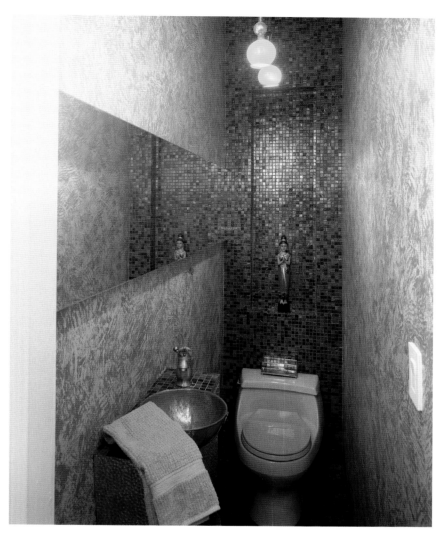

ABOVE: *In the tiny parlor-floor powder room, metallic paint and other humble materials are used to shimmering effect.*

OPPOSITE: *Steel-legged leather-covered furniture with fur cushions, as well as ethnic accents, provide surprisingly clean lines in the pale pink parlor.*

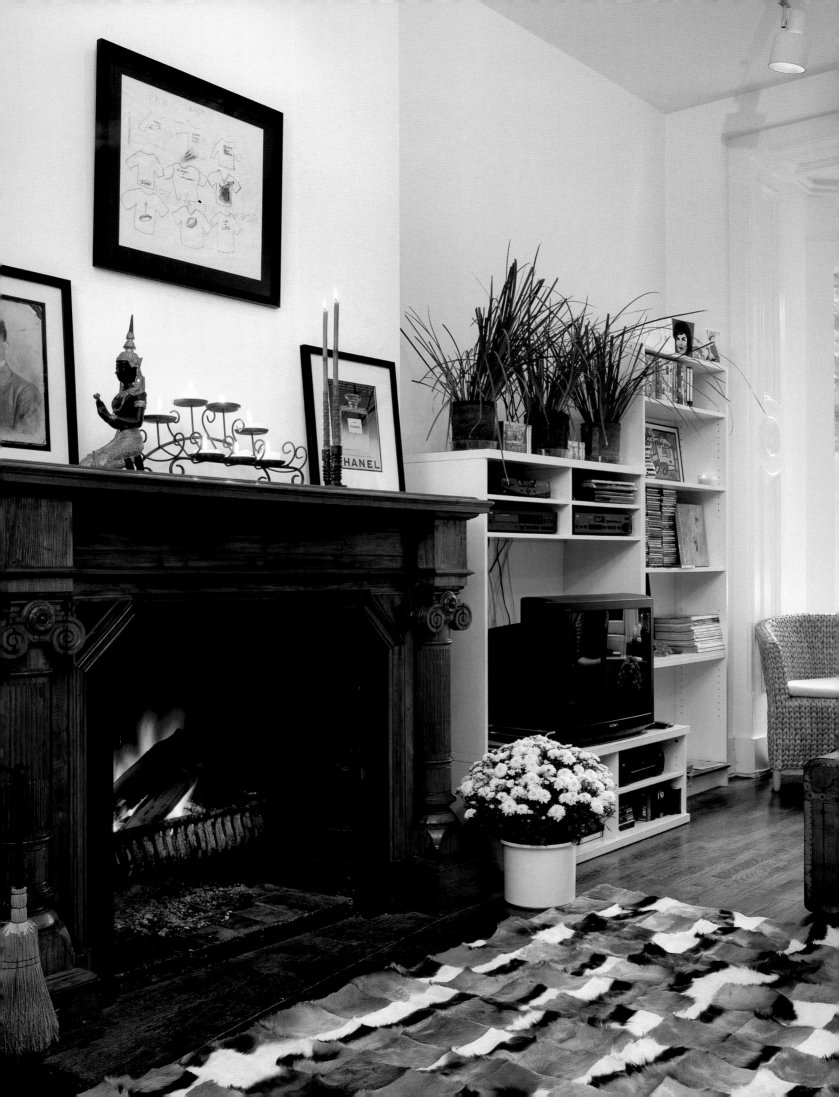

Johnny Machado
and Gerd Breckling

SIMPLY, SUPERBLY BROOKLYN

This warm and alluring Brooklyn Heights duplex apartment is shared by Johnny Machado, a freelance fashion producer and actor who appeared in John Leguizamo's HBO feature film *Infamous*, and cameraman and webmaster Gerd Breckling.

It occupies a good part of an 1870s brick and brownstone house on Pierrepont Street and epitomizes what so many want in a New York home. Devoid of frills, it boasts every comfort, space to spare, light, high ceilings, a garden, and two fireplaces.

This special setting is a new achievement in Patty Duke's make-believe hometown, where extraordinary people like Johnny and Gerd are not the exception.

ABOVE: *A vintage photo of Machado's Cuban grandfather occupies a place of honor.*
LEFT: *Elegantly articulated by Italianate molding and a walnut mantelpiece, the parlor utilizes a restrained color palette of brown, beige, and white.*

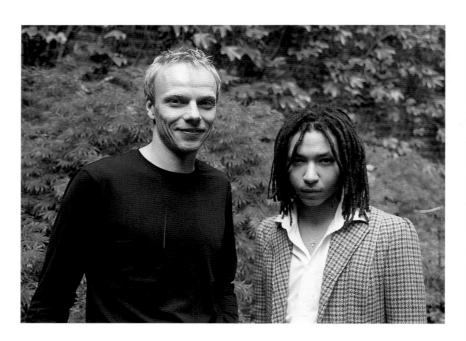

ABOVE: *Intercultural style describes Johnny Machado, Gerd Breckling,
and their sublimely accoutred duplex in Brooklyn Heights.*

RIGHT: *Polished but informal, the dining area would fit as well in
Provence as it does in Brooklyn.*

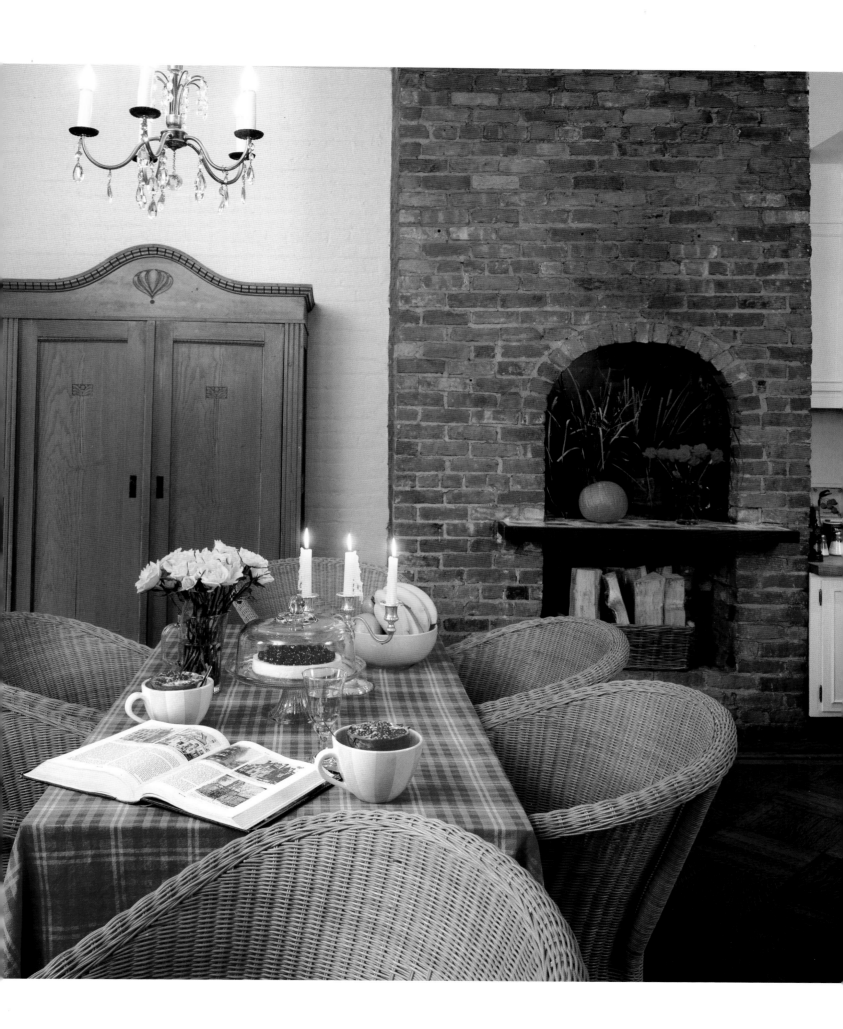

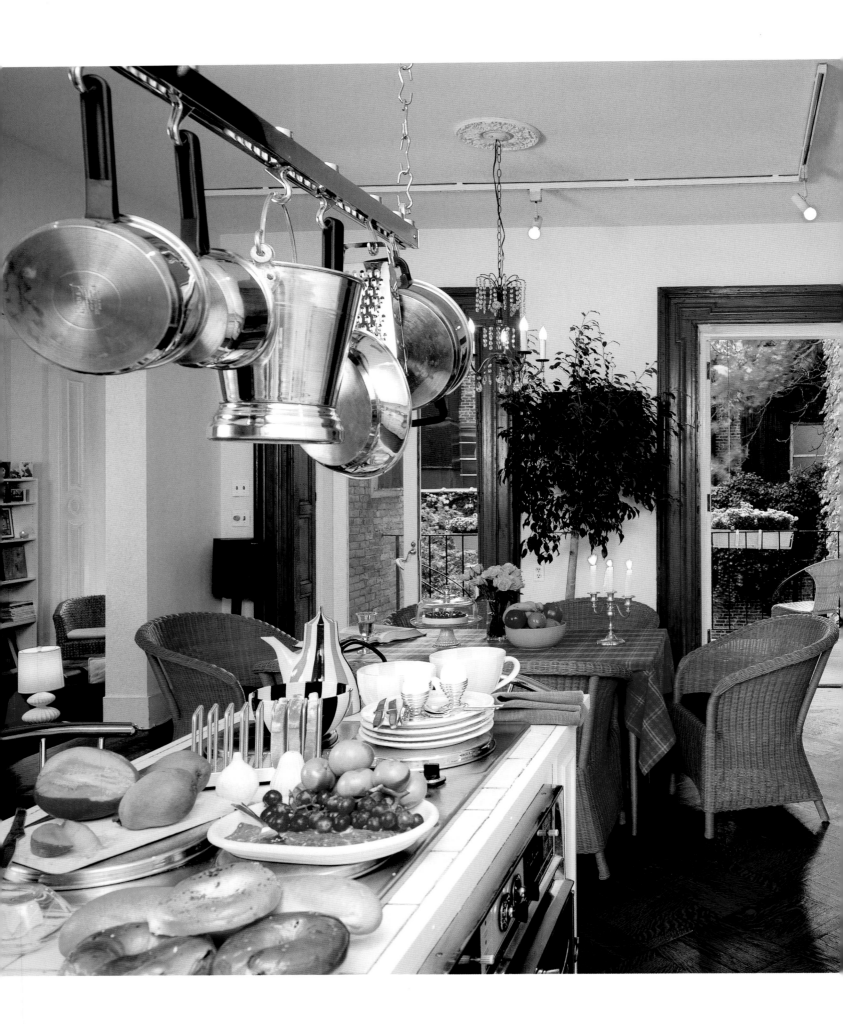

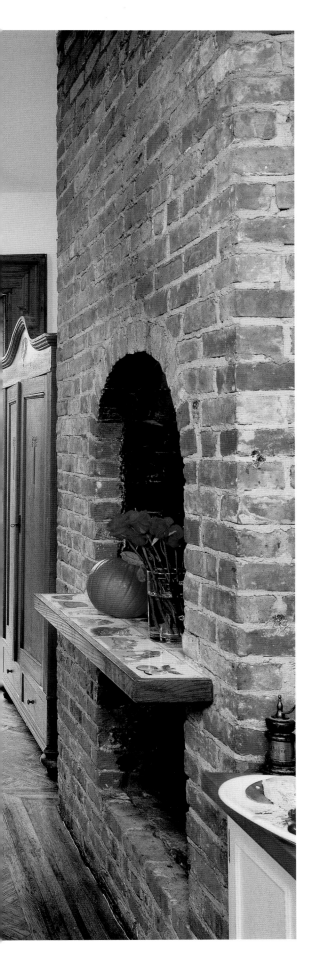

ABOVE: *Filled with compact disks and videotapes, a bookshelf in the living room also displays quirky pop art icons.*

LEFT: *In keeping with more spontaneous living, the one-time formal dining room now accommodates a state-of-the-art kitchen. The adjacent balcony overlooks a garden spacious enough for summer gatherings.*

Michael McCollom

ORDINARY EXTRAORDINARY

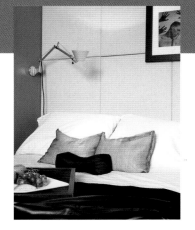

Michael Henry McCollom, former director of a Seventh Avenue fashion house, today is occupied in making arresting photographs. His powerful figure studies have made the artist's apartment a studio as well as a place to live. When he found it, the space was tiny and poorly laid out, but with elements easily found at Home Depot, all this was changed. No one-time cold-water apartment can ever have gone through so thorough a metamorphosis.

Out of the way, in lower East Harlem, it's extremely private. Existing doors and walls, though left in place, were not left as they were. Employing mirrored transoms, silvered door surrounds, steel-clad walls, and his own custom-made steel furniture, McCollom has devised a polished refuge. More audacious than the use of industrial materials and metallic paint is his embrace of the tried and true, only with an inimitable freshness—the leaning looking glass, carnations—which elsewhere seem so trite. Here the ordinary is extraordinary.

ABOVE: *Rich textures and a neutral palette of khaki, gray, and black against a cream background create a chic aesthetic in the bedroom.*
LEFT: *Using industrial mats and furniture made to his own design, McCollom has transformed an East Harlem tenement into a space of luxury and refinement.*

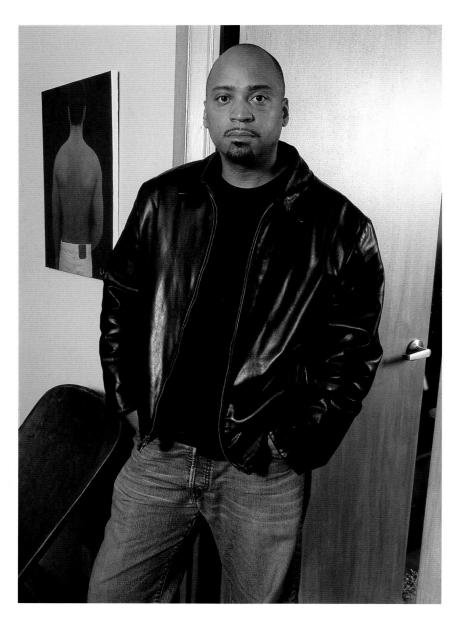

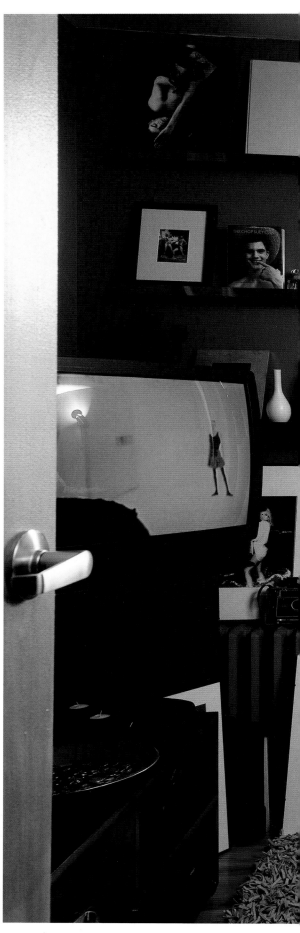

ABOVE: *Previously a sportswear designer, Michael McCollom has begun a new career as an art photographer.*

RIGHT: *The tone-on-tone serenity of McCollom's space is punctuated by his striking photographs.*

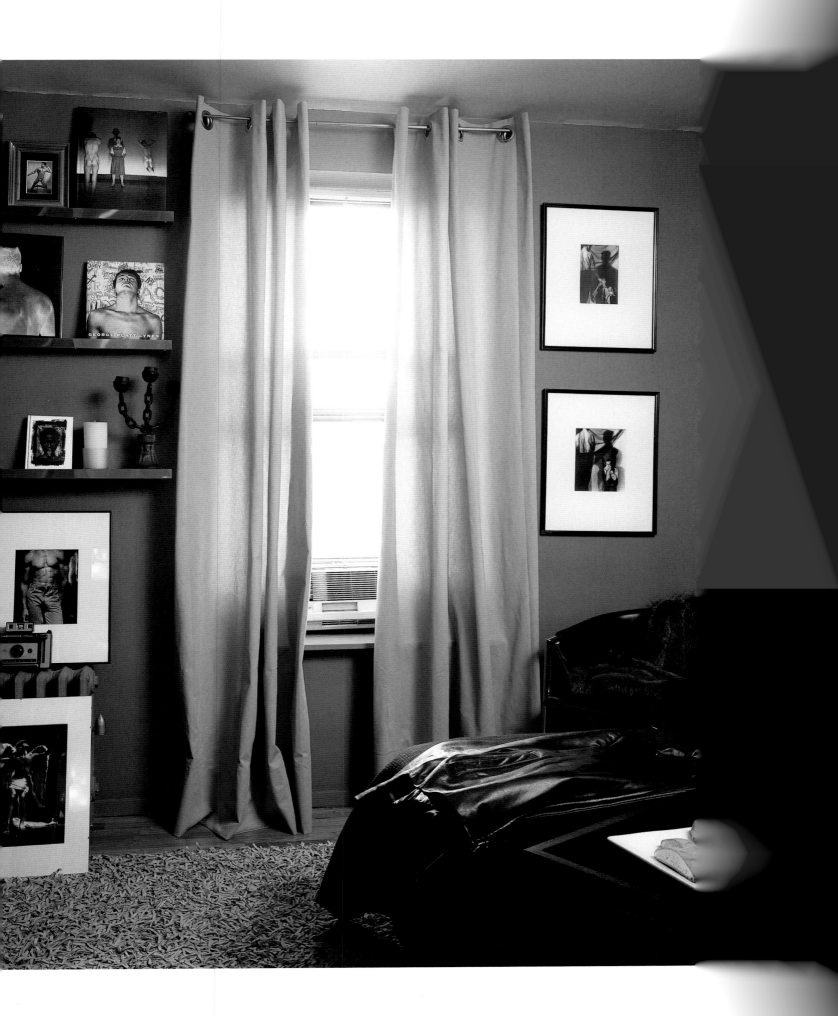

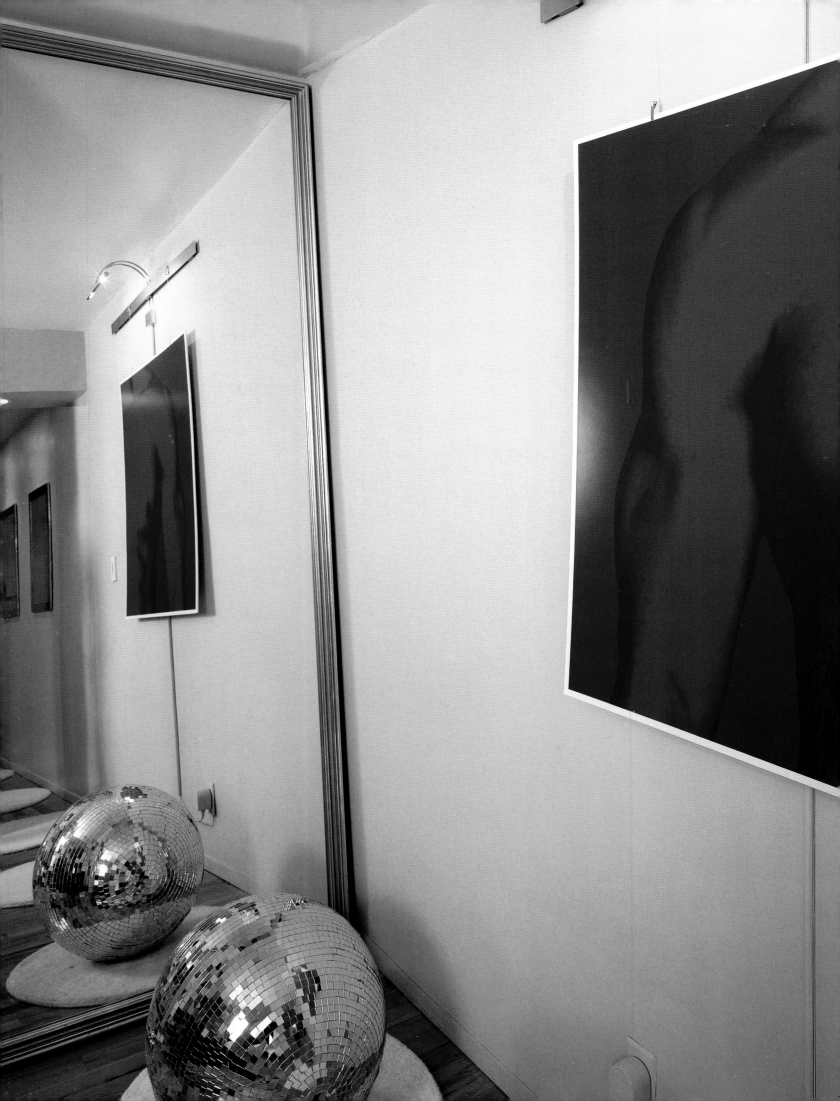

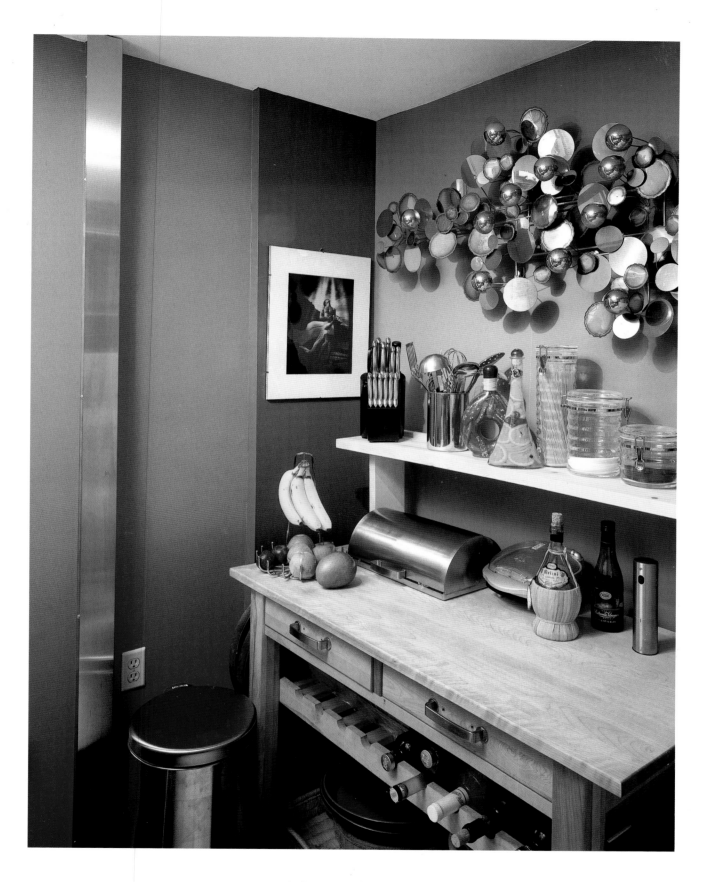

ABOVE: *Even the kitchen displays dynamic works of art.*

OPPOSITE: *A leaning looking glass is the ordinary made
extraordinary when placed at the end of a long passage to reflect a
series of carpet circles, a disco ball, and a print by McCollom.*

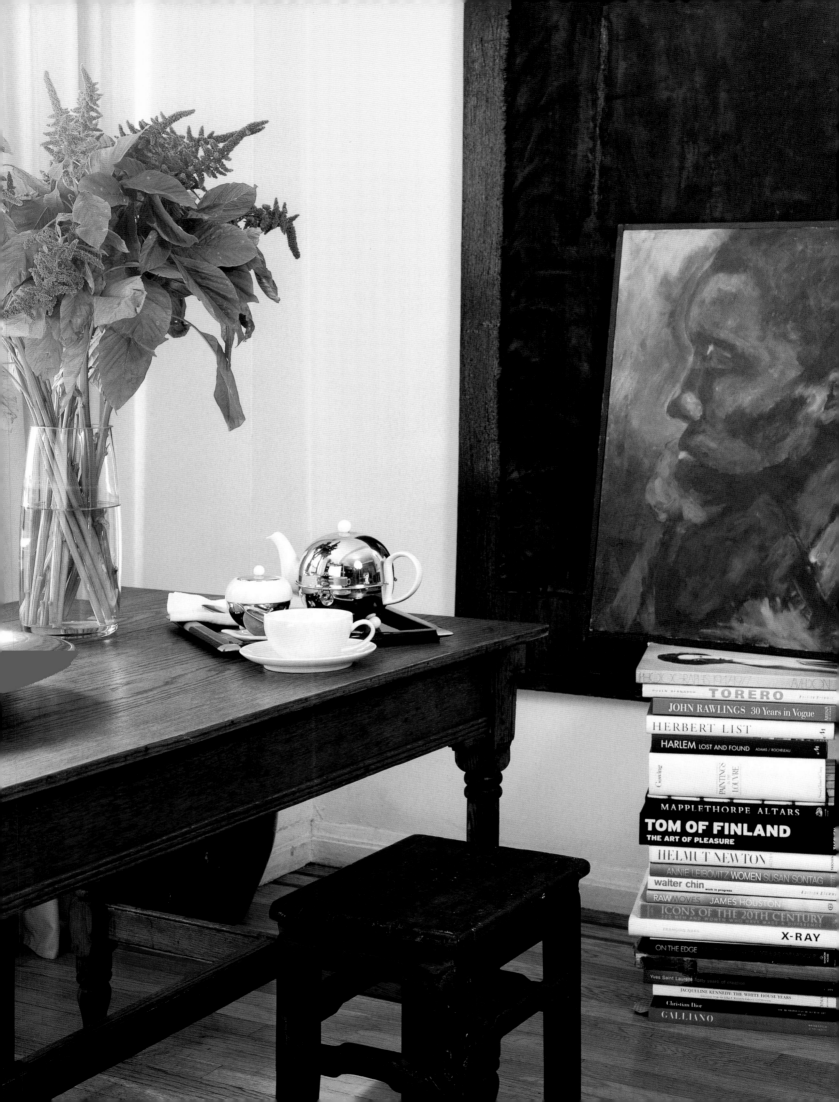

TORERO

JOHN RAWLINGS 30 Years in Vogue

HERBERT LIST

HARLEM LOST AND FOUND ADAMS / ROCHEAU

PAINTINGS LOUVRE

MAPPLETHORPE ALTARS

TOM OF FINLAND
THE ART OF PLEASURE

HELMUT NEWTON

ANNIE LEIBOVITZ WOMEN SUSAN SONTAG

walter chin work in progress

RAW MOVES JAMES HOUSTON

ICONS OF THE 20TH CENTURY

X-RAY

ON THE EDGE

Yves Saint Laurent forty years of creation

JACQUELINE KENNEDY: THE WHITE HOUSE YEARS

Christian Dior

GALLIANO

Curtis Q. Phelps

INTIMATE ELEGANCE

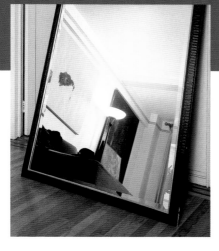

Curtis Quintin Phelps was brought up in Cleveland, Ohio, where no one in his right mind would ever pay high rent for a mere five hundred square feet. Now, in his smart Chelsea studio, entered via a spacious foyer, he is the consummate New Yorker.

His apartment is a form that originated in late nineteenth-century Greenwich Village. Converted from stables, brownstones, and tenements, sky-lit "studios" were combination living-and-work places exclusively for artists. Circa 1930, when Phelps' apartment building was designed by Emory Roth, they were primarily meant to house middle-class workers in an economically compact setting. Like Mr. Phelps' studio, these later ones were too dark for serious painting and sculpting. This loss of light was

ABOVE: *An immense mirror leans against the wall and boldly seizes every ray of light.*
LEFT: *With characteristic understatement, Curtis describes his apartment as having only a table, some stools, and a few paintings. However, these few paintings include extraordinary works.*

offset by gains in convenient planning and stylistic refinement. For instance, the entrance into the main room is down a few steps. Capitalizing on such features, Phelps has deliberately left the beamed space as sparsely furnished as possible.

"I only have a bed, a table, chairs, a mirror, and some bookcases," he pronounces with understatement, referring to his antique English pine refectory table and his library of volumes, which are elegantly wrapped in hand-lettered, vellumlike paper. They are style statements, exceptionally imaginative.

On the move, Phelps, who until recently was employed by Bobbi Brown cosmetics, has just leased a manufacturing loft space turned apartment, the present-day equivalent of earlier artist studios. With five times as many square feet, what might Phelps do? One thing is sure—whatever emerges, his new space is bound to be simply exquisite.

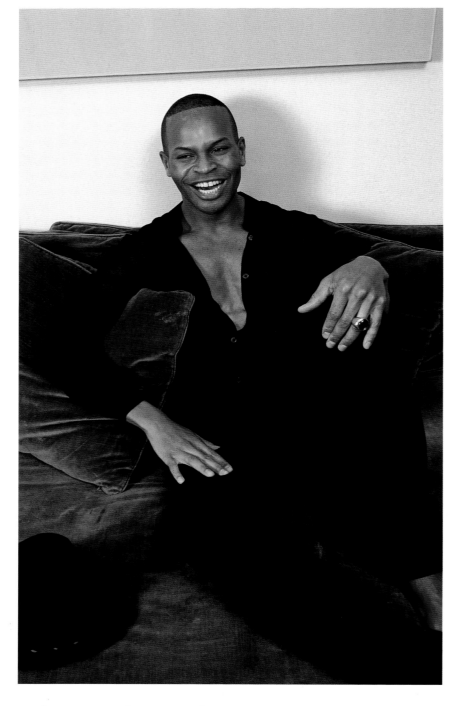

ABOVE: *Always impeccably turned out, Phelps' personal and home style is princely.*

OPPOSITE: *Stylishly arranged books covered in hand-lettered vellum stand in marked contrast to the dark wooden bookcases that cover an entire wall in Phelps' Chelsea studio.*

Emil Wilbekin

ROOMS WITH A VIEW

"This is the New York apartment I always dreamed of," says *Vibe* magazine editor Emil Wilbekin. On the twenty-eighth floor, his dramatic views, overlooking landmark Midtown skyscrapers and the Hudson River, are breathtaking. It has a décor that is both romantic and up-to-date.

One of his earliest jobs in New York was at *Metropolitan Home* magazine, so his current and earlier apartments were designed without any professional help. "My previous space in Greenwich Village was very much a dark and atmospheric environment, reminiscent of a gentleman's club or a country house smoking room. I didn't want to discard my books and wooden bookcases when I moved here. But, with all this light, in a new clean place, I wanted the apartment to reflect more of my affinity for modernism."

ABOVE: *Geometric shapes draw the eye to a dream-come-true view.*
LEFT: *Retained from a previous Greenwich Village apartment, paintings, photographs, and a series of wooden bookcases housing magazines, compact disks, and books adorn a long wall in the living room of Wilbekin's apartment.*

A happy compromise between old and new involved slipcovering his green sofa in duck white. Other ideas were suggested during a trip to London. "I was staying at St. Martin's Lane. I really admire Phillipe Starck. At the Asia de Cuba restaurant there, I saw these columns, wrapped halfway in bookcases, with photographs displayed above, introducing some clear, bright color accents. That's what I've tried to reproduce here, a little of Starck's elegant restraint."

With a view of Ernest Flagg's 1909 Metropolitan Life Building, he has succeeded fabulously.

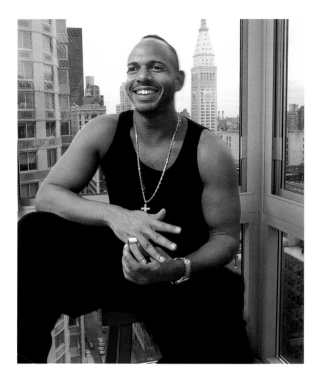

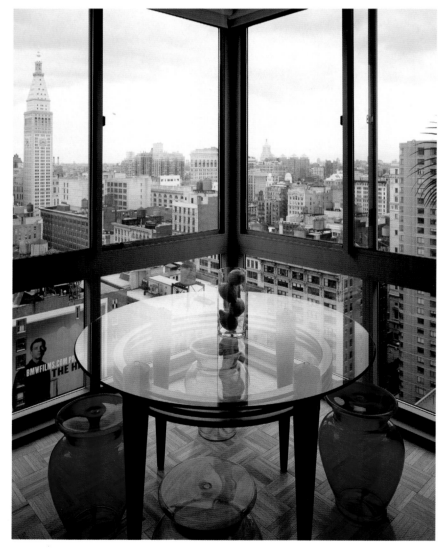

ABOVE: *With the Beaux Arts–style Metropolitan Life tower looming behind him, Emil Wilbekin of* Vibe *magazine is on top of the world.*

LEFT: *Floor-to-ceiling windows form a dramatic dining corner in Wilbekin's living room. Colorful stools in transparent plastic glow in the sunlight.*

OPPOSITE: *A bold painting in the entrance of Emil Wilbekin's Chelsea apartment is the background for a classically modern red glass vase.*

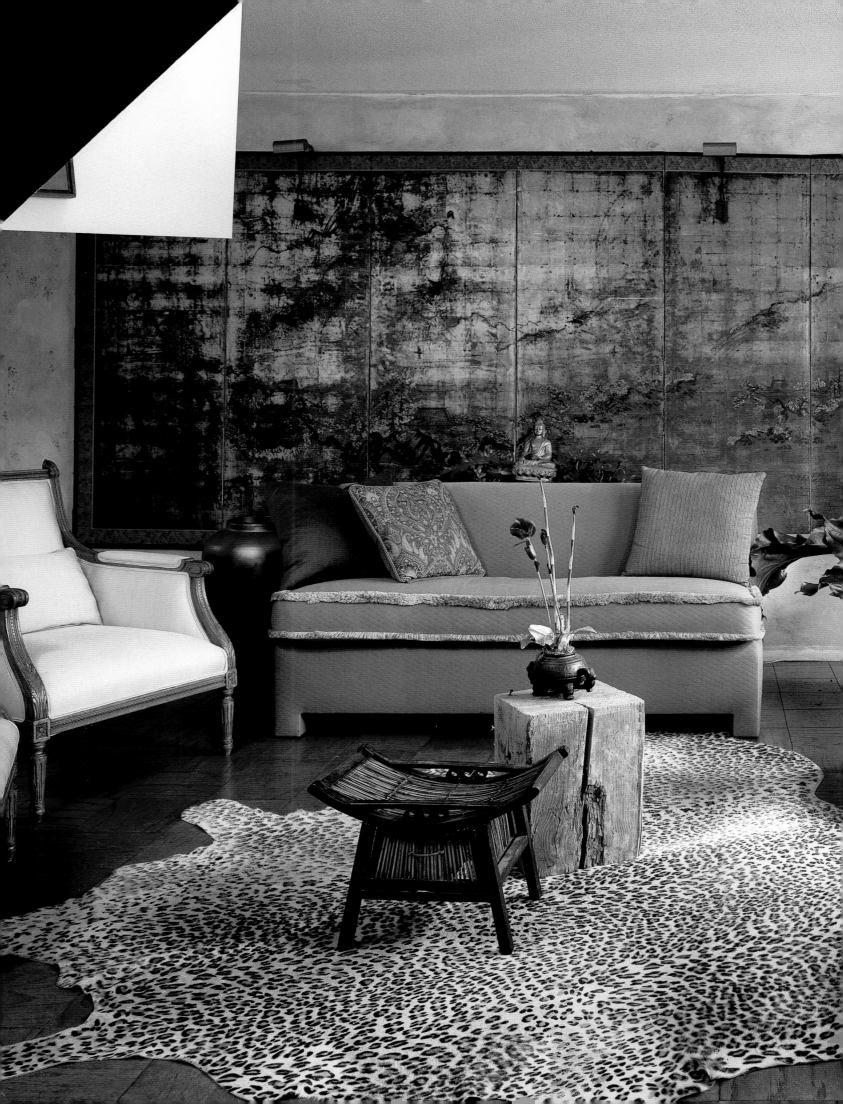

David Lloyd Flemming

THE ATTRACTION OF OPPOSITES

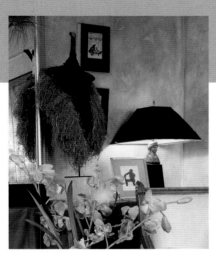

In his high-rise mid-Manhattan apartment, Flemming's approach might be termed "the décor of diversity," for East and West are each exploited to provide an environment that totally represents his personal eclecticism.

Over the past two decades his distinct aesthetic was shaped by a rigorous career in commercial commissions for retail stores. Initially a graphic artist, he was design director for Bergdorf Goodman and Calvin Klein. Later he designed the H & M store on New York's Fifth Avenue and the Gucci showroom on 57th Street.

LEFT: *A pair of Louis XVI bergères upholstered in white Thai silk stand in dramatic contrast to faux-finished limestone walls and a chopping block that functions as an occasional table.*

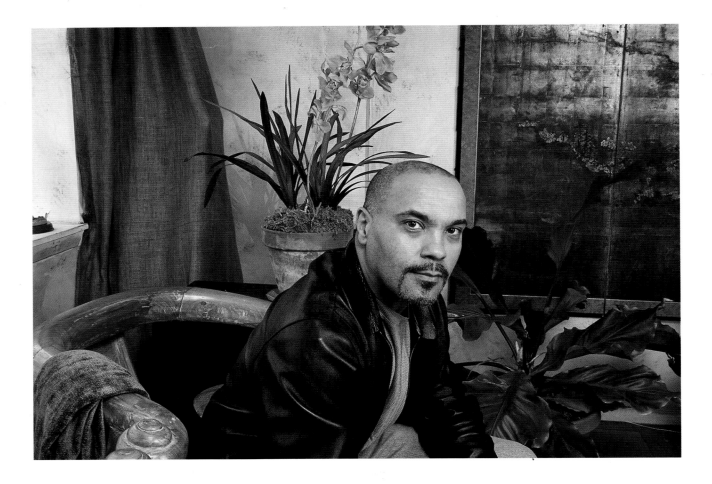

Spontaneity and receptivity are "what creativity is all about," he stresses, pointing out his windows' classical drapery. It was improvised using burlap. "The silk I originally intended hadn't been ordered when an opportunity to be photographed for an important article came along." The walls, mottled to convincingly suggest limestone, he says resulted from a bout of insomnia a few years ago. "It was the hottest night of the decade. I couldn't sleep, so I sponged the walls," he says of the faux finish.

A waxed Louise XVI bergère covered in Thai silk, moss fringe added to a settee, a Chinese screen depicting a misty hillside landscape with gnarly pines, combined with continental porcelains of African kings, a leopard-print cowhide, an Indian Buddha, stalks of papyrus, and burlap draperies—all reflect the artistry of David Lloyd Flemming.

ABOVE: *David Lloyd Flemming employs a broad aesthetic in his career and home.*

RIGHT: *East and West come together in Flemming's eclectic mix of art and furniture.*

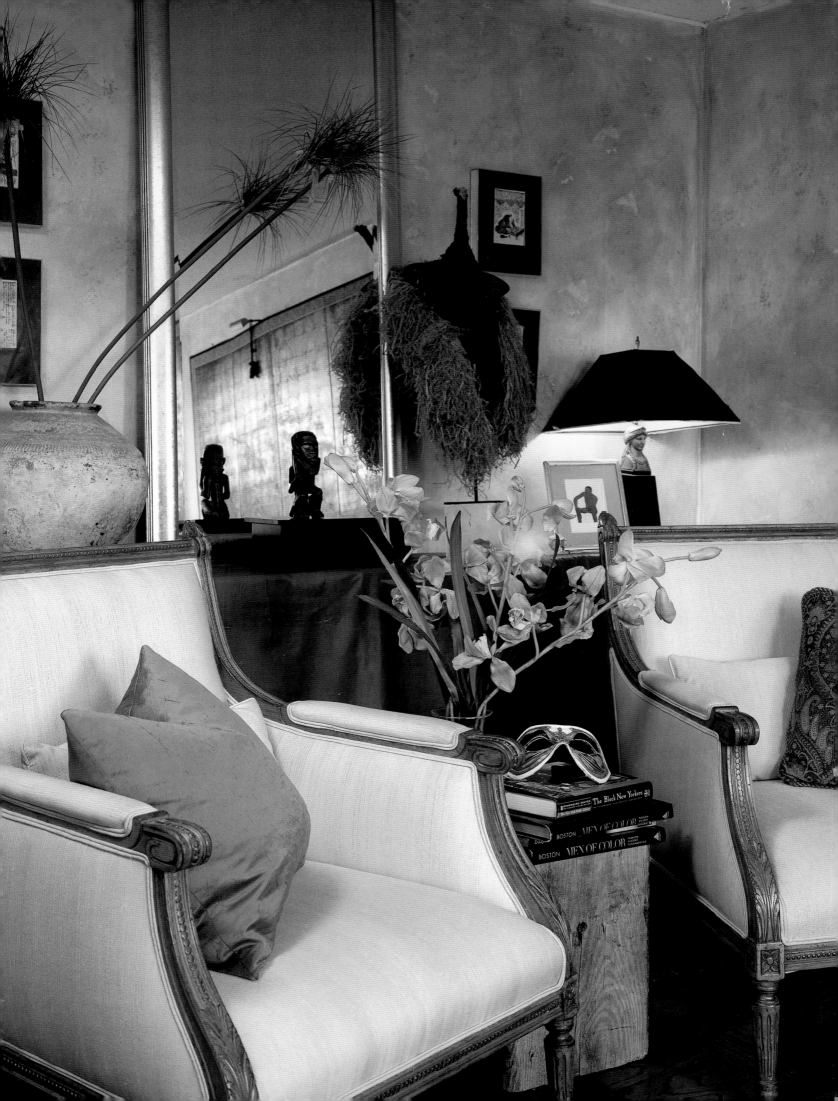

INDEX